TOWNSCAPE PAINTING AND DRAWING

frontispiece: The Market Place, Vienna, by Bernardo Bellotto

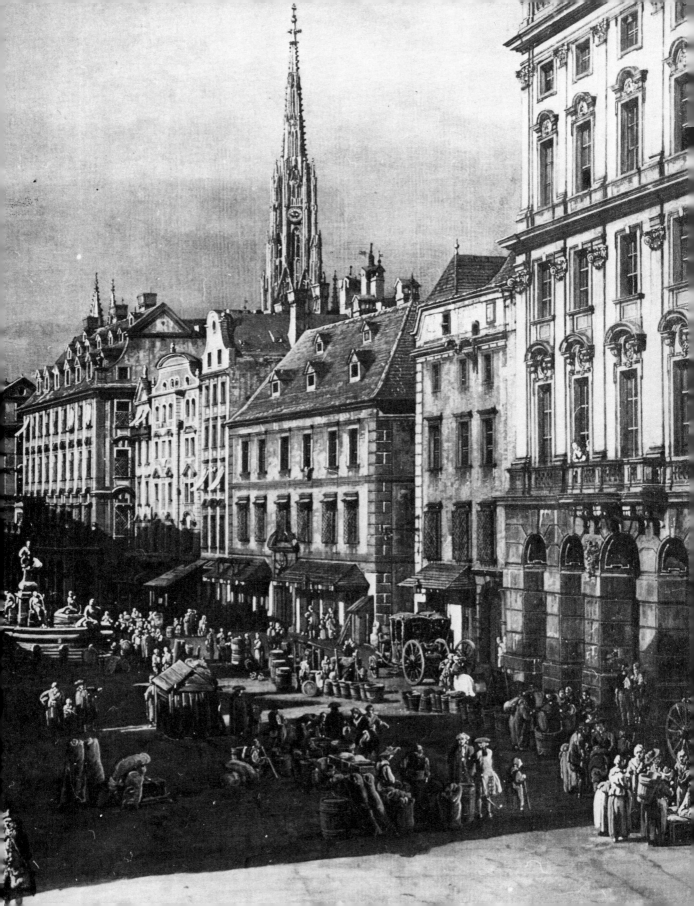

J. G. Links

TOWNSCAPE
PAINTING
AND DRAWING

B. T. BATSFORD LTD London

First published 1972
© J. G. Links 1972

Printed and bound in Great Britain by
Jarrold & Sons Limited, Norwich, Norfolk, for the publishers
B. T. Batsford Limited, 4 Fitzhardinge Street, London w.1
7134 0726 3

Contents

List of illustrations

1 Unknown artist; An Italian hill-town with country houses outside its walls; marble relief; first century AD; Villa Torlonia, Avezzano (recovered from Lake Torlonia); height 2 ft 1½ ins; Photo Alinari.

2 Unknown artist; The harbour of Stabiae; 1st century AD; Museo Nazionale, Naples (illustration from an eighteenth century engraving); 9½ ins × 10½ ins.

3 Unknown artist; Buildings by a lake with a city in the background; wall-painting, from Pompeii; before AD 79; Museo Nazionale, Naples; Photo Alinari.

4 Unknown Mosaicist; mosaic Border depicting a tour of Antioch and Daphne; 4th century AD; part from *Ancient Antioch* by Glanville Downey, (C) 1963 by Princeton University Press, part from Arkeoloji Müzesi, Müdürlügü, Turkey; Reproduced by permission.

5 Probably Saxon embroiderers; William outside Hastings Castle, from the Bayeux tapestry; eleventh century AD; Bayeux, France; height 1 ft 8 ins; Photo Giraudon.

6 Unknown mosaicist; The Removal of the body of St Mark, *c.* 1260; Sant'Alipio arch, St Mark's Cathedral, Venice; Photo Böhm.

7 Artist unknown; Seal of the City of Bruges; 1281; Rouen, Bibliothèque Municipale (Ms. Leber 5650 (3135)); 3 ins diameter; Photo Ellebe, Rouen.

8 Simone Martini (1280/85–1341/44): *Guidoriccio da Fogliano*; 1328; Palazzo Pubblico, Siena; Photo Anderson.

9 Ambrogio Lorenzetti (*c.* 1280–1348): Effects of Good Government: *the Country of Good Government*; 1337–1340; Palazzo Pubblico, Siena; height about 6 ft 6 ins; Photo Grassi, Siena.

10 Ambrogio Lorenzetti: Effects of Good Government: *the City of Good Government*; 1337–1340; Palazzo Pubblico, Siena; height about 6 ft 6 ins; Photo Alinari.

11 Model in wood of Siena in the fifteenth century based on Lorenzetti's *City of Good Government* (by G. Barbetti); 1932; Palazzo Pubblico, Siena; height about 3 ft; Photo Grassi, Siena.

12 Ambrogio Lorenzetti: City by the Sea; date unknown; Pinacoteca, Siena; 9 ins × 12½ ins; Photo Alinari.

13 Ascribed to Piero di Cosimo (*c.* 1462– after 1515): detail from *Portrait of a Man in Armour* showing the Palazzo Vecchio and Loggia di Lanzi, Florence; 1504–1534; Reproduced by courtesy of the Trustees, the National Gallery, London; 2 ft 3¾ ins × 1 ft 8¼ ins (whole).

ix

14 Artist unknown; City of Constantinople, detail the Luttrell Psalter; *c.* 1340; British Museum; Trustees of the British Museum.

15 St Sophia, Constantinople from *Illustrations to the Travels of Sir John Mandeville*; early fifteenth century; Trustees of the British Museum.

16 Procession of the Clergy in Constantinople from *Illustrations to Sir John Mandeville*; early fifteenth century; Trustees of the British Museum.

17 Unknown artist; Venice about 1400; from *Li Livres du graunt Caam* by Marco Polo, MS 264, Bodley. By permission of the Bodleian Library; 9½ ins × 11¼ ins; Photo Böhm.

18 The Limbourg brothers (*c.* 1380/90–*c.* 1416): *Les Très Riches Heures du Duc de Berry*: the Month of June (Ste Chapelle) ms. 65 (1284) fol. 6v; early fifteenth century; Musée Condé, Chantilly; Photo Giraudon.

19 The Limbourg brothers; detail showing Paris from the Meeting of the Magis in *Les Très Riches Heures du Duc de Berry;* fol. 51v; early 15th century; Musée Condé, Chantilly; Photo Giraudon.

20 The Limbourg brothers: Mont St Michel from *Les Très Riches Heures du Duc de Berry*; fol. 195r; Musée Condé, Chantilly; Photo Giraudon.

21 Boucicaut Master and Workshop: Martyrdom of St Denis and his companions at Montmartre; Paris in the background (detail); before 1415; Châteauroux, Bibl. municipale, ms. 2, fol. 364; 11 ins × 7½ ins (whole page); Photo: Studio Robert, Châteauroux.

22 Boucicaut Master and Workshop: Preaching of St Denis near Paris (detail); Before 1415; Châteauroux, ms. 2, fol. 367v; 11 ins × 7½ ins (whole page); Photo: Studio Robert.

23 Boucicaut Master and Workshop: Salmon giving his book to Charles VI; 1409; Paris, Bibliothèque Nationale ms. fr. 23279, fol. 53; 11 ins × 8 ins (whole page).

24 Boucicaut Master and Workshop: Salmon with Richard II of England; 1409; 11 ins × 8 ins (whole page); Paris, Bibl. Nat. ms. fr. 23279 fol. 60v.

25 Jean Fouquet (1416–*c.* 1480): Descent of the Holy Spirit, from the Book of Hours of Etienne Chevalier (detail); probably before 1450; 7½ ins × 5½ ins (whole page); The Lehman Collection, New York.

26 Fouquet: *Les Grands Chroniques de France* (ms. 6465 fol. 442), The arrival of the Emperor at St Denis; 6½ ins × 9 ins; Bibliothèque Nationale, Paris.

27 Jean Fouquet: King Clodaire finding his son asleep on the tomb of St Denis; (fol. 57), from *Les Grands Chroniques de France* (ms. 6465); 4 ins × 4 ins (picture); Bibliothèque Nationale, Paris.

28 Jean Fouquet: *Les Antiquités Judaïques* (ms. 247); Entry of Ptolemy into Jerusalem (fol. 248); 8 ins × 7 ins; Bibliothèque Nationale, Paris.

29 Fouquet: *Les Antiquités Judaïques*: The Taking of Jericho (fol. 89) (detail); 8 ins × 7 ins; Bibliothèque Nationale.

30 Master of Flemalle/Robert Campin (*c.* 1378–1444): The Nativity (detail); 2 ft 10 ins high (whole); Musée de Dijon; Photo Remy.

31 Robert Campin: The Annunciation (Ingelbrecht Altarpiece, formerly Princess of Mérode); height of original 3 ft 9½ ins; Metropolitan Museum of Art, The Cloisters Collection, New York.

32 Robert Campin: The Virgin and Child before a Firescreen; before 1430; height of whole picture 2 ft 1 in; Reproduced by courtesy of the Trustees, the National Gallery, London.

33 Hubert or Jan van Eyck (Jan *c.* 1380–1441, Hubert *d.* 1426): The Adoration of the Lamb (Ghent Altarpiece); Finished about 1432; St Bavo, Ghent; height of whole altarpiece about 12 ft; Photo Paul Bijtebier, Brussels.

34 Jan van Eyck: Adoration of the Lamb, detail from right background; St Bavo, Ghent; Photo Bijtebier.

35 Jan van Eyck: Adoration of the Lamb, detail from left background; St Bavo, Ghent; Photo Bijtebier.

36 Jan van Eyck: Madonna of Chancellor Rolin; about 1430–35 (but perhaps before 1422: *see text*); Louvre; 2 ft 2 ins × 2 ft (whole); Photo Giraudon.

37 Jan van Eyck (? and Petrus Christus): Madonna with St Elizabeth of Hungary and a Carthusian donor, detail of background; about 1435–40; height of whole picture 1 ft 6½ ins; Frick Collection, New York; Copyright The Frick Collection.

38 Roger van der Weyden (1399–1464): The Nativity (Bladelin Altarpiece); *c.* 1452–55; height of whole picture 3 ft; Staatliche Museen, Berlin-Dahlem; Photo Walter Steinkopf, Berlin.

39 Roger van der Weyden: Adoration of the Magi (St Columba altarpiece); *c.* 1460–64; height of whole picture 4 ft 7 ins; Alte Pinakothek, Munich; Photo Pinakothek.

40 Roger van der Weyden: St Luke Painting the Virgin; height of whole picture 4 ft 6 ins; Museum of Fine Arts, Boston; Photo courtesy of Museum of Fine Arts, Boston. Gift of Mr and Mrs Henry L. Higginson.

41 Hans Memlinc (1433–1494): Shrine of St Ursula; detail: The arrival in Cologne; 1489; height 2 ft 10 ins, length 3 ft; Hospital of St Jean (Memlinc Museum) Bruges.

42 Domenico di Michelino (1417–91): Dante and his Poems; Cathedral, Florence; Photo Alinari.

43 Benedetto Bonfigli (1420–96): Siege of Perugia; 1454–1496; Palazzo Pubblico, Perugia; Photo Alinari.

44 Benedetto Bonfigli: Madonna della Misericordia; 1464; Photo Alinari.

45 Jean Fouquet: from *Antiquités Judaïques* (ms. 247), The Building of the Temple (fol. 163); 8 ins × 7 ins; Bibliothèque Nationale, Paris.

46 Jean Fouquet: *Les Antiquités Judaïques*, The Taking of Jerusalem (fol. 163); 8 ins × 7 ins; Bibliothèque Nationale.

47 Artist disputed; S. Bernardino Healing a Blind Man; 1473; Perugia, Pinacoteca; 3 ft × 2 ft 1 in; Photo Alinari.

48 Attributed to Luciano Laurana: Ideal City (or Architectural Perspective); about 1470; 4 ft ½ in × 7 ft 8 ins; Berlin, Staatliche Museen.

49 Piero della Francesca (?) (*c.* 1416–1492): Ideal City; 3 ft 7 ins × 12 ft 6 ins; Urbino, Palazzo Ducale; Photo Alinari.

50 Francesco di Giorgio (1439–1502): *Intarsia* panel; about 1476; Palazzo Ducale, Urbino.

51 Fra Sebastiano and others: Act in the Life of St Mark, intarsia panel reminiscent of the Piazzetta; Sacristy of St Mark's, Venice; 3 ft 5 ins × 2 ft 8 ins; Photo Fondazione Giorgio Cini.

52 *Intarsia* panel with church reminiscent of S. Zaccaria, Venice; Sacristy of St Mark's, Venice.

53 *Intarsia* panel with reminiscence of the clock-tower, Venice; Sacristy of St Mark's, Venice.

54 Domenico Morone (1442– after 1517): Expulsion of the Bonacolsi from Mantua; 1494; 5 ft 7 ins × 10 ft 7 ins; Palazzo Gonzaga, Mantua; Photo Calzolari , Mantua.

55 *Intarsia* panel; Palazzo Gonzaga, Mantua.

56 Gentile Bellini (1429–1507): Procession of the Holy Cross in the Piazza S. Marco; 1500; 12 ft × 24 ft 6 ins; Accademia, Venice; Photo Böhm.

57 Gentile Bellini: detail from the Procession of the Cross showing Sant'Alipio arch, St Mark's, with thirteenth century mosaic (compare Plate 6); 1500; Accademia, Venice; Photo Böhm, Venice.

58 Vittore Carpaccio (c. 1465–1525): Miracle of the Reliquary of the Holy Cross borne by the Patriarch of Grado; about 1500; 11 ft × 12½ ft; Accademia, Venice; Photo Böhm.

59 Gentile Bellini: Miracle of the Cross at S. Lorenzo; 1500; 12 ft 2 ins × 14 ft 1 in; Accademia, Venice; Photo Böhm.

60 Erhard Reuwich: detail of woodcut of Jerusalem from *Peregrinationes* of Bernhard von Breydenbach; 1483–4 (published 1486).

61 Erhard Reuwich; detail of woodcut of Venice from *Peregrinationes*; published 1486.

62 View of Florence in the fifteenth century; Woodcut; 1 ft 11 ins × 4 ft 4 ins, in six pieces; Kupferstichkabinett, Berlin.

63 View of Florence; Workshop of Francesco Rosselli (?); About 1490; 3 ft 1½ ins × 4 ft 8½ ins; Mrs Herbert Bier, London.

64 Artist unknown; The burning of Savonarola in the Piazza della Signoria; Florence; sixteenth century; Museo di S. Marco, Florence; Photo Alinari.

65 Jacopo de'Barbari (1440/50–c. 1515): Bird's-eye View of Venice; woodcut; 4 ft 2 ins × 9 ft 2 ins.

66 de'Barbari: detail showing the Piazzetta etc.

67 de'Barbari: detail showing the Riva degli Schiavoni etc.

68 de'Barbari: detail showing S.S. Giovanni e Paolo etc.

69 Giovanni Bellini (c. 1430–1516): La Pietà, detail of background; 2 ft 1½ ins × 2 ft 10 ins (whole picture); Accademia, Venice; Photo Böhm.

70 Giambattista Cima da Conegliano (1459–1517/18 or 27): Madonna of the Orange Tree, detail of background; 7 ft 1 in × 4 ft 7 ins (whole); Accademia, Venice; Photo Böhm.

71 Albrecht Dürer (1471–1528): Innsbruck and the Patscherkofel; 1494; actual size (5 × 7⅞ ins); Albertina, Vienna; Photo Schroll, Vienna.

72 Albrecht Dürer: Nuremberg with the Little Church of St John; about 1494; 11½ ins × 16½ ins; Kunsthalle, Bremen.

73 Francesco Ubertini called Bacchiacca (1494–1557): Sheltering the Pilgrims; 1540–50; 2 ft 11½ ins × 2 ft 2 ins; Rijksmuseum, Amsterdam; fotocommissie Rijksmuseum.

74 Joachim Patinir (c. 1480–1524): Landscape with Martyrdom of St Catherine; before 1515; 11 ins × 1 ft 5½ ins (including strips at side and top removed in 1954); Vienna, Kunsthistorisches Museum.

75 Patinir: Landscape with St Jerome; probably 1515–1519; 2 ft 5 ins × 3 ft; Prado, Madrid; Photo Anderson, detail Prado.

76 Gerard David (1460–1523): Marriage at Cana; end of fifteenth century; 3 ft 2 ins × 4 ft 2 ins (whole picture); Louvre; Photo Giraudon.

77 Jan Gossaert called Mabuse (c. 1478–c. 1533/6): St Luke Painting the Virgin; National Gallery, Prague; Photo Narodni Galerie.

xii

78 Pieter Breughel (1525–1569): Battle between Carnival and Lent; 1559; 3 ft 10½ ins × 5 ft 6 ins; Kunsthistorisches Museum, Vienna.

79a Pieter Pourbus (1524–1584): Background detail from Portrait of Jean Fernaguut; 1551; whole picture 3 ft 2½ ins × 2 ft 4 ins; Groeningen Museum, Bruges; Photo Paul Bijtebier.

79 Pieter Pourbus: Background detail from Portrait of Adrienne De Buck; 1551; Groeningen Museum, Bruges; Photo Paul Bijtebier.

80 Jakob Sandtner (fl. 1565–75): Detail from limewood model of Munich; 1570; about 6½ ft square (199 × 189 cms); Bavarian National Museum, Munich.

81 Antony van den Wyngaerde: detail of Bird's-eye view of London; about 1543–1550; Ashmolean Museum, Oxford.

82 Marcus Gheraerts (about 1525– before 1604): detail from Bird's-eye view of Bruges; 1562; Bruges Town Hall; from a modern reproduction from the original plates.

83 Venice, from Braun and Hogenberg's *Civitates Orbis Terrarum*; 1572.

84 Georg Hoefnagel: Venice, the burning of the Doge's Palace in 1577 (from Braun and Hogenberg).

85 Georg Hoefnagel: Venice, Piazza San Marco; 1578.

86 George Hoefnagel: London, from Braun and Hogenberg; 1572; original 13 inches high.

87 Matthew Merian (1593–1650): Basle, from Braun and Hogenberg.

88 George Hoefnagel: Toledo, from Braun and Hogenberg; 1566 (published 1598).

89 Lucas van Valckenborch (before 1535–1597): Gmünden, from Braun and Hogenberg; 1594.

90. El Greco (Domenicos Theotocopoulos (1541–1614)): Toledo; 1604–1614; 4 ft × 3 ft 7 ins; Metropolitan Museum of Art, New York; Bequest of Mrs H. O. Havemeyer, 1929, The H. O. Havemeyer Collection.

91 El Greco: View and Plan of Toledo; 4 ft 5 ins × 7 ft 6 ins; Toledo Museum; Photo Anderson.

92 Juan Bautista del Mazo (c. 1515–1607) with, perhaps, Diego Rodriguez de Silva Velasquez (1599–1660): View of Saragossa; 1647; 6 ft 10 ins × 10 ft 10 ins; Prado, Madrid.

93 Hans Bol (1534–1593): Landscape near the River Schelde (Gallery title); 1572 or 1578; 1 ft 6 ins × 2 ft 5 ins; Los Angeles County Museum of Art. (William Randolph Hearst Collection).

94 Unknown draughtsman: London before the burning of St Paul's Ste[eple], woodcut; Pepys Library, Cambridge; 10 ins × 15 ins; By courtesy of the Master and Fellows of Magdalene College Cambridge.

95 Claes Jansz Visscher (b. 1587): View of London, Westminster and Southwark from Whitehall to St Katherine's-by-the-Tower; etching; 1616; 4 sheets each 1 ft 4½ ins × 1 ft 9 ins.

96 Mathew Merian: detail from View of London published 1638; engraving; 8 ins × 2 ft 3 ins (excluding key).

97 Claude de Jonghe (c. 1600– after 1650) (attributed): London from Bankside; about 1630; 1 ft 10 ins × 2 ft 10 ins; London Borough of Tower Hamlets, Central Library.

98 de Jonghe: Old London Bridge; 1630; 1 ft 8 ins × 5 ft 8 ins; The Greater London Council as Trustees of the Iveagh Bequest, Kenwood.

120 G. Berckheyde: The Bend of the Heerengracht in Amsterdam (from the Vyzelstraat Bridge); 1685; 1 ft 9 ins × 2 ft $\frac{3}{4}$ in; Rijksmuseum; Fotocommissie Rijksmuseum.

121 Joseph Heintz the younger (*c.* 1600–*c.* 1678): Piazza San Marco, Venice 3 ft 9$\frac{1}{2}$ ins × 6 ft 9 ins; Rome, Gallery Doria Pamphili; Photo Cacco, Venice.

122 Gaspar Vanvitelli (or van Wittel) (1653–1736): Piazza Navona, Rome; 1 ft 7$\frac{1}{2}$ ins × 2 ft 3 ins; Rome, Chinni collection; Photo Cacco, Venice.

123 Gaspar Vanvitelli (or van Wittel) (1653–1736): The Molo, Piazzetta and Doge's Palace, Venice; 1697; 3 ft 2$\frac{1}{2}$ ins × 5 ft 8$\frac{1}{2}$ ins; Prado, Madrid.

124 Luca Carlevaris (1665–1731): Entry of the Earl of Manchester to the Doge's Palace, detail (see text for date); 4 ft 4 ins × 8 ft 8 ins; By permission of the Birmingham Museum and Art Gallery.

125 Luca Carlevaris: Regatta on the Grand Canal in Honour of King Frederick of Denmark; about 1710; 4 ft 5 ins × 8 ft 6 ins; Frediksborg Castle, Copenhagen.

126 Andrea Palladio (1508–1580), executed by Vincenzo Scamozzi 1552–1616: Stage of the Teatro Olimpico, Vicenza; Photo Alinari.

127 Giovanni Antonio Canal, called Canaletto (1697–1768): Piazza San Marco, Venice, looking East; in or before 1723; 4 ft 8 ins × 6 ft 9 ins; Thyssen-Bornemisza Collection, Castagnola, Switzerland.

128 Canaletto: Grand Canal: looking East from the Campo di S. Vio; about 1723; 4 ft 8 ins × 6 ft 8$\frac{1}{2}$ ins; Thyssen-Bornemisza Collection.

129 Canaletto: SS. Giovanni e Paolo and the Scuola di S. Marco, Venice; 1726; 3 ft × 4 ft 4 ins; estate of the late Elwood B. Hosmer, Montreal.

130 Canaletto: S. Giacomo di Rialto; 3 ft 2 ins × 3 ft 10 ins; Staatliche Gemäldegalerie, Dresden.

131 Canaletto: Grand Canal: the Rialto Bridge from the North about 1727; 1 ft 6 ins × 1 ft 11 ins; Trustees of the Goodwood Collection.

132 Canaletto: Reception of the Imperial Ambassador Count Giuseppe di Bolagno, at the Doge's Palace; Probably 1729; 6 ft × 8 ft 8 ins; Milan, Aldo Crespi Collection.

133 Canaletto: Grand Canal; 'The Stonemason's Yard'; Sta. Maria della Carità from across the Grand Canal; probably before 1730; 4 ft 1 in × 5 ft 4 ins; Reproduced by courtesy of the Trustees, the National Gallery, London.

134 Canaletto: Grand Canal; looking East from the Campo di S. Vio; before 1735; 1 ft 6 ins × 2 ft 6$\frac{1}{2}$ ins; By gracious permission of H.M. The Queen.

135 Canaletto: Piazza S. Marco, looking East; probably 1731–2; 2 ft 6 ins × 3 ft 10$\frac{1}{2}$ ins; Courtesy of the Fogg Art Museum, Harvard University, Grenville L. Winthrop Bequest.

136 Canaletto: S.S. Apostoli, Church and Campo, Venice; 1730–5; 1 ft 6$\frac{1}{2}$ ins × 3 ft 7$\frac{1}{2}$ ins; Formerly Duke of Buckingham and Sir Robert Harvy; location now unknown.

137 Canaletto: Bacino di S. Marco, looking East; Probably about 1735; 4 ft 1 in × 5 ft; Courtesy of the Museum of Fine Arts, Boston.

138 Canaletto: Piazza S. Marco, the north-east corner (pen and brown ink); Probably about 1735; 11 ins × 14$\frac{1}{2}$ ins; By gracious permission of H.M. The Queen.

139 Canaletto: 'le Preson V' (The Prison, Venice); etching; about 1741; 5$\frac{1}{2}$ ins × 8 ins.

140 Michele Marieschi (1710–1743): Venice, Sta Maria della Salute; 4 ft in × 6 ft 11 ins; Paris, Louvre.

141 Michele Marieschi (1710–1743): The Grand Canal, looking towards the Rialto Bridge from the Fishmarket; about 1740; 2 ft × 3 ft 2 ins; Reproduced by permission of the Syndics of the Fitzwilliam Museum, Cambridge.

142 Canaletto: Grand Canal, looking towards the Rialto Bridge from the Fishmarket; 1730–35; 1 ft 7 ins × 2 ft 6½ ins; formerly Duke of Buckingham then Sir Robert Harvey, now unknown.

143 Giuseppe Zocchi (1711–1767): The Corsi and Viviani palaces, Florence; pen and black ink; before 1744; 1 ft 7 ins × 2 ft 2½ ins; Pierpont Morgan Library, New York.

144 Giovanni Battista Piranesi (1720–78): Piazza del Popolo, Rome, etching; about 1750; 1 ft 4 ins × 1 ft 9½ ins.

145 Piranesi: Piazza Navona, Rome; etching; about 1773; 1 ft 6½ ins × 2 ft 3½ ins.

146 Leonard Knyff (1650–1721): Old Somerset House (engraved by J. Kip); 1724.

147 Jan Kip (1653–1722): View of London and Westminster from Buckingham House, detail. (St James's Palace, St James's Street and St James's, Piccadilly, can be seen on the left; Northumberland House and Whitehall in mid-distance on the right); about 1710.

148 Sutton Nicholls (fl. 1700–1740): Charing Cross, looking from the Strand towards the Haymarket, Whitehall on the left, old Royal mews (now Trafalgar Square) on the right; 1720.

149 Hendrick Danckerts (c. 1630–1678): Whitehall from St James's Park; about 1670; 5 ft × 3 ft 1 in; Captain Berkeley of Berkeley Castle Gloucestershire; Photo Freke, Bristol.

150 Thomas Wyck (c. 1616–1677): Westminster from below York Water Gate (the Banqueting House on the right); mid-seventeenth century; 5 ft × 2 ft 7½ ins; Mrs Grenfell.

151 J. van Aken (1699–1749): about 1726; Covent Garden, looking East; The Trustees of the London Museum.

152 Antonio Joli (c. 1700–1777): The Building of Westminster Bridge; about 1746; 1 ft 3 ins × 2 ft 4 ins; By permission of the Richmond-on-Thames Borough Council.

153 Samuel Scott (1710–1772): The Temple from Mitre Court; c. 1750; 4 ft × 2 ft 7½ ins; By permission of the Masters of the Bench of the Inner Temple Collection, London.

154 Canaletto: London, Whitehall and the Privy Garden from Richmond House; 1746–7; 3 ft 7 ins × 3 ft 11 ins (sky reduced); Trustees of the Goodwood Collection.

155 Canaletto: The Thames and City of London from Richmond House; 1746 or 1747; 3 ft 6 ins × 3 ft 8 ins; Trustees of the Goodwood Collection.

156 S. Scott: The Thames at Westminster; about 1746; 2 ft 3 ins × 3 ft 10 ins; Guildhall Art Gallery, London.

157 Canaletto: detail from Pl. 154, about 1½ times original size.

158 Canaletto: London, The Thames and Westminster from Lambeth; 1746–7; 3 ft 10½ ins × 7 ft 10 ins; National Gallery, Prague.

159 Antonio Visentini (1688–1782): Grand Canal: looking North from the Rialto Bridge; engraving after Canaletto; published 1735.

160 Canaletto: Grand Canal: looking North from the Rialto Bridge; detail; 1 ft 7 ins × 2 ft 7 ins; painted before 1735; detail alteration after 1741; By gracious permission of H.M. The Queen.

161 Canaletto: London, Northumberland House; 1752 or later; 2 ft 9 ins × 4 ft 6 ins; The Duke of Northumberland, Alnwick Castle.

162 Canaletto (engraving by G. Bickham after): The Monument and Fish Street Hill; before 1752, engraving; 9 ins × 15½ ins; particulars of original drawing unknown.

163 Canaletto: Old Walton Bridge; 1754; 1 ft 6 ins × 2 ft 6 ins; By permission of the Governors of the Dulwich College Picture Gallery.

164 Bernardo Bellotto (1720–1780): Dresden, New Market Place; about 1750; 4 ft 5 ins × 7 ft 9 ins; Dresden, Staatliche Kunstsammlungen.

165 Bellotto: Piazza della Signoria, Florence; about 1745; 2 ft × 3 ft; Budapest, Museum of Fine Arts.

166 Bellotto: Pirna, Market Place; 1753–4; 4 ft 5 ins × 7 ft 10 ins; Dresden, Staatliche Kunstsammlungen.

167 Detail from Pl. 166.

168 Bellotto: Nowy Swiat Street, Warsaw, detail; before 1771; 2 ft 9 ins × 3 ft 6½ ins; Warsaw, National Museum; Photo L. & M. Taylor.

169 Bellotto: Krakowskie Przedmiescie Street facing towards Castle Square; 3 ft 8 ins × 5 ft 6 ins; Warsaw, National Museum; Photo Taylor.

170 Bellotto: Krakowskie Przedmiescie Street seen from Castle Square; before 1771; 3 ft 8½ ins × 5 ft 6 ins; Warsaw, National Museum; Photo Taylor.

171 Bellotto: Miodowa Street; 2 ft 9 ins × 3 ft 6 ins; Warsaw, National Museum; Photo Taylor.

172 Canaletto: Capriccio: a colonnade opening on to the courtyard of a palace; 1765; 4 ft 3 ins × 3 ft; Accademia, Venice; Photo Böhm.

173 Francesco Guardi (1712–1793): The Rialto Bridge; probably about 1760; 2 ft 4½ ins × 3 ft 1 in; By permission of the Trustees of the Wallace Collection, London.

174 F. Guardi: Piazza S. Marco; 1760–5; 2 ft 4 ins × 3 ft 9 ins; Reproduced by courtesy of the Trustees, the National Gallery, London.

175 Thomas Sandby (1721–1798): The Thames and St Paul's from Somerset House; water colour and black lead, part of three-sheet drawing; 1 ft 8 ins × 6 ft 2 ins (whole); Trustees of the British Museum.

176 Canaletto: The Thames and St Paul's from Somerset House; 1750–1; painting: 3 ft × 6 ft 2 ins, H.M. The Queen; drawing: pen in black/greyish ink with grey wash over pencil; 8 ins × 1 ft 7 ins; By gracious permission of H.M. The Queen.

177 Paul Sandby (1725–1809): Eton College from the West; Trustees of the British Museum.

178 Canaletto: Eton College from the East; 2 ft × 3 ft 6 ins; Reproduced by courtesy of the Trustees, the National Gallery, London.

179 William Marlow (1740–1813): St Paul's in a Venetian setting; Tate Gallery, London.

180 Joseph Farington (1747–1821): View in Bruges, The Carmelite Church inscribed 'Canaletti brick'; 1793; Trustees of the British Museum.

181 Thomas Malton (1726–1801): The King's Mews, Charing Cross; 1 ft × 9 ins; Trustees of the British Museum.

182 Thomas Girtin (1775–1802): The Mansion House, after T. Malton; 1 ft 2 ins × 1 ft 1 in; Trustees of the British Museum.

183 and 184 Thomas Girtin: Studies for Panorama of London (Eidometropolis); Trustees of the British Museum.

xvii

185 Richard Parkes Bonington (1802–1828): Paris, The Institut, seen from the Quai; Trustees of the British Museum.

186 Thomas Shotter Boys: Pavillon de Flore, Tuileries, Paris; water-colour drawing; 1829 1 ft 1½ ins × 10½ ins; Victoria and Albert Museum, London, Crown copyright.

187 Camille Corot (1796–1875): Notre-Dame and the Quai des Orfèvres; 1833; 1 ft 5 ins × 2 ft; Musée Carnavalet, Paris; Photo Giraudon.

188 Piazza San Marco, Venice, from a daguerreotype in John Ruskin's collection; probably 1841; Ruskin Galleries, Bembridge School.

189 Pont St Michel, Paris; Stereoscopic photograph; about 1860; Collection André Jammes, Paris.

190 Claude Monet (1840–1926): Quai du Louvre; 1866; 2 ft 2 ins × 3 ft; Collection Haags Gemeentemuseum, Thè Hague.

191 Vincent van Gogh (1853–1890): View of Paris from Montmartre; 1886; 1 ft 3 ins × 2 ft; Oeffentliche Kunstsammlung, Basel.

192 Camille Pissarro (1830–1903): Pluie, Place du Théatre Français (or Avenue de l'Opéra); 1898; 1 ft 5 ins × 3 ft; The Minneapolis Institute of Arts.

193 Oskar Kokoschka (b. 1886): London (with the Houses of Parliament); 1967; 3 ft × 4 ft 2 ins; copyright Marlborough Fine Art (London) Ltd on behalf of the artist.

I THE FIRST FOURTEEN HUNDRED YEARS
Plain Topography and the Illuminators

INTRODUCTION

Topographical art did not become respectable, in the sense of being prac-tised and bought by those who were generally respected, until the second half of the eighteenth century. Esteem once gained has never been lost and topography in one form or another is today the most popular subject of all both for painters and patrons. This byway of art history, involving in its early stages parts of pictures rather than pictures, became after many centuries one of the highroads but its development is a subject which has so far been left unexplored.

Townscape painting cannot be considered without townscape drawing, which generally developed faster than painting at each stage. Sometimes a drawing in stone or mosaic or needlework fills a gap left by those who worked with pen or pencil and examples have therefore been included. This book is concerned primarily with the development of townscape painting, that is to say the portrayal of identifiable streets and buildings, but it is impossible to omit consideration of the painting of identifiable landscapes where the paths of the two converged ('identifiable' and 'topo-graphical' are here used as roughly synonymous). Sometimes, too, one has to turn to subjects which can no longer be identified or which may have existed more in the memory or imagination of the artist than before his eyes. Although the town as seen from within is the main theme of the book, the town as seen from a distance cannot be neglected, particularly at certain stages of the development of the art. All this is written in explanation of a net that must sometimes seem to have been cast wide. I have, however, tried to retain only that which throws light on the theme as expressed in the book's title. I am more conscious of the omissions than of the inclusions

and if the book encourages the reader to make these good himself it will have succeeded in its purpose.

Sources for statements which are generally accepted today are not quoted, nor are the gallery or library catalogues and standard reference books which have provided much of the information. Direct quotations are acknowledged on the page on which they appear (except Ruskin's) and all other sources (and Ruskin quotations) on p. 249. Key-words are given to the source notes to avoid the need for numbered references on the pages and amplifications and afterthoughts appear as footnotes, not among the source notes. The reader need not therefore bother with the source notes unless he wishes to pursue a subject further (or doubts the veracity of a statement). The acknowledged source may well have influenced more than the sentence referred to and in some cases, to which attention is drawn, much more.

In the choice of illustrations, where choice existed, I have preferred the readily accessible picture to the lesser-known one in private collections or far-away lands; the photographs being so inadequate in themselves, their object is to tempt the reader to seek out the original. An exception is made in the case of artists (e.g. Canaletto) whose work is readily available in bulk and already well-known to most readers. Here I have thought the reader might prefer to be introduced to something less familiar and which he may be able to imagine from the photograph.

Details have been reproduced as near as practicable to their original size and where the relationship of the detail to the whole painting appears to be significant a small reproduction of the whole has been included. Captions in the text have been kept to the minimum and only height, or relative size to the original, indicated: full information on the originals will be found in the List of Illustrations on p. ix. Measurements are given in feet and inches to the nearest half-inch in order to convey the size with the least effort on the reader's part.

My debt to past and present art historians is acknowledged by the existence of the source notes and I tender thanks to all of them, singling out only W. G. Constable and Francis Watson for a special word of gratitude. Finally I must give thanks for the London Library without which this, like so many books, could never have been written.

2

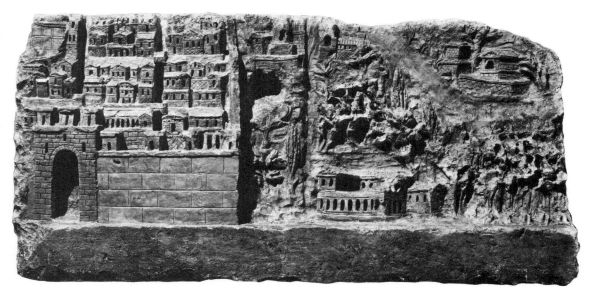

1 *An Italian hill-town in the first century* AD, *2 ft 1½ ins high*

TOPOGRAPHY AND ART

Topography has become so acceptable as a subject – the idea of questioning the artist's choice of *any* subject has become so unthinkable – that it is necessary to remember how relatively recent such indulgence is. Ruskin found it necessary to defend the 'historical' as opposed to the 'poetical' artist and did so in *Modern Painters* in 1856:

'. . . the quarrels which have so woefully divided the world of art', he wrote, 'are caused only by want of understanding this simplest of all canons – "It is always wrong to draw what you don't see". This law is inviolable. But then, some people see only things that exist, and others see things that do not exist, or do not exist apparently. And if they really *see* these non-apparent things, they are quite right to draw them. . . . If people really see angels where others see only empty space, let them paint the angels; only let not anybody else think *he* can paint an angel too, on any calculated principles of the angelic.'

But those who saw no angels need not despair.

'Pure history and pure topography are most precious things,' Ruskin went on, a little later, 'in many cases more useful to the human race than high imaginative work; and assuredly it is intended that a large majority of all who are employed in art should never aim at anything higher. It is

3

only vanity, never love, nor any other noble feeling, which prompts men to desert their allegiance to the simple truth, in vain pursuit of the imaginative truth which has been appointed to be for evermore sealed to them. . . . Be a plain topographer if you possibly can; if Nature meant you to be anything else, she will force you to it.' This book is concerned for the most part with the plain topographers: they have left us much of interest. A few of them were forced by Nature, in Ruskin's words, to something else: topography, he recognised, does not inhibit the true artist from seeing angels.

2 The harbour of Stabiae in the first century AD, $\frac{3}{4}$ *original height*

3 Buildings by a lake with a city in the background

To study the beginning of most forms of art we are generally compelled to rely on artists who worked in imperishable materials or on those whose work has been preserved by chance. A sculptor of Avezzano, in the Abruzzi district of Italy, left the earliest true townscape we know, a portrait in stone of an Italian hill-town. It was preserved both by the nature of the material he worked in and the fact that it seems to have spent many centuries at the bottom of a lake.

plate I

He worked, perhaps, in Christ's lifetime, certainly within a century of his death. In the same century the eruption of Vesuvius sealed up a vast number of paintings which would otherwise have been lost to us. This tragic miracle of A.D. 79 enabled men of the eighteenth century to learn something for the first time of those who lived in Pompeii, Stabiae and Herculaneum – and of their buildings seen through their own eyes. Engraving, and later photography, enabled even those in distant lands to see, for example, the Harbour of Stabiae as it appeared to an artist who knew its wharves, warehouses and monuments; we can also see the artists groping with the problems of perspective in their paintings of houses with their porticos, terraces and gardens.

It was to be many centuries before the 'rules of perspective' were to be discovered and conviction given to the townscapes drawn under its guidance. Meanwhile the Roman artists had to manage as best they could and, as can be seen, they managed reasonably well. The problem of transferring a three-dimensional subject on to a two-dimensional wall was well understood to be a problem; only its solution eluded them. It had *nearly* been

5

solved 400 years earlier when Vitruvius recorded the conclusions of philosophers following a discussion about stage scenery in these words: 'It behoved that a certain spot should be determined as the centre in respect of the line of sight and the convergence of lines, and we should follow these lines in accordance with a natural law, so that the appearance of buildings may be rendered conventionally in stage scenery and that what is figured on simple plane surfaces may seem to be in some cases receding, in others projecting.' This is not a very long way from the modern discovery that parallel lines appear to converge at the 'vanishing point', the discovery on which the 'rules of perspective' are based. Sir Mortimer Wheeler reasonably calls it 'a near miss' but, far or near, it was a miss and for the following 1,800 years men were to go on trying to show space in pictures without any knowledge of the way in which it could be done.

HOW DARK AN AGE?

The idea of preserving secular works of art for posterity is a relatively modern one and that of putting them into museums scarcely two centuries old. Without a Vesuvius to act the part of museum keeper we cannot therefore hope to find much in the way of townscape painting between the decline of Rome and the rise of modern man at the beginning of the Renaissance. There is little but art to illuminate an age for later generations and only the less perishable kinds of art can be expected to survive. Among these there are clues which indicate that even in the so-called Dark Ages men were impelled to record the nature of their cities and buildings. As the barbarians spread through Europe the size and number of cities declined and there were few glories of architecture to commemorate, as the Romans had commemorated their Colosseum on coins or their Forum buildings on triumphal arches. Nevertheless it is reasonable to assume that where there was a city there was generally a recorder of it, although for the best example we must for a moment step outside Europe and into Syria.

Daphne was a suburb of Antioch which must have been almost a paradise to live in. Antioch itself lasted as a great city for 800 years and when it was 400 years old, and Christianity was officially born there, the population is estimated to have been half a million. Between that time (for which we have the paintings of Pompeii to guide us) and the fifth and sixth centuries, for which we can turn to the mosaics of Italian churches, there is little evidence of what men were painting except buried mosaics and it is only as they are brought to the surface that a new ray of light is thrown on the

6

dark ages. A rich haul of this nature was found in the 1930s at Antioch and among them was the 'topographical border' to the mosaic floor of a villa in Daphne which took the visitor on a tour of the city.

plate 4

In 360 A.D., about a century before the Daphne mosaic was laid down, the Greek writer Libanius had described the streets of his native city and the mosaic might almost be an illustration to his words. 'As you walk along the streets', Libanius wrote, 'you find a succession of private houses with public buildings distributed among them at intervals, here a temple, there a bath establishment, at such distances that they are handy for each quarter and in each case the entrance is in the colonnade. What does that mean? Well, it seems to me that the pleasantest, yes, and most profitable side of city life is society and human intercourse. . . . People in other cities who have no colonnades before their houses are kept apart by bad weather; nominally they live in the same town, but in fact they are as remote from each other as if they lived in different towns.' The colonnades can be clearly seen in the mosaic and even the shade they provide is indicated by shadows on the ground. It is instructive to tour the streets of Antioch with the aid of the earliest known true townscape picture.

The visitor enters by the city gate and rides along the main street, past a house with grilled windows on either side of the door. He passes a café with an open porch on the upper floor and crosses the bridge over the Orontes. Then there is the Emperor's track, lined with trees, on which a rider is exercising, followed by the Great Church of Constantine. Another bridge, on to which a man is driving two donkeys, shows that the visitor has returned from the island to the mainland; after that there is a gap in the sequence where the mosaic has perished. When the visitor gets back he is in the main street among columns bearing imperial statues. He passes another colonnaded building, with men playing a game in front of it, and then shops where meat and bread are being bought. Now the road leads away from Antioch to Daphne, five miles distant. There are splendid villas on the way, probably friends of the owner of the villa with the mosaic, for their names are shown above their houses. At the entrance to Daphne is the public bath and a man sells refreshments from a table beside it. Then comes the covered walk where two men are playing dominoes, and a workshop, marked with its name, so that it can be identified as the place where souvenirs were made; the manager is reclining outside with his dog. Beyond is the Olympic Stadium with its tower and then another bath, this time a privately owned one, which charged entrance fees but provided amenities such as a garden and servants to carry one's clothes. Here the tired traveller had the choice between the water of the spring Kastalia where he could swim under the trees, or the reservoir fed by the spring Pallas, both clearly

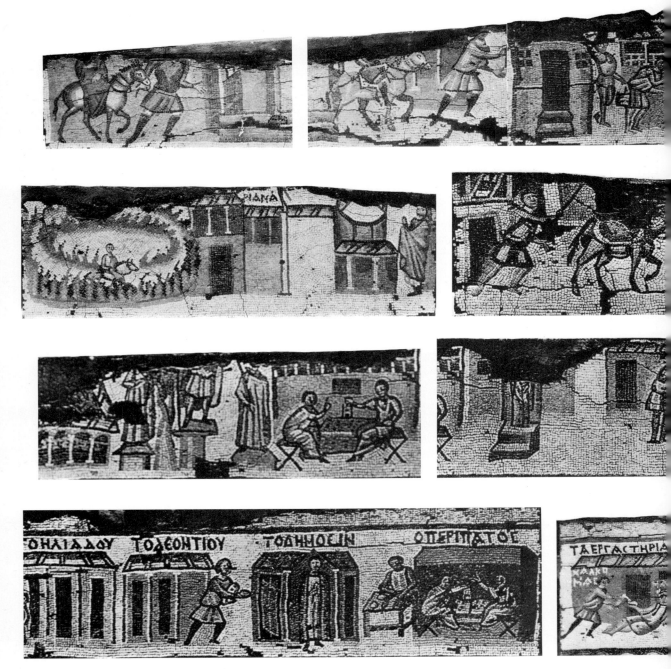

4 *A tour of Antioch and Daphne, fourth century*

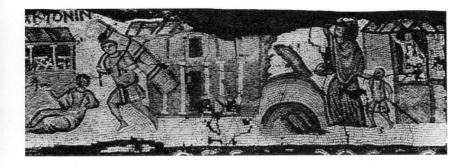

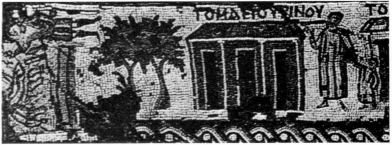

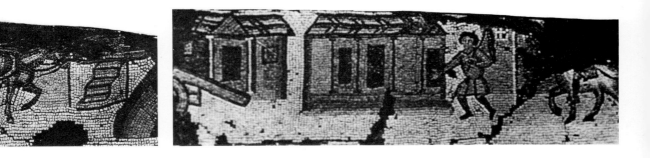

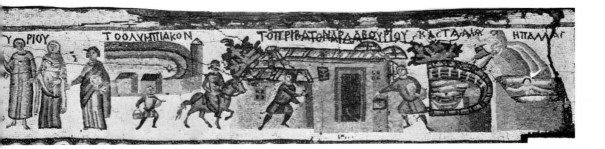

marked. He had toured Antioch and Daphne thoroughly and he could retrace his steps after dark if he so wished for Libanius assured us that 'the citizens of Antioch have shaken off the tyranny of sleep. Here the lamp of the sun is succeeded by other lamps; with us night differs from day only in the kind of lighting. Trades go on as before; some ply their handicrafts, while others give themselves to laughter and song.' This was more than could be said even for Rome at the height of the Empire, where streets were dark at night and people ventured forth at the risk of their lives.

A LITTLE LIGHT

It is hard to believe that the designer of the topographical border in Daphne worked in a vacuum and there must surely have been similar paintings or mosaics elsewhere. However, we can but guess: nothing has been found. In a well-known mosaic in Santa Sophia, Constantine is seen presenting a model of his city of Constantinople to the Virgin and there are other similar examples. But they are not the work of men such as the wall painters of Pompeii, the marble cutter of Avezzano or the mosaicist of Daphne who delighted in the achievements of their architects and builders and wanted to depict them for their contemporaries and successors.

Admittedly they suffered under a severe handicap with their limited technical equipment. Until many experiments had been made with the problems of spatial realism they must have felt on surer ground in the use of symbols, which were immediately recognisable and accepted, than in attempts at trying to represent space on a flat surface which could not yet succeed. Thus the designer of the Bayeux tapestry in the eleventh century made no attempt to show places as they really were, in spite of the necessity

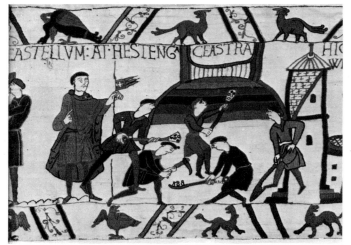

5 *Hastings in 1066,
1 ft 8 ins high*

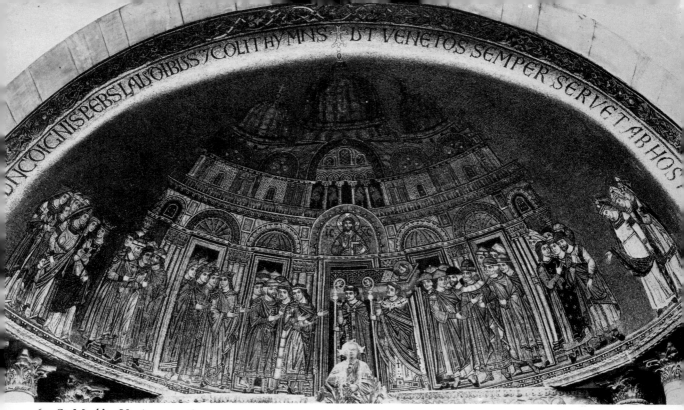

6 *St Mark's, Venice, c. 1260*

of making the venue of his events beyond doubt. It was enough to show
a castle which everyone would recognise as a castle and to mark it 'Hastings'
– and probably safer as it would lead to no misunderstanding. Most people
knew where William had landed anyway and the others would be told
by those who could read.

By the century before the birth of Giotto there was a clear desire to
show things as they really were, and so avoid the need for labels such as
those in the Bayeux tapestry or the names of the Daphne villa owners. The
mosaicist who, about 1260, portrayed the body of St Mark being carried
into St Mark's, Venice, showed the Basilica as it really was – almost, indeed,
as it is today where we can stand under his mosaic and compare the two.
The four bronze horses are there; the cupolas are there; everything is much
as it is now, except for the Gothic pinnacles which were added later, and
the mosaics themselves which were, of course, not yet in place. It would
be hard to find an earlier piece of exact representation of a building and
one must not cavil at the fact that St Mark's had not really been built four
centuries earlier when the event depicted, the carrying-off of St Mark to
Venice, had taken place.

Soon after the mosaic was set in the arch of St Mark's the burghers of

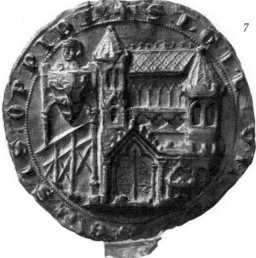

Bruges caused a new seal to be carved for their use and so provided us with evidence that in the north, too, the art of showing three-dimensional buildings was being studied seriously. Dated 1281, it shows the Town Hall of Bruges with much fidelity and one wonders how much envy it aroused at Rouen when the document to which it is still affixed was delivered there.

By this time, Giotto was born and the whole course of art was about to change its direction. This is no place to try to assess Giotto's majestic achievement in the world of art, although he did more than any artist before him to free painting from the rigid Byzantine convention and to show real human beings moving in space. But they were the people of the Bible rather than those of his own time, and they moved in a world of his own creation which, marvellous as it was, showed little of the plants and trees around him and nothing of the buildings. For that we must turn to Ambrogio Lorenzetti who was born when Giotto was still a young man.

AMBROGIO LORENZETTI

The visitor to the Palazzo Pubblico in Siena has a foretaste of what is in store for him when he goes into the Sala del Mappamondo and finds Simone Martini's entrancing painting of Guidoriccio da Fogliano over the door he intends to pass through. Guidoriccio was elected Captain of War by the Sienese for six months in 1326 and then re-elected every six months for seven years. In 1328 he led the Sienese against Montemassi and this may well be the city he approaches alone in the picture; on the other hand it may be Sassoforte ahead of him and Montemassi behind. The fresco is

12

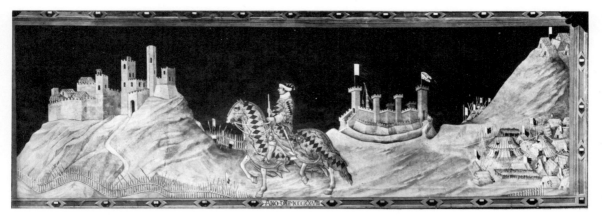

8 Guidoriccio da Fogliano by Simone Martini, 1328

bright enough to have been painted yesterday but it boldly shows the date 1328 in Roman figures. It is already apparent that the fourteenth-century Sienese were concerned with the appearance of their cities.

It is when he enters the next room but one, the Sala della Pace, that the visitor learns the extent of this concern. A ruined fresco high on the wall once depicted, according to the guidebook, the *Effects of Bad Government in the Country*. Facing it on the opposite wall are two frescos in reasonably good condition showing the *Effects of Good Government*, one in the country and the other in the city. They may well be the first landscape and the first townscape paintings ever completed; they are certainly the oldest of their kind to have survived.

plate 10

9 Siena in 1340: the country, Ambrogio Lorenzetti, about 6 ft 6 ins high

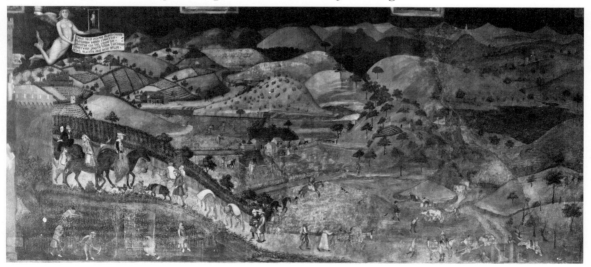

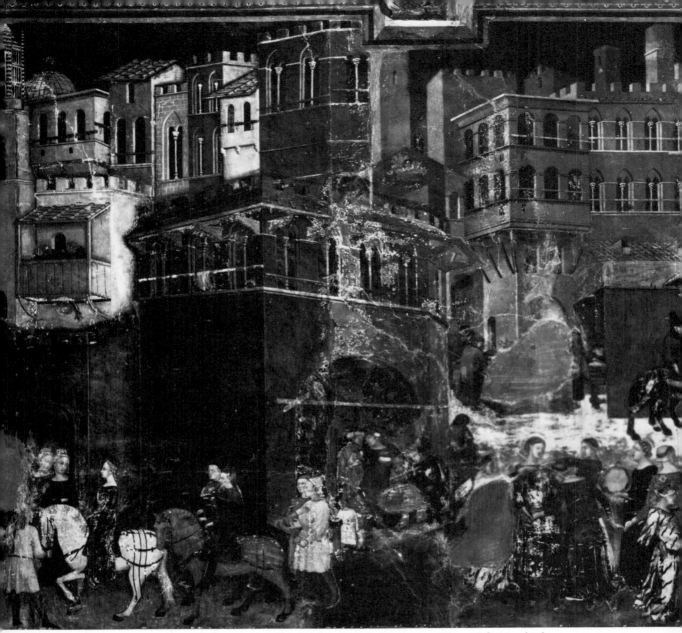

10 *Siena in 1340: the city, Ambrogio Lorenzetti, about 6 ft 6 ins high*

They were not 'pure' landscape and townscape and one must beware of giving the impression that such a thing existed in the fourteenth century. Writing of a picture painted two centuries later, a scholar used the words, 'We are led to the edge of pure landscape'. Quickly he pulled himself together and added, '— but I fear lest the modern concept of art for art's sake be transplanted into the Renaissance'.

14

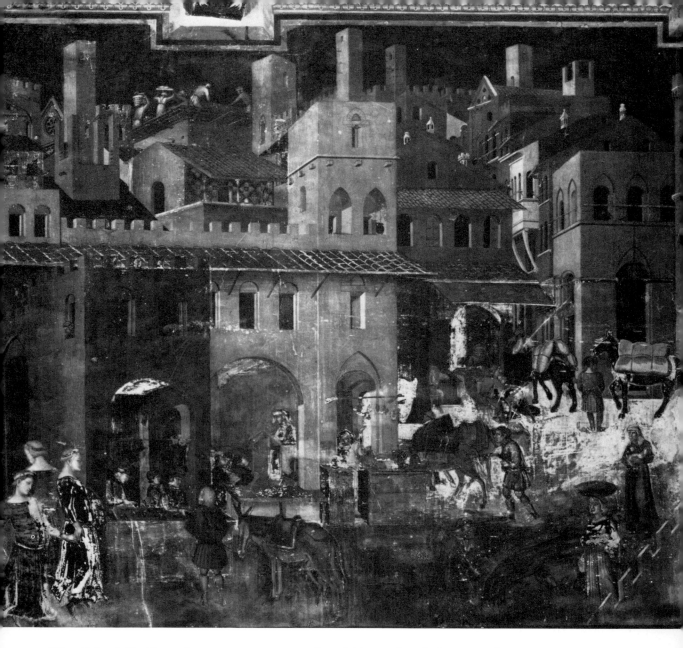

The Sala della Pace frescoes were not painted 'for art's sake' or to give pleasure, but to express in symbol language the ideas which the Government of Siena, who commissioned them, wanted to impress on their people. These ideas were intended to lead to the conclusion that all would be well if the business of government were to be left to the nine merchants then responsible for it – and who met in the room containing the pictures, then called the Sala dei Nove.

15

Siena had certainly enjoyed 'good government' for some 70 years, judging by results achieved in the most unpromising circumstances. Far from the sea, lacking river transport, surrounded by rocky desert or swamp, the people of Siena had little with which to compete against the brilliant and terrible Florentines. One thing only enabled them to rise above every handicap and that was an understanding of money, how to acquire it and how to use it to the greatest advantage. At the beginning of the thirteenth century the Sienese were the principal bankers of Italy and by the end of the century they had bought themselves allies and used their money adroitly enough even to have defeated their enemies of Florence on the battlefield. Their reputation as bankers was such that in 1368, when Charles IV attacked them and found himself their prisoner, he managed to use his imprisonment to borrow money from his captors.

The Government's tenets, whatever they were, were symbolised in the *Allegory of Good Government*, the key picture to the series and, although its symbolism can be unravelled today, few of us have the knowledge, or the heart, for the task.

The symbolism is contained in the Good Government frescoes as well but it is not for this that we now enjoy them. For the first time an artist is painting both country and town just as we know them. Giotto, Duccio and Maso show us rooms and buildings of the fourteenth century and Simone Martini a sketchy city or two among his frescoes in Assisi and Avignon as well as in Siena. Only Ambrogio takes us right inside a medieval city, among the masons and shopkeepers, the shoemakers and tailors, the public writer and the judge dispensing justice (or is it a professor in his Chair?). The buildings themselves may have crumbled away but we know that this is what Siena must have looked like and we can easily reconstruct the city from Ambrogio's fresco – indeed, that is precisely what a professor did in 1932, and his model still remains in the Palazzo Pubblico.

11 *Fifteenth century Siena, Wood model about 3 ft high*

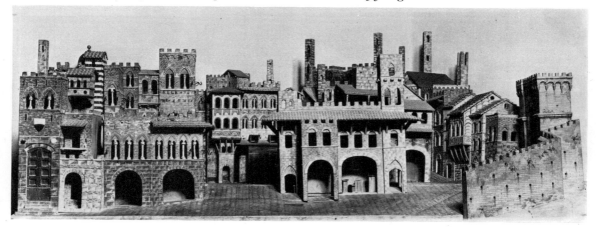

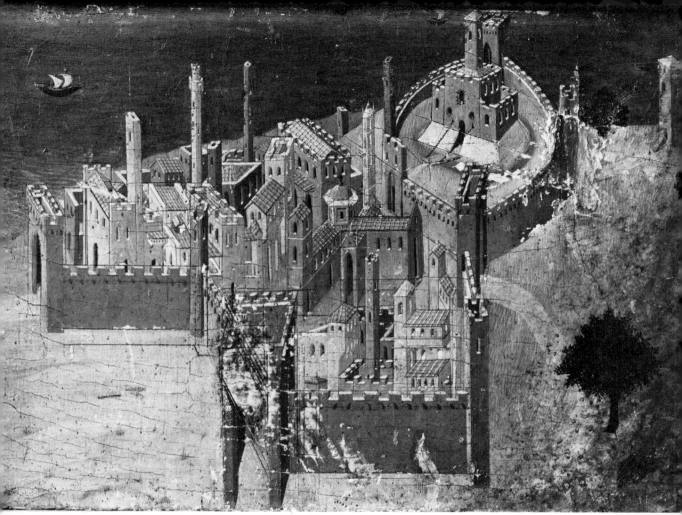

12 A city by the sea, Ambrogio Lorenzetti, 9 ins high

At first the absence of perspective, as we understand it, is puzzling. There is no vanishing point 'sucking the composition in towards a single point'. The centre of the picture is the group of dancing girls and everything recedes gently from them to left and to right – outwards from the centre and not inwards towards it, as was soon to become the accepted convention right up to the present day. Without embarking on a study of the intricacies of perspective, it is worth while examining the form of composition, casting aside all one's preconceptions on the subject and remembering that Ambrogio's 'rules of perspective' were very different from those familiar to us.

There is another pair of townscape and landscape pictures in Siena, at the Pinacoteca, also bearing the name of Ambrogio Lorenzetti. They are the famous *City By the Sea* and its lesser-known companion, referred to as

17

The Castle on the Beach. Much ink has been spilt on the question of whether they are in fact by Ambrogio and, of far greater importance, whether they are complete works or pieces cut from other pictures. If they are complete in themselves, regardless of who painted them, then they are the first 'pure' landscapes (in one case townscape) in the whole history of European painting. Not only that: they are at least two centuries earlier than anything else of their kind, for there is no question of symbolism here and there is no suggestion of any 'subject' except the city and the castle themselves.

However, it is very difficult to accept that they are anything but details cut from another, or two other paintings. The frames are not original; the edges are clumsily cut and the composition is distinctly odd. It will be difficult enough to trace the beginning of 'pure' landscape and it would be reasonable to enjoy these two little pictures without trying to find a place for them in its history. The city has been said to be Talamone in south–west Tuscany, which may also be the harbour shown in the background of the *City of Good Government* (Pl. 10). It was bought by the Sienese in 1303 in the hope that they would be able to make a seaport out of it which would rival Genoa or even Venice. They spent a fortune in trying to keep the harbour clear of silt but failed and, before the century was out, Talamone had been yielded to the Pope, like so many of Siena's possessions.

With the *Good Government* frescoes we return to certainty, for nothing can deprive Ambrogio Lorenzetti of these or of having originated, as far as we know, a new form of art in the course of carrying out his commission to paint an allegory. The effect on other artists·seems to have been minimal. No similar painting followed for almost a century and even in our own time Ambrogio is dismissed by a critic of such eminence as Berenson. 'He seems to have an itch to reproduce whatever he saw', he wrote[1], adding disapprovingly, 'you get much information about the way of living at Siena in the fourteenth century but none of the life-enhancement which comes with the vivid apprehension of thoughts and feelings vaster and deeper than our own.' Many of us will be grateful nevertheless for the information about the way of living in Siena.

THE FIRST TOPOGRAPHICAL PAINTING

By the end of the fourteenth century the nine merchants who governed Siena had given way, first to small tradesmen with a special thirst for power and finally to government by the working classes. With true democracy

[1] Bernard Berenson, *Italian Painters of the Renaissance*, Phaidon 1952, p. 101.

came ruin, and Florence, under a firm aristocratic government, was ready to take over the financial leadership of Italy with the support of the great merchant families. The bankruptcies and plagues of the 1300s were behind her; the first Medici was soon to begin the 300-year rule of Florence by one family and, in 1403, the Renaissance may be said to have dawned for in that year Lorenzo Ghiberti began to carve the bronzes for the north door of the Baptistery. Among the competitors for the work was Filippo Brunelleschi who was said (not by Ghiberti) to have withdrawn in Ghiberti's favour. He was not awarded the prize, whatever the reason may have been, but while Ghiberti was at work Brunelleschi painted a picture of the Baptistery and the Piazza del Duomo in which it stands which, if contemporary accounts are to be believed, was the first topographically accurate townscape painting. Brunelleschi's painting was never to be described by Michelangelo as worthy to form the entrance to Paradise, as was Ghiberti's carving, but its influence on other painters was as great or greater.

Brunelleschi, born in Florence in 1377, was a goldsmith, sculptor, mathematician and, above all, the man chiefly responsible for the creation of Renaissance architecture as it was understood for more than 400 years after he had designed such buildings as the Pazzi Chapel and the Pitti Palace in Florence. As if this was not sufficient achievement for one man, he was also the inventor of the system of mathematical perspective which governed the work of all artists for centuries to follow (Uccello, who was born 20 years later than Brunelleschi, talked so lovingly about perspective that he is sometimes credited with its invention – with no justification at all). The method chosen by Brunelleschi to bring his invention to the public notice some time between 1401 and 1409 was to paint a picture incorporating his discoveries and exhibit it. What these discoveries were has been described by Antonio Manetti, who called perspective 'Part of that science which aims at setting down well and rationally the differences of size that men see in far and near objects – and which assigns to figures and other things the right size that corresponds to the distance at which they are shown' – in other words, the trick of making things 'seem to be in some cases receding and in others projecting' which Vitruvius's philosophers were seeking.

The picture is lost, together with a companion piece depicting the Piazza della Signoria, but Antonio Manetti, who knew Brunelleschi and wrote his biography, has described both in detail. The painting of the Baptistery and the Piazza del Duomo was, it seems, about two feet square and Brunelleschi's viewpoint was about six feet inside the main entrance to the Duomo. It took in the wide angle of 90 degrees (much more than can be seen without

moving the eyes round) and Manetti described the buildings and streets which were included. Then, he went on, Brunelleschi painted in the sky in burnished silver and added clouds which moved against the silver background if the picture was exposed to the wind.

Finally, the artist devised a trick to ensure that the picture would be seen from the one place from which all the angles would be correct and so create a complete illusion of reality. At the vanishing point of his perspective lines he made a hole in the panel 'as small as a lentil' and the spectator was instructed to look through this hole from the back and see the picture reflected in a mirror placed at the exact distance of the artist's original viewpoint. The effect of this, together with the moving clouds on the burnished silver sky, was, Manetti assured us, 'as if the real thing was seen: and I have had it in my hand and I can give testimony'. We cannot see the picture but we can still stand in the almost unchanged Piazza del Duomo with his description of it and we can easily believe him.

In the case of the companion piece, the Piazza della Signoria, the viewpoint was from a far greater distance and it was not practicable to see the picture from the back. 'The reason', wrote Manetti, 'is that the view of such a big square had to be fairly large in order to include so many different things. With a painting of such size it would not have been possible, as with that of S. Giovanni [the Baptistery], to hold it up to the eye with one hand and hold a mirror with the other – for the arm of a man is not long enough.' Instead of the burnished silver sky Brunelleschi resorted to another experiment to heighten the illusion: he cut the panel round the tops of the buildings so that they appeared in silhouette. None of these devices, however, was of real importance compared with the fact that the pictures demonstrated for the first time how a three-dimensional scene could be accurately conveyed to a two-dimensional surface. It is not surprising that Brunelleschi's contemporaries came to wonder at his achievement, that Uccello copied it ('but it was not as well done', according to Manetti) and that representational art was never again to be the same.

The background of a Piero di Cosimo painting in the National Gallery shows the Palazzo Vecchio in the Piazza della Signoria taken from much the same angle as it appeared in Brunelleschi's painting according to Manetti's description. From the fact that Michelangelo's *David* is shown, the picture must have been painted after 1504; it is therefore a poor substitute for Brunelleschi's epoch-making work of almost a century earlier, but it must serve.

13 *Piazza della Signoria, Florence, early sixteenth century, almost original siz*

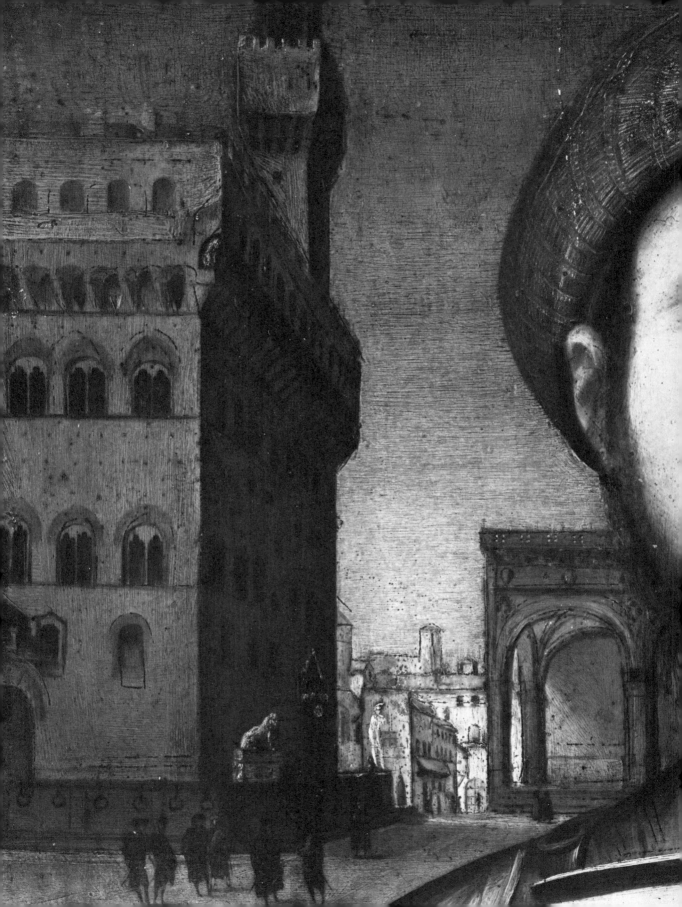

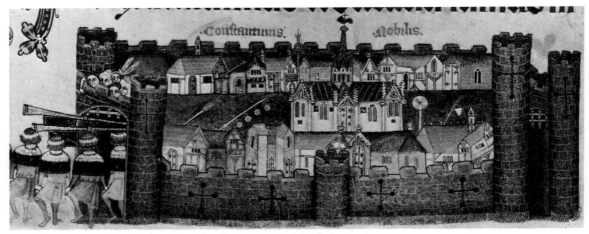

14 Constantinople about 1340, original size

ENGLISH ILLUMINATORS

Brunelleschi's paintings were unusual not only in being the first examples of true perspective painting but also in their size. They seem to have been what have come to be known as 'easel pictures'. At the period we were considering, the end of the fourteenth and beginning of the fifteenth centuries, it would perhaps be a fair generalisation to say that painting south of the Alps was on a large scale and north of the Alps on a small scale. Windows were not a feature of buildings in Italy at the time and so there were huge areas of wall to be frescoed such as those of the Palazzo Pubblico in Siena. In the north, such sun as they had was welcomed and gladly admitted through windows; large frescoes were therefore rarer, hence the later development of the Flemish 'easel picture' of which Brunelleschi's *tours de force* were forerunners. Meanwhile the typical painting of the north was in the illuminated manuscript.

The townscape appeared often enough and the artist generally obeyed Ruskin's first rule of painting the scene as he saw it. The scene he saw, though, was often very different from the one he was supposed to be portraying which was generally the Holy Land. Seldom indeed had the artist been to the East and, provided the right label was attached to the illustration, the reader would have no difficulty in understanding what he was looking at. In the Luttrell Psalter in the British Museum, for example, we have a typical walled city of the period, 1340. The church has a central spire with a weathercock and its close extends the whole length of the city. There are rows of houses with alternately thatched and stone roofs, an inn with its sign (a bush on a pole) and a number of other signs indicating

22

shops. Only the words *Constantinus Nobilis* indicate that it is not a medieval English town which is depicted. But there is no mistaking the words – it is Constantinople the artist means to convey and the reader is expected to use his own imagination.

There was another way to meet the demand for pictures to illustrate the stories returning pilgrims from the Holy Land brought back with them. That was to listen to their descriptions and base drawings upon them. This is probably what the artist did who drew illustrations for 'Sir John Mandeville's' travels, also in the British Museum. His Constantinople shows Santa Sophia in a town of houses of fairly western appearance but with a minaret here and there and a serious attempt to show Santa Sophia as it must have been described (although not very much as we know it). The artist's informant had told him there was a statue of Justinian in front of the church, but not that the Emperor was mounted on horseback, so he stands erect. In this, and the procession of clergy exhibiting holy relics to the Emperor, there is an attempt to give substance to the houses by showing some of them obliquely but these drawings are later than one would think from their appearance. The extraordinary travel book they were meant to illustrate was first published, in French, between 1357 and 1371 and gradually became translated into many other languages. It was

15, 16 Santa Sophia, Constantinople, early fifteenth century

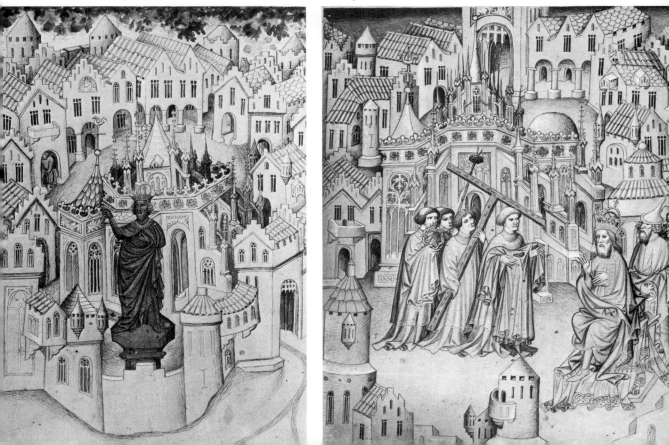

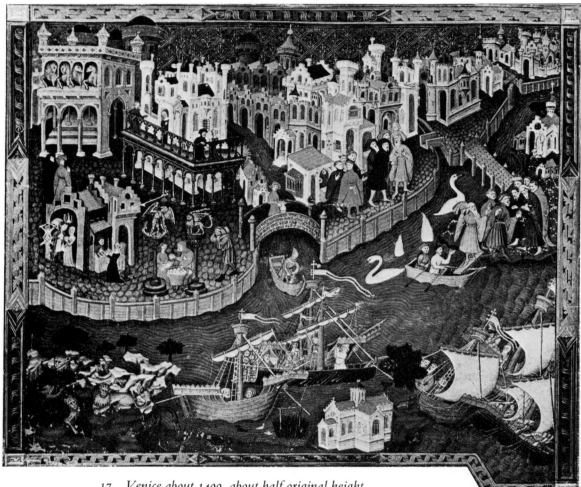

17 *Venice about 1400, about half original height*

made up from a number of genuine travel books and the English edition credited to a wholly fictitious 'Sir John Mandeville' who acquired a tremendous reputation as a writer of English prose as a result. All this took time and it is unlikely that these drawings, which were not part of the original edition, were made much before Brunelleschi was announcing his startling discoveries.

The English illustrator of Marco Polo's *Milione* in the Bodleian Library worked on much the same lines but rather more successfully. He had clearly never been to Venice but he knew enough about it to realise that something

more was called for than the English walled city which satisfied his predecessor of the Luttrell Psalter as a representation of Constantinople. He must therefore have made enquiries as to the general appearance of Venice for his illustration and have been given a number of details as well. He was told, apparently, that there were street vendors between the columns of St Mark and St Theodore and little shops on the Piazzetta (as indeed there were at the time) and that there were four horses on St Mark's, all of which he accordingly put in his picture. If he was told what sort of a church St Mark's was, he had forgotten, and he concluded, as a number of later artists who ought to have known better also concluded, that the columns of the Doge's Palace must have bases. As a topographical artist he has reluctantly to be excluded on the grounds that he was not painting what he saw but, unlike many contemporaries and successors, he was doing his best to be truthful and his painting has earned justifiable fame as perhaps the first painting of Venice and a delectable little picture.

THE DUKE OF BERRY'S INFLUENCE

All this was changed by John, Duke of Berry, and the illustrators he employed. Third son of the King of France, he owned 17 châteaux and private residences and seems to have loved them all. He also loved his unparalleled collection of precious stones, his 400 yards of tapestries, his swans and his bears, all of which he was apt to insist should be taken with him when he moved from one house to another. Above all he loved illuminated manuscripts and it is for these, particularly for his *Très Riches Heures*, that the Duke of Berry will be remembered when almost all his contemporaries, with all their great deeds, are forgotten. Since they were his chief love, they also had to travel with him, whether they were finished or not. It did not matter if they were not finished: he employed artists in all his châteaux and each was quite capable of carrying on where another had left off.

Skilled as these artists were, three of them, the brothers Pol, Jean and Armand de Limbourg, were possessed of something far more than skill, a sort of genius for portraying light and space in a small compass and of endowing pictures of the utmost precision and detail with a charm that has never been surpassed. Whether this gift was shared equally among all three brothers we do not know. Pol, the eldest, was *valet de chambre* to the Duke (which meant that he was an honoured member of the staff, not that he had any menial duties) and there is some evidence that he visited

25

18 *Île de la Cité, Paris, early fifteenth century, The Limbourg brothers, original size*

Italy. If so, and if as a result he learnt something from the Lorenzetti brothers, he repaid in full his debt to the art of realism by the heritage he left it.

When the Duke of Berry died in 1416 he left incalculable possessions but no money, and work on the *Très Riches Heures* stopped. The following year Pol de Limbourg himself died and the manuscript remained for nearly 70 years in an unfinished state. It was then finished by a lesser, but skilled, illuminator, Jean Colombe. The calendar, with its pictures of the 12 months, so often reproduced, was practically finished in the Duke's lifetime and certainly 10 out of the 12 months were entirely the work of the Limbourgs. These enchanting pictures have become so well-known that it is often overlooked that the book contains also well over 100 other illuminations and miniatures, most of them of the highest quality.

As the Duke employed the best builders and architects and the best artists it was natural that he should require his artists to depict the work of his other employees. Nine of the 12 miniatures in the calendar part of the book show a castle or town in the background, the castle belonging either

26

19 Meeting of the Magi, The Limbourg brothers
Below: detail showing the Île de la Cité

to the Duke or to his father, the King. The miniature illustrating June shows the Île de la Cité from the Duke's Paris home, the Hôtel de Nesle, on the site of which now stands the Institut de France. The palace of the Duke's mad nephew, Charles VI, is shown in full detail with the Sainte-Chapelle, built by St Louis 150 years earlier, on the right; this, and four of the towers, can be seen from the same spot today. Much later in the book, when illustrating the Meeting of the Magi, the Limbourgs returned to this scene and, in a space of two square inches, continued it from the Sainte-Chapelle on the left to Notre-Dame on the right.

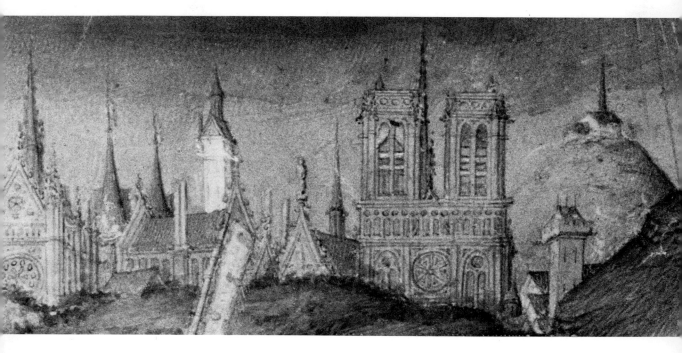

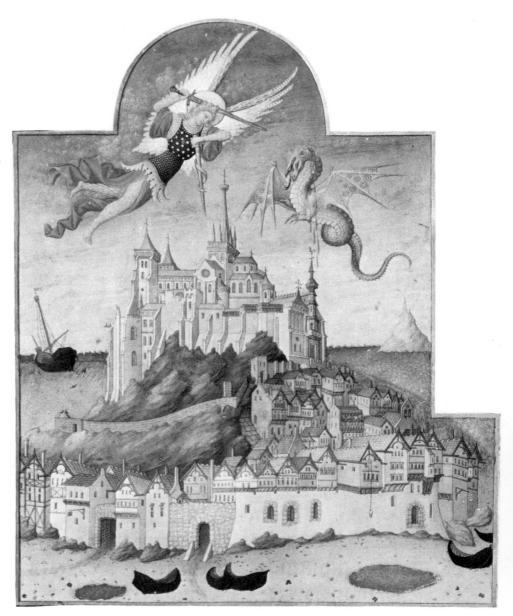

20 Mont St Michel
The Limbourg brothers,
original size

Near the end of the book there is an illustration of the battle of St Michael with a dragon and this is shown taking place above the island of Mont St Michel, then a place of pilgrimage almost as celebrated as it is now. Every tourist will recognise the gigantic abbey, the houses of the village crowded below it and the ramparts surrounding them. The Limbourgs had founded topographical art as we know it today.

They were by no means the only artists patronised by the Duke of Berry, nor was he the only patron of his day. At the end of the fourteenth and beginning of the fifteenth centuries, half way through the Hundred Years War, this art of the miniature flowered as never before or after and often a whole microcosm seemed to be included in those tiny strokes of brilliant colour, of gold and lapis lazuli, making up a marvellous page only a few inches high. One artist who sometimes worked for the Duke, but who never was on his staff and preferred to maintain a workshop of his own, is known generally as the Boucicaut Master from a celebrated Book of Hours commissioned by Marshal Boucicaut of France while Governor of Genoa around the year 1400.

The Boucicaut Master, like others of his day, was making faltering experiments with the art of perspective and his ceilings and floors often show a consciousness of the idea of a vanishing point, so soon to be developed in its entirety by Brunelleschi. In one way he even out-distanced Brunelleschi

21 *Paris from Montmarte, before 1415*

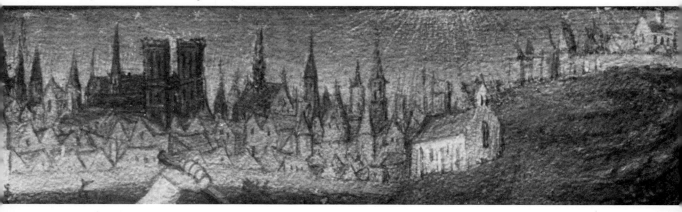

22 *Paris from near Montmartre*

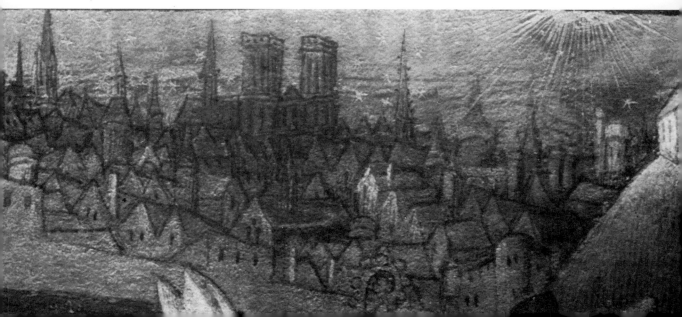

for he certainly discovered the fact that distant objects look paler in colour than those in the foreground, that the colour drains out, so to speak, and that there is always a slight haze in the distance. The recognition of this has come to be known as aerial perspective as opposed to the linear perspective based on objects getting smaller as they recede. Two rare examples of it occur in a breviary now at Châteauroux in which the city of Paris provides the background for an incident in the life, and also the martyrdom, of St Denis. From the heights of Montmartre, where the tourists of today gaze down at the panorama of Paris, the spectator looks across to the city centre and sees Notre Dame and the Sainte Chapelle rising from a sea of

plate 21
plate 22

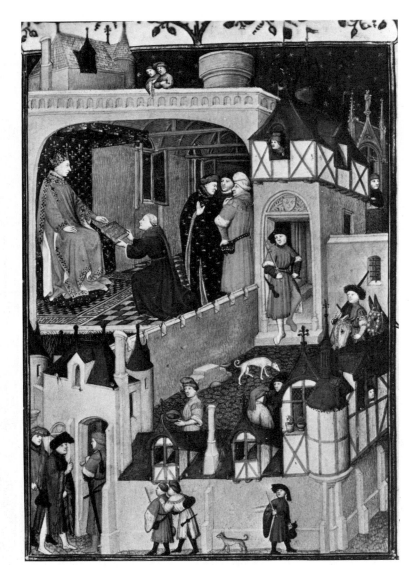

23 *Salmon giving his book
to Charles VI*

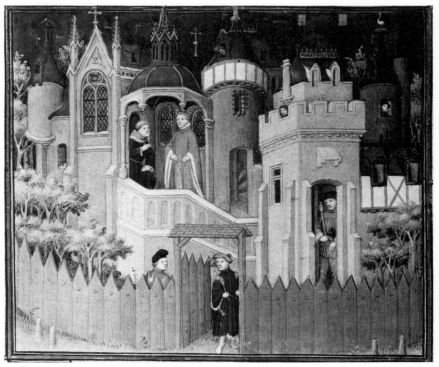

buildings. The Limbourgs showed these two buildings as they knew them to be (Pls. 18 and 19): the Boucicaut Master showed them as they appeared from the distance, the nearer roofs of Paris blue, the more distant buildings grey and the starry sky in the background giving an impression of distance.

These were the first of several views of Paris from the spot where St Denis, so they say, walked after his martyrdom, with his head in his hands, to his burial place five miles away over which the Basilica of St Denis was later built. Identifiable views within the city are rare and conventional but when the Master or his associates gave rein to their imagination their townscapes were full of life. They illustrated a manuscript written by Pierre Salmon, a Counsellor to the mad king, Charles VI, and given by him to the King. In one of the miniatures Salmon is making his gift and we see not only the palace, but its courtyard and the busy street outside; in another Salmon is seen with Richard II of England, the King's son-in-law. These are glimpses of town life and buildings but in neither is there any attempt to paint a city as it really appears to the spectator in the way the Master had painted Paris from Montmartre.

31

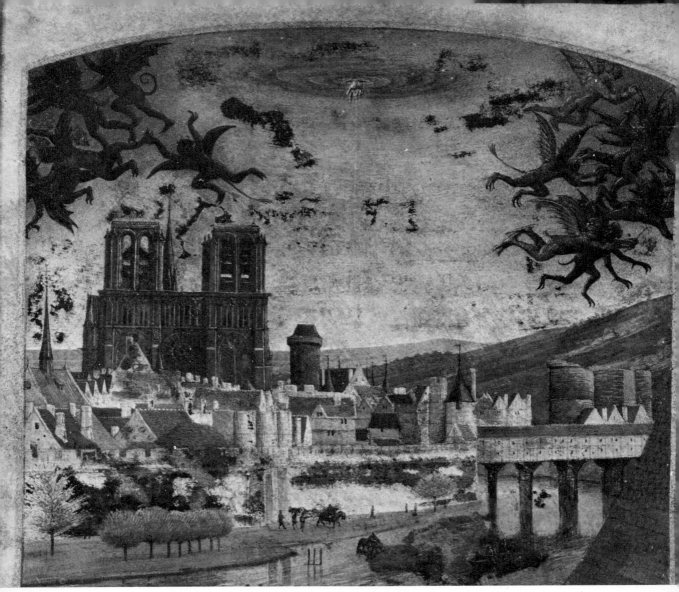

25 *Ile de la Cité and Notre Dame, Paris, about 1450, Jean Fouquet, original size*

JEAN FOUQUET

Jean Fouquet was born soon after the Duke of Berry died, in 1416, when France was at her lowest ebb following her defeat at Agincourt and the struggle between her Dukes for what was left. Before he had grown up Charles VII had been crowned with Joan of Arc beside him and there was a new hope. Fouquet prospered with France itself and became her most

famous painter in his lifetime and an illuminator of manuscripts possessed of immense skill, if lacking the magic of the Limbourgs. After his death in about 1480 he was forgotten for almost 400 years until, at the end of the nineteenth century, art historians rediscovered and identified his work and gave him back the position he had lost.

In his early 30s, already a recognised master, Fouquet visited Italy, where the great topic of conversation among artists was the new discovery of the laws of linear perspective. Probably his first commission on his return to his birthplace, Tours, was a Book of Hours for the courtier, Etienne Chevalier. Three (or, perhaps, four) of the miniatures in this book show Fouquet in full command of the new ideas, but then he seems to have decided that they were not for him and that there were other ways in which he could add a third dimension to the little pictures in which he loved to portray street life.

Etienne Chevalier's prayer-book was subsequently broken up and, although most of its pages are now in the Musée Condé in Chantilly, others are scattered elsewhere and many are missing. One of the most interesting of all appeared miraculously as late as 1946 when a descendant of an old émigré family of Huguenots put two pages of the precious book up for sale, knowing nothing of their history. One of them showed the Île de la Cité from a very much nearer viewpoint than Montmartre. If we stand at the end of the Rue Dauphine, where the Pont Neuf begins, we can see much the same view today with Notre Dame and the Pont St Michel; if we join the Limbourgs' miniatures reproduced in Plates 18 and 19 to Fouquet's we have a close-up view of the centre of Paris in the fifteenth century, an experience that could hardly be repeated in the case of any city in the world except Venice. There is no vanishing point and no aerial perspective, yet Fouquet has left a miraculous picture of fifteenth-century Paris in a picture less than eight inches high.

In 1458 Fouquet received a commission from King Charles VII himself to illustrate a new edition of the *Grandes Chroniques des Rois de France* which had been kept up to date for over 150 years. The book was essentially what its full title suggests and not *Chroniques de France* as it is generally described; that is to say, it records the meetings of monarchs, their banquets, coronations and other ceremonies rather than the history of France and it took all Fouquet's skill to bring life to these uninspiring events. His solution was to show the characters in the dress of his own time, often with familiar buildings as the background and sometimes, as in the case of the *Arrival of Emperor Charles IV at the Basilica of St Denis*, in the kind of street plate 26 that everyone would know. One of the Chronicles told of King Clotaire finding his son, Dagobert, asleep on the tomb of St Denis, not far from

26 *The Emperor at St Denis, about 1460*

Montmartre, the Martyr's Mount. Whether or not Fouquet had seen the Boucicaut Master's views of Paris from this spot (Pls. 21 and 22), he painted his own version of the view in meticulous detail in an area less than an inch high and four inches wide. As well as Notre Dame, the church of St Germain des Près is recognisable and experts in Parisian topography claim to have identified more than a dozen other churches with varying degrees of conviction.

Some time after 1470 Fouquet had a commission from the Duke of Nemours. The Duke had inherited from his grandfather, the Duke of Berry, two volumes of the *Antiquités Judaïques* by Flavius Josephus, a favourite history book of the time, full of battles, heroism and atrocities. There were three miniatures from the Limbourg workshop in the book and blank spaces for a number of others which Fouquet proceeded to fill. The subjects were far more interesting than those provided by the dull round of monarchs and Fouquet was free to make his own selection and to choose his own backgrounds. He made no attempt to imagine what the Holy Land looked like but simply transferred the history of the Jews to France, the country scenes to the banks of the Loire or Seine and the town scenes to

34

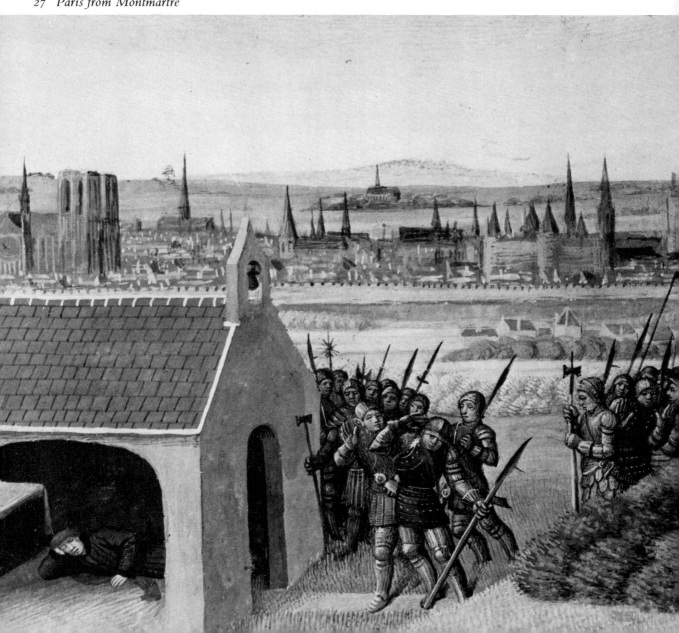

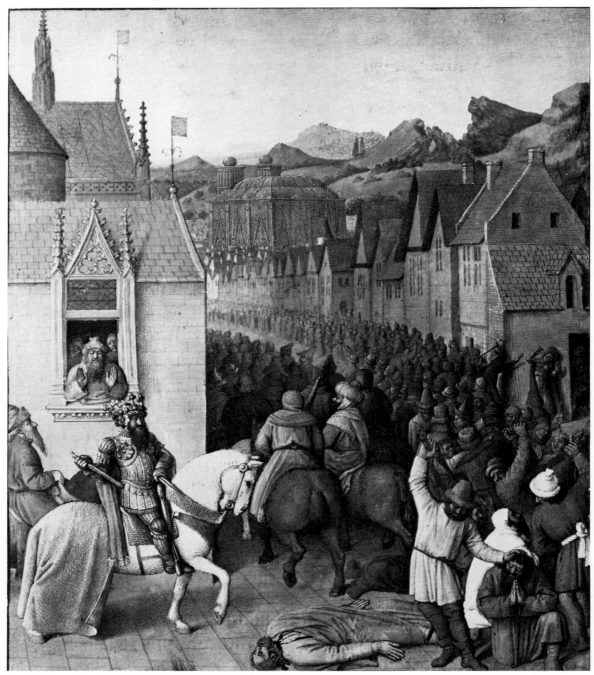

28 *Entry of Ptolemy into Jerusalem*

the towns he knew. For the *Entry of Ptolemy* into Jerusalem and the *Taking of Jericho* he showed the streets, not of Jerusalem or Jericho as they might have been, but of medieval France as they were, and very much the same as they were at St Denis (Pl. 26). Even the Temple of Jerusalem, conventionally thought of as a circular building, became in Fouquet's paintings the Cathedral of Tours, his native town, with an oriental cupola instead of its spires. Perhaps Fouquet thought that the streets and buildings which people knew would bring the subjects to life more vividly than would eastern towns of his own imagining. Perhaps the English artist of the Luttrell Psalter thought on the same lines when he made Constantinople an English town (Pl. 14). Whatever the object, if there was an object at all, the idea of a familiar background to a historical or religious painting was now firmly entrenched.

29 *The Taking of Jericho*

II THE FIFTEENTH-CENTURY
Perspective: Experience or Science

ROBERT CAMPIN

The Battle of Agincourt in 1415 brought about the downfall of the French aristocracy and was followed in 1419 by the assassination of the Duke of Burgundy, a patron of the arts comparable to his brother the Duke of Berry. His Court at Dijon had attracted a number of Flemish artists but now his son, Philip the Good, transferred his capital and court to Bruges (then a port) which soon became the undisputed centre of the arts in northern Europe. It was the painters of this school who first showed how to transfer to wood panel, in the new medium of oil paint, the world outside their churches and studios in all its infinite variety. True, their tiny scenes of city and country life, their busy streets lined with shops, their houses with small gardens, were but the backgrounds to their expressions of religious faith. They were satisfied, though, that they could best tell their story by showing their saints in a world which everyone knew.

There could be no better example than the background of *The Nativity* at Dijon by the mysterious Master of Flémalle, generally considered today to be the same person as Robert Campin, the teacher of Roger van der Weyden. Occasionally a known place can be identified in a Campin picture but not in *The Nativity*. Here instead we have a road which invites us to travel along it towards the lake in the distance, to join the man leading his wife away from the pies she is being offered, to pass the comfortable farm house and later the more modest house with its farm buildings beside it. Almost for the first time we have a background landscape. The picture is known to have been painted before 1430, that is to say before Brunelleschi's discovery of the rules of perspective had become known in northern Europe.

*30 The Nativity, Robert Campin, about 1420
detail ¾ original height*

The Flemish artists had to work things out for themselves and it is surprising how far they were able to go by their trial-and-error method. In emphasising the fall of light by the long shadows cast by the trees and people, Campin was breaking new ground and it was almost certainly he who gave us the first of the backgrounds with detailed studies of Flemish town life.

There are two little townscapes in the Ingelbrecht (or Mérode) altarpiece in the Cloisters Museum, New York. The subject is the Annunciation and, in a space of a few square inches, we are given first a glimpse of a street

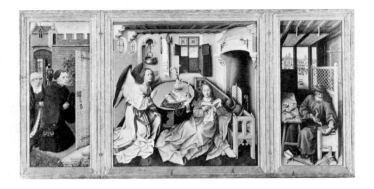

31 *The Annunciation, Robert Campin*
Below: left panel and detail
Opposite: right panel and detail
(details almost original size)

through a window in the left wing and then, in the right wing, a view of a market place. There is no imaginary Nazareth here, with the usual jagged mountains and fairy castles; instead there is a fifteenth-century Flemish town which everyone who saw the altarpiece must have recognised. Moreover there is a subtle difference between the two scenes. In the left wing a girl sits in the open air by a shop with an open window; it is spring, 25 March, the date of the Annunciation. In the right wing nine months have passed and it is 25 December, the Nativity. The shop windows are closed; everyone wears winter clothes and there is a little snow on the roofs.

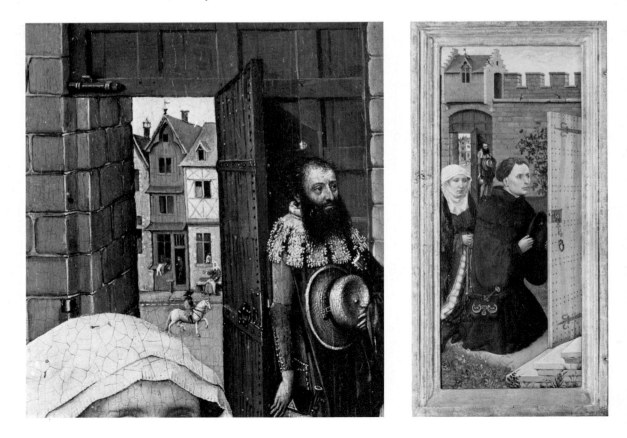

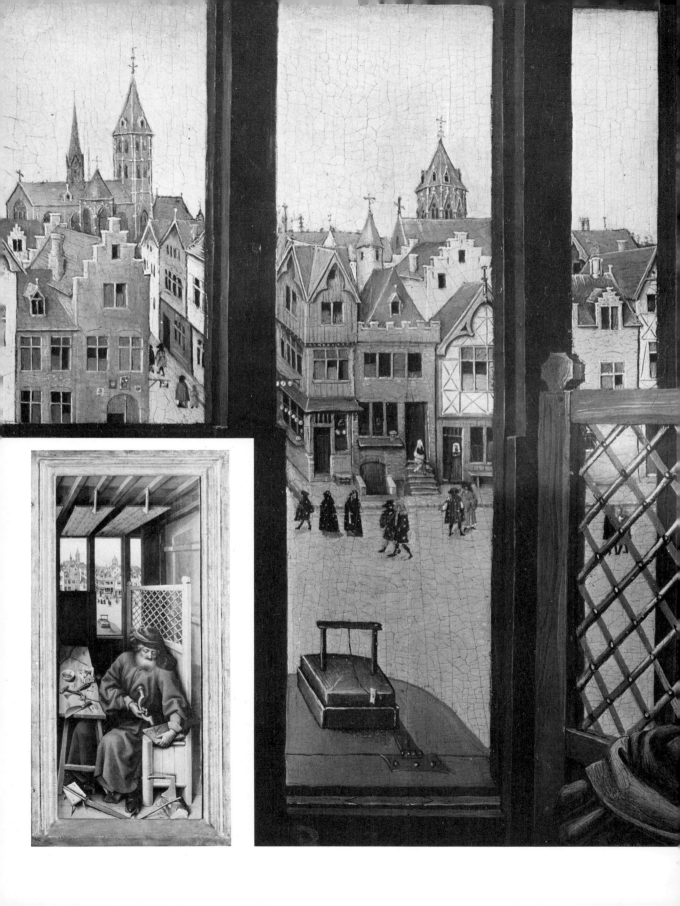

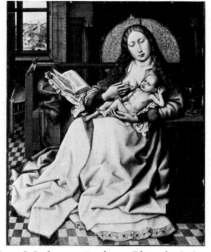

32 Left: a Flemish street, before 1430, detail from the Virgin before a Firescreen, Robert Campin, greatly enlarged

Again in the *Virgin before a Firescreen* (or *Madonna in her Chamber*) in the National Gallery, Campin uses a Flemish market place seen through a window as his background. One man mends a roof while another stands on the ladder to steady it; one shopkeeper awaits custom while another displays some unidentifiable objects; a riderless white horse is being chased. We shall hear more of the shop and the horse.

JAN VAN EYCK

As Duke of Burgundy, Philip the Good ruled a dominion which included the whole of modern Belgium and Luxembourg, the greater part of Holland and much of northern France. Most of his time was spent in Flanders where Bruges and Ghent were the most prosperous towns of northern Europe, as well as centres of art. He ruled for 48 years from 1419 and under him music and poetry, as well as painting and architecture, all received patronage of the most enlightened sort. But the patronage came from the Flemish wool merchants and weavers as well as the Court. The 'flamboyant' Gothic architecture of the period appeared in private mansions and richly decorated town halls and cloth halls as well as churches. Fraternities commissioned altarpieces for churches and business men ordered portraits of themselves and their wives.

Jan van Eyck entered the service of Philip the Good in 1425 and served his master by undertaking secret journeys for him, as well as in the capacity of painter. He was the most famous artist of his day and achieved a degree of luminosity in his painting such as had not before been seen and is even

43

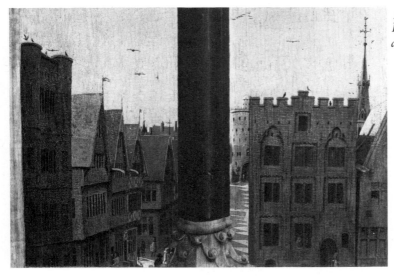

33 'The Most Ancient View in Ghent',
Hubert or Jan van Eyck,
almost original size

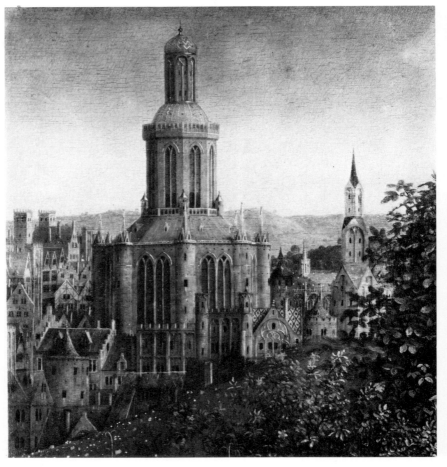

34 The Gothic City

35 The Romanesque City
Details from the Ghent
Altarpiece

44

yet not fully understood. His brother Hubert is too shadowy a figure for consideration here but it is generally conceded that both brothers played a part in the great altarpiece at Ghent.

Jan van Eyck's backgrounds have always intrigued scholars and intense research has been devoted to the extent, if any, to which they depict indentifiable places. The glimpse of a Flemish street on the front of the Ghent Altarpiece, for example, has been described as the view from Hubert's own window and was lithographed as *The Most Ancient View in Ghent*, even an address being found for it – 26 Rue aux Vaches. The Gothic and Romanesque cities in the background to the *Adoration of the Lamb*, the principal subject of the altarpiece, have been the subject of more convincing studies. The Tower of St Martin at Utrecht and the churches of St Martin in Cologne and St Jean in Maastricht have been found among the Gothic churches clustering in the background, and Jan's known visit to England is said to have borne fruit: distinct resemblances to the cathedrals of Ely and Ilminster have been noticed.

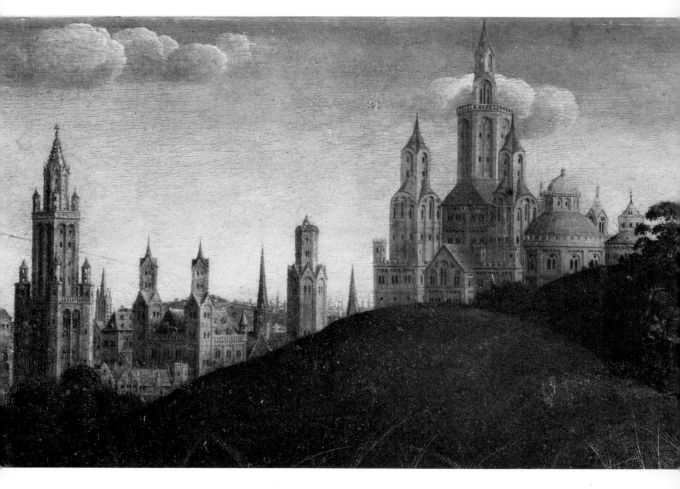

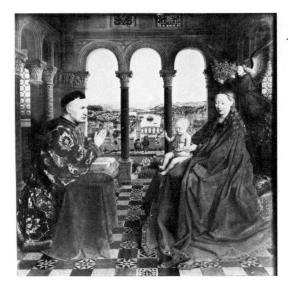

36 *Madonna of Chancellor Rolin,*
Jan van Eyck
Below: detail about half original size
Opposite: details enlarged several times

But it is the background of Jan van Eyck's Louvre *Madonna of Chancellor Rolin*, perhaps the best-loved of all his paintings, followed to a considerable extent in the background to his *Madonna with St Elizabeth of Hungary and a Carthusian Donor* in the Frick Museum, which has stimulated the most persistent efforts of identification. Intrigued by the Rolin background, as the two strange figures studying it from the ramparts seem to be, and finding it hard to believe that a city so lifelike could be imaginary, scholars have delved into topographical archives with even more enthusiasm than in the case of the Ghent Altarpiece.

plate 37

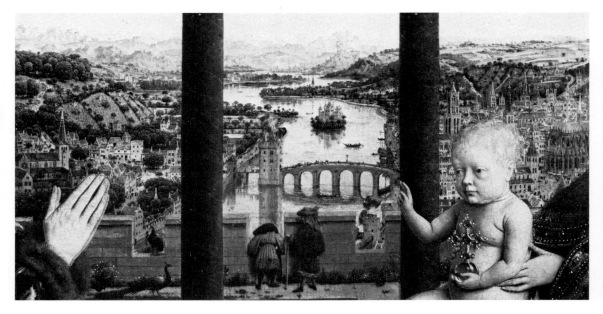

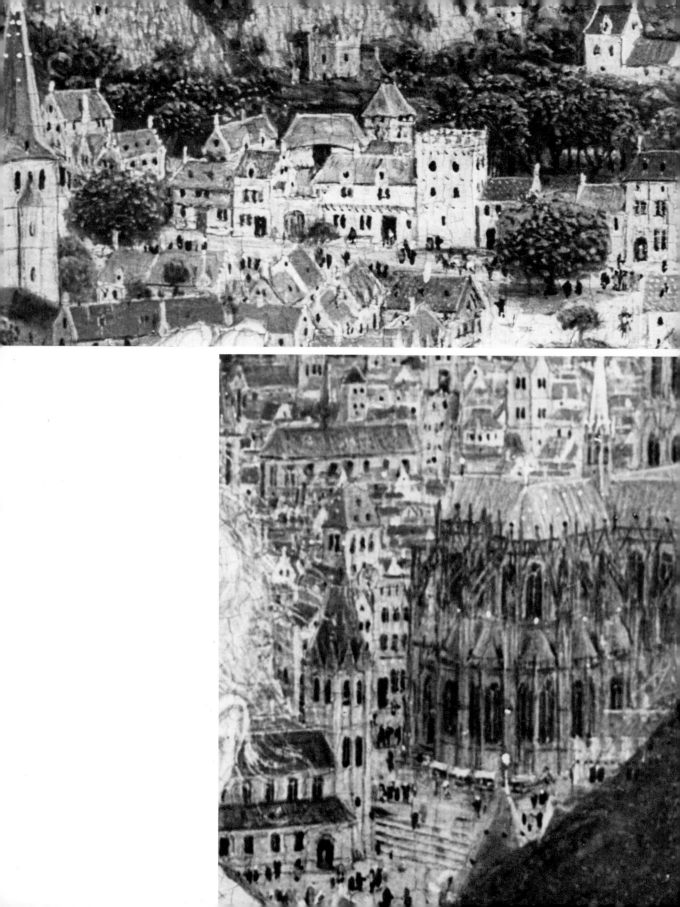

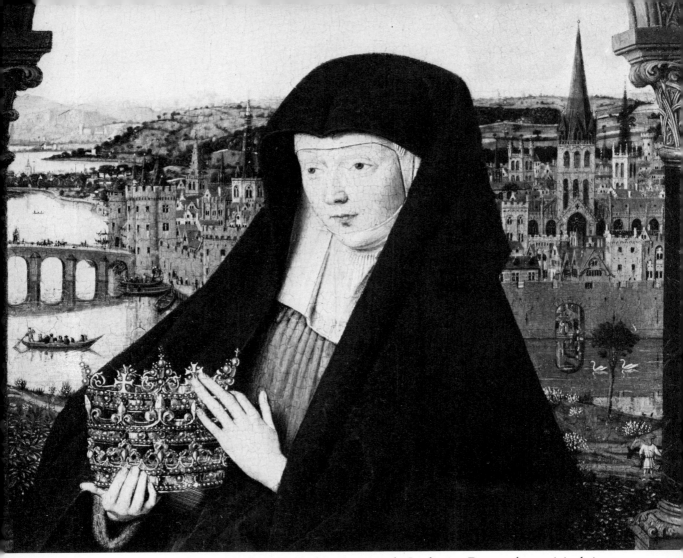

37 *St Elizabeth, detail of Madonna with Carthusian Donor, about original size*

Maastricht (where van Eyck is most generally thought to have been born), Liège, Utrecht, Lyons, Prague, Geneva and Autun have all had their supporters. One of them studied contemporary plans of all possible candidate cities – including London, only to dismiss it because Chiswick provides the only suitable bend in the river and there are no hills at Chiswick. Lyons was his final selection and with geological and topographical plans he made a convincing case. This, however, was in 1916; 40 years later, a certain Professor Lejeune, a *Liègeois*, exposed the results of what must have been lifelong research in an endeavour to establish that Liège, not Maastricht, was van Eyck's birthplace and that it was Liège, and no other city, depicted in both the Rolin and Carthusian Madonnas.

We must resist the temptation to follow this ardent scholar's researches bridge by bridge, tower by tower and almost brick by brick. Their presence or absence, and their condition if present, established to his satisfaction that the city was Liège and that the picture must have been painted before 1422. The startling conclusion followed that the donor of the Louvre painting could not be Chancellor Rolin at all since he was too young at the time and a man of Autun, not Liège.

Even Kenneth Clark has relied on the identification of a background building for evidence that van Eyck was in London. He is known to have been sent on a series of mysterious journeys for John of Bavaria, Count of Holland, perhaps to make portraits of possible wives, and he knew Europe better than most of his contemporaries. Lord Clark sees an accurate rendering of old St Paul's in the background of the Carthusian Madonna and writes, 'No one else alive at the time could have provided him with such a drawing'[1], so the background must have been painted from drawings made on the spot. One of the few drawings of St Paul's before its steeple was burnt in 1561 is reproduced in Pl. 94 and the reader may consider the evidence for himself.

The people who crowd the streets in the few square inches of the Rolin Madonna have been studied as closely as the buildings themselves. As many as 2,000 could be counted with the aid of a magnifying glass, wrote one scholar in 1885. Not at all, replied another in 1916: he had actually taken his magnifying glass and counted only 112 people.

ROGER VAN DER WEYDEN

Roger van der Weyden, or de la Pasture in the French version of his name, was born in 1399 and died in 1464. He was thus half a generation younger than Jan van Eyck and, as he was the pupil of Robert Campin, he was influenced by both throughout his life. He visited Italy when his reputation was already high and his own immediate influence on the world of art was greater than that of van Eyck. He never signed a picture and, of the 100 or so works now attributed to him, not one is documented by contemporary archives as is van Eyck's Ghent Altarpiece. Nevertheless, he had a style on which a securely based reputation has been built.

It was Roger van der Weyden who was commissioned by Pierre Bladelin to paint a *Nativity* for the church in the new town of Middelbourg, near

plate 38

[1] *Landscape Into Art*, John Murray, 1949, p. 19.

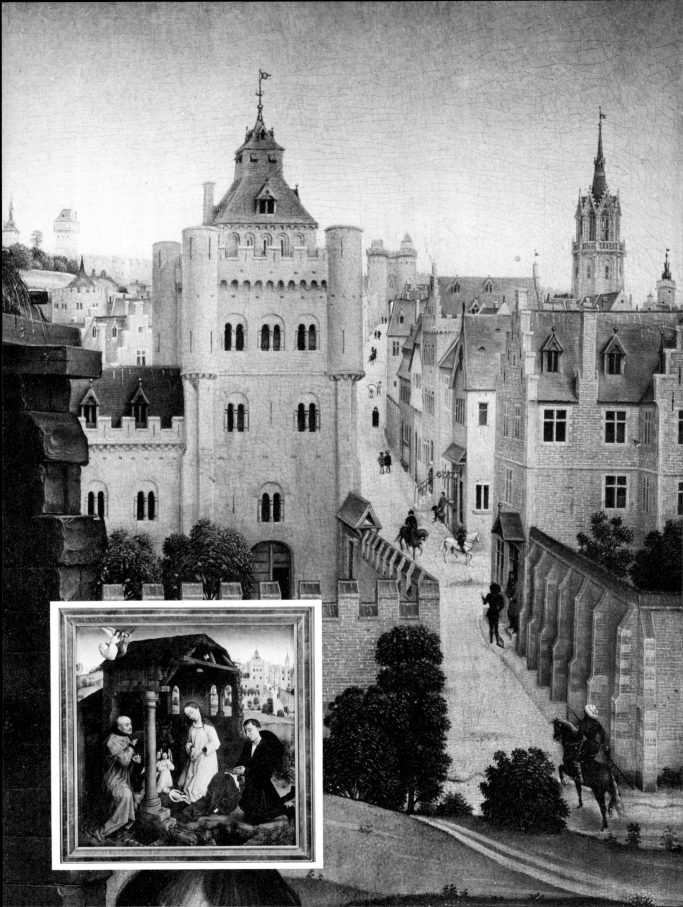

Flushing on the island of Walcheren. Bladelin was Receiver-General to Philip the Good and when in 1430 Philip created the Order of the Golden Fleece, in recognition of wool as the great source of Flemish prosperity, Bladelin became treasurer to the Order. He could well afford to create a new town and by 1460 Roger's altarpiece was installed in the church, its background showing the main street, with the church itself, and some delectable glimpses of the outskirts.

In a much larger altarpiece, this time painted for the church of St Columba in Cologne and now in Munich, Roger painted an *Adoration of the Magi* with, as background, a street full of detail. It winds through the suburb of the town and we see the whole length of the main street ending with the gate. A white horse, with the tiny head Roger chose to give his horses, is being ridden away from the town in one direction while the procession of Magi leaves it in another.

plate 39

The white horse with the tiny head returns in the background of *St Luke Painting the Virgin*, one of the most intriguing of all Flemish pictures to the lover of townscapes. The design obviously derives from van Eyck's Rolin Madonna but the scene spread out before the two figures on the ramparts is much simpler than the one van Eyck's two figures are studying. The shop behind the white horse is strangely similar to the shops in Campin's *Virgin before a Firescreen* and Ingelbrecht Altarpiece. It has been suggested that it is really the same shop in all three pictures, one selling the bladders which artists used to buy their pigments in (*vessies*). The smallness of the horse's head has also come under examination and it is true that a white horse with a small head stands outside the shop in all three pictures. This has led, as may be imagined, to a questioning of the generally accepted relationship between Campin and van der Weyden. However, it is our purpose to allow the artist, whoever he was, to take us into these medieval streets without raising matters beyond our scope.

plate 40

plate 31

plate 32

It is rare that identifiable buildings are found in the work of the Flemish artists. It was their genius to give the sense of being *in* the streets they were depicting and it was the town itself, rather than any particular monument, that interested them. Roger's view of Middelbourg was exceptional, as was the occasion – a new church in a new town.

38 Middelbourg about 1455, detail from centre panel of the Bladelin Altarpiece, Roger van der Weyden, ¾ original height

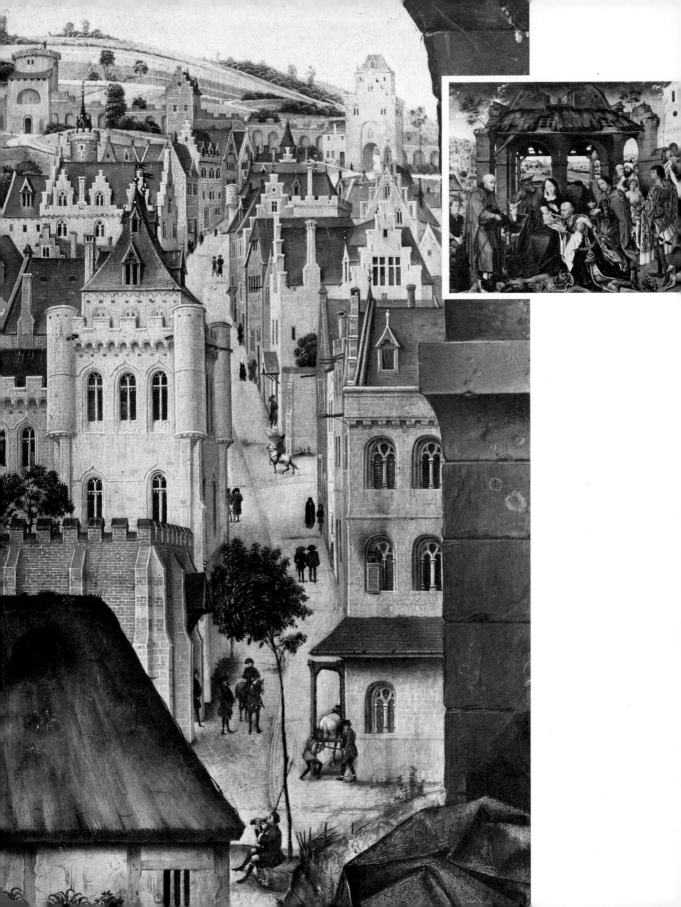

39 Details from centre panel of the St Columba Altarpiece, ¾ original height

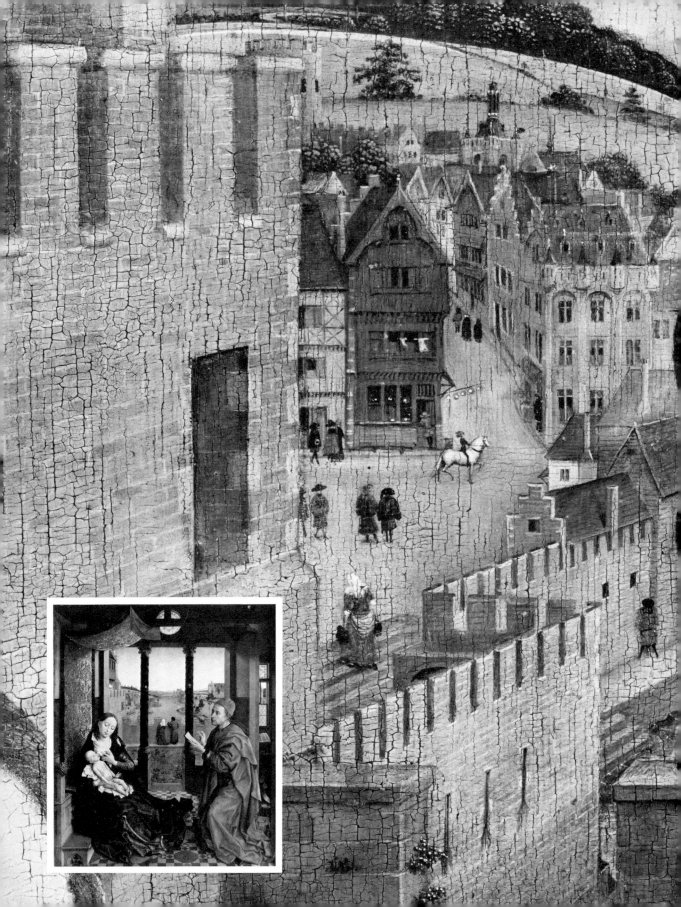

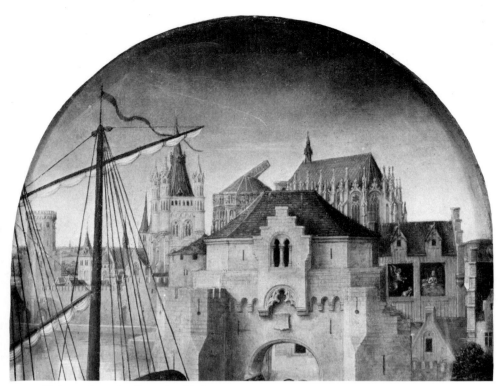

41　*Cologne in 1489, from the Shrine
of St Ursula, Memlinc*

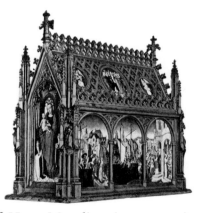

There is another exception in the case of Hans Memlinc (1433–1494)
who was probably at some time a pupil of Roger van der Weyden in
Brussels. Born in Germany, most of his working life was spent in Bruges,
then a flourishing port in the days before its harbour silted up, and there
he was commissioned to paint the sides of the Shrine of St Ursula for the
Hospital of St Jean (it is less than three feet high and stands on a turntable
so that we may turn it to the light as we wish). For his background he

55

40　*Detail from St Luke Painting the Virgin, enlarged*

plate 41

chose, not one of the Bruges churches, but the old Cologne Cathedral which he showed on both sides of the shrine, together, it is said, with the old town hall of Brussels. On the top of the tower of Cologne Cathedral is a crane and we shall see this crane again in a picture painted two centuries later.

QUATTROCENTO ITALY

For the realistic painting of places there is nothing to be found in fifteenth-century Italy like the work of Memlinc or van der Weyden, nor even of the earlier French illuminators. The great masters were not interested in, and the lesser ones had no gift for, bringing a city to life on their panels. Occasionally public buildings appear as the background to the recording of a notable event or, as in the example by Fra Angelico's pupil, Domenico di Michelino, the reading of a poem. The ancient monuments of Rome or the latest *palazzo pubblico* sometimes form the background of a religious painting. But Dante, although outside a wall containing a number of famous Florentine buildings, does not really seem to be outside Florence, and in none of these paintings is there an illusion of daily street life. This is not townscape painting.

42 Fifteenth century Florence, Domenico di Michelino

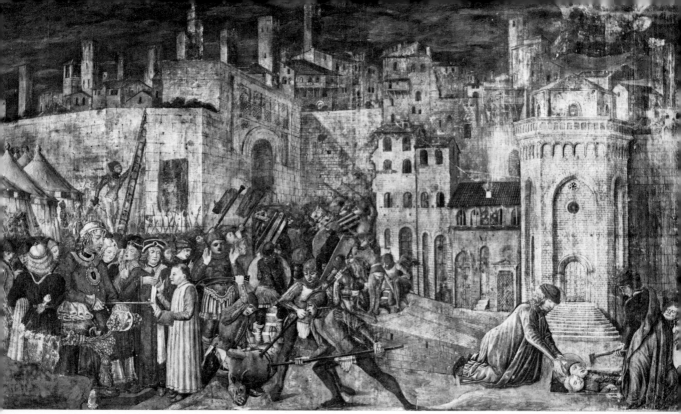

43 Fifteenth century Perugia, Benedetto Bonfigli

In 1454, more than a century after Lorenzetti had decorated the Sala della Pace in Siena, Benedetto Bonfigli was commissioned to decorate some walls in the Palazzo Pubblico of Perugia. This was a period when the Republic of Perugia, founded in 1130, had virtually ceased to exist and the city was at the mercy of the quarrels between the leading families and between them and the Pope, with cruelties on all sides too horrible to contemplate. Yet there was still time for Art and Benedetto chose, or was instructed, to portray Perugia under attack by the Goths some 900 years earlier. In the scene representing the martyrdom of her bishop, St Ercolano, he included three identifiable churches, those of the sainted bishop himself, S. Pietro and S. Domenico, as well as the Porta Marzia and the street leading to it with part of the ancient walls.

Benedetto Bonfigli was a pupil of Benozzo Gozzoli, the painter of those marvellous frescoes in the little chapel of the Riccardi–Medici Palace in Florence – the son of a peasant who had no difficulty in apprenting himself to both Ghiberti, the most celebrated sculptor of his day, *and* Fra Angelico. Bonfigli spent about 40 years, off and on, working in the Palazzo Pubblico and had not finished when he died in 1496; halfway through the work Fra Filippo Lippi and Fra Angelico had, under his agreement, to

57

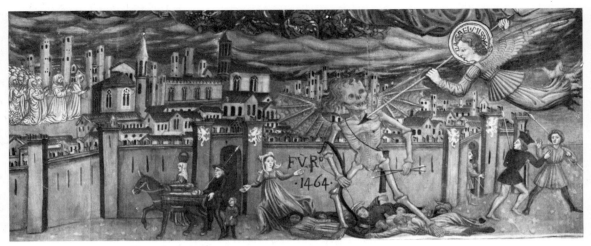

44 *Perugia in 1464*

be called in to inspect the work and advise whether it should continue and how much the artist should be paid.

Benedetto Bonfigli was unusual for his century in that he really loved painting buildings, as can be seen from his view of Perugia during its siege. He was never more than a minor master, though, and spent much of his time painting processional banners called *gonfalone*. There is a Church of the Gonfalone in Perugia and on one of the banners Benedetto painted another detailed view of the city. There had clearly not been much advance in this kind of painting since the Lorenzetti brothers had been working a century earlier.

The truth of it was that the adventurous spirits among the Italian painters of the fifteenth century had other things in mind when they thought of the representation of streets and buildings. They had none of the concern of the Netherlands painters for representing the textures of brick and stone or for trying to capture the atmosphere of a village street or of a town seen from a balcony. What interested them was the amazing discovery that by following a certain set of rules their canvas or panel could become a window through which a spectator could see their streets and buildings receding away into the background just as they appeared to do in real life. But which precise set of rules to follow was still a matter for discussion.

THE THRILL OF PERSPECTIVE

Brunelleschi had discovered the new mathematically based system of perspective; Alberti codified it in his book, *Della Pittura*, written in 1435

and dedicated to Brunelleschi. In the last decade of the fifteenth-century Leonardo da Vinci began making notes on painting which he continued for 20 years and which have come down to us, through a manuscript compiled by his friend Francesco Melzi, as the *Treatise on Painting* ('the most precious document in the whole history of art' in Kenneth Clark's opinion). There are references in it to a chapter on perspective which has been lost but on one aspect of the new discovery Leonardo had much to say (although no painting demonstrating his teaching has survived).

'There is another perspective which we call aerial', he wrote, 'because through the differences in the air we can perceive the varying distances of various buildings. If in painting you wished to make one seem more distant than the other it is necessary to represent the air as a little thick. . . . Paint the first building its true colour; the next in distance make less sharp in outline and bluer; another which you wish to place an equal distance away, paint correspondingly bluer still; and one which you wish to show as five times more distant, make five times bluer. By this rule, the buildings which are on one line and seem to be of the same size will be clearly understood, so that it will be known which is most distant and which is larger than the other.'

This made it all sound easy, but linear perspective was a different matter and Leonardo, while saying little that was new, systematically examined everything that was known on the subject and pointed out all the weaknesses of the theory – for it is only a theory. As Brunelleschi had himself shown from the beginning, the only way to make the illusion complete is to ensure that the spectator looks at the picture from a predetermined point, and nowhere else, and with one eye shut (see p. 20). As soon as he moves, up, down or sideways, or opens both eyes, the theory partially collapses. The various ways of compensating for this perverse habit of picture-viewers provided plenty of ground for conversation among artists throughout the second half of the fifteenth century. Ucello became so obsessed with the problems that he spent most of the nights of his old age studying them. 'Oh, what a sweet thing this perspective is', he is said to have called out when his wife called him for a meal.

The artist's viewpoint when painting his picture was the first subject to be settled; then the assumed viewpoint of the observer (if he could be prevailed upon to stand still); then the degree of foreshortening of the various parts of the picture, for very few had only one viewpoint. Then there was the colour variation as the distance receded – the 'aerial' perspective to which Leonardo attached such importance.

And all this concerned only the new invention of 'artificial' perspective. The old 'natural' perspective, based on the optical theories of antiquity

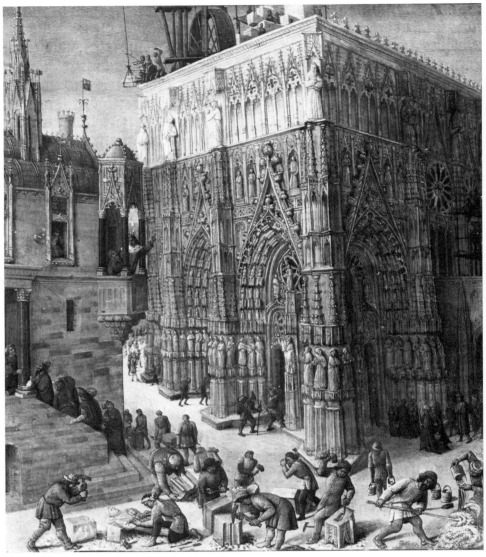

45 *The Building of the Temple, Jean Fouquet*

and known through the works of medieval commentators, was far from dead. Leonardo often relied upon it when Brunelleschi's and Alberti's methods failed, particularly in the case of objects close to the eye.

This extremely complex subject may be simplified (and, the reader must be warned, over-simplified) by considering artificial perspective as a system of straight lines involving, for its full effect, a fairly distant subject

seen by a stationary spectator with one eye shut, and natural (or optical) perspective as a system of curves which takes into account binocular vision and the movement of the eyes. There will be plenty of examples of the first, beginning on the next page or two; Jean Fouquet's *Arrival of the Emperor Charles IV* (Pl. 26) is a good example of the second. Fouquet nearly always drew a chequer-board pattern as a series of curves on the theory that that is how the eye normally sees straight lines, and in Pl. 26 there is every reason to suppose that he intended to convey, not a curved street as it appears to be, but a straight street as the human eye would see it. The tendency of high buildings with straight sides to appear to lean outwards, and for two buildings with a gap between them to appear to converge, is another aspect of the same problem and Fouquet recognised this in two other miniatures in *Les Antiquités Judaïques* both showing the Temple of Jerusalem. In Pl. 45 the Temple is seen close to and the lines are deliberately distorted. In Pl. 46, the same building is seen from a distance and there is no distortion.

E. H. Gombrich reminds us that none of these theories can be anything but a compromise and that what really counts is the beholder's share in the reading and interpretation of visual image. Any system that carries conviction in the case of a particular artist and a particular observer is the

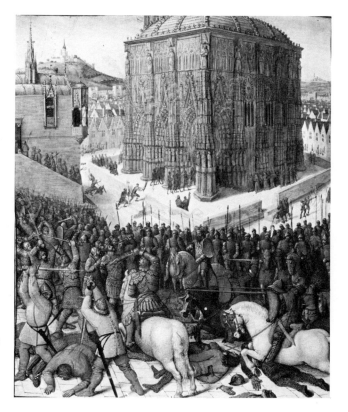

46 *The Taking of Jerusalem*

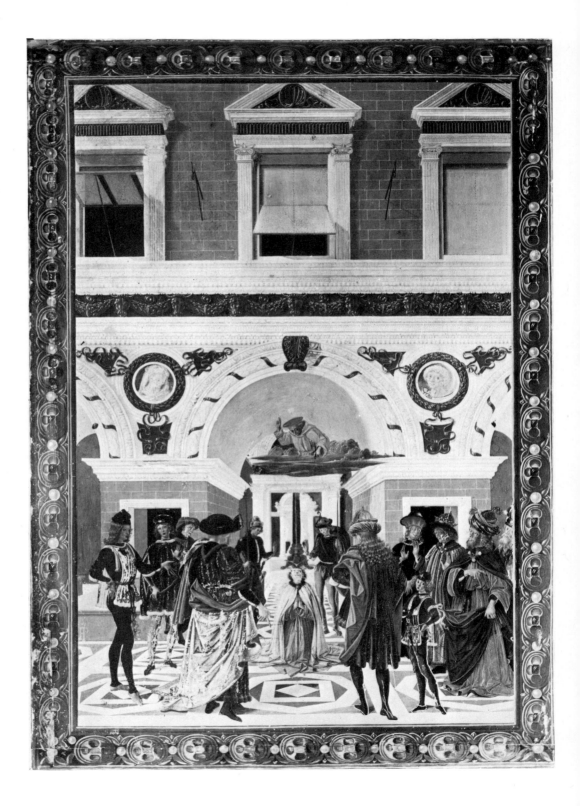

right system for them. In the fifteenth century it seemed possible to resolve the problems into an exact science, and discussion of the merits of different systems was heady stuff.

Where did it all lead? Ultimately it led to an acceptance of the 'artificial' system of straight lines which, with modifications, has persisted to this day. In Italy its immediate result was a passionate interest in any experiment involving perspective. Architecture became the favoured background for paintings of all types and allowed the artist to indulge his own talents as a designer of buildings at the same time as he played with various ways of giving his buildings substance and the illusion of reality. Very few of them were portrayals of existing buildings so they have but a peripheral interest for us. One example must therefore suffice and it is hard to know which to choose. *S. Bernardino Healing a Blind Man* may be a reasonable choice since it is anonymous to the extent that no two art historians seem to agree as to who painted it; no particular artist will therefore seem to be favoured at the expense of all the others. It comes from one of eight panels which once decorated the cupboard in a church in Perugia where the *gonfalone* used to be kept. It is an ideal illustration of the mastery of perspective which had been attained by 1473 when the picture was painted. Here is the world as the Renaissance artist saw it and here is his absorption with the portrayal of it in every detail – even to the way in which the windows are opened.

IDEAL PERSPECTIVE

The intelligentsia among the fifteenth-century Italian painters were so carried away by their discovery of perspective rules that they indulged in exercises with no other purpose but to demonstrate them – and this was by no means confined to the less talented artists: one of the giants, Piero della Francesca, wrote a treatise on perspective in 1452. It was from Piero's workshop in Urbino that four panels came which have proved of enduring interest and of which one was very probably painted by Piero himself.

They may well have been painted originally for the sides of those great chests called *cassone*. Such chests had been decorated by sculptors or moderately skilled craftsmen before the beginning of the fifteenth century but now they began to attract the real artists. As they presented a very wide surface for their height they were suitable for a particular kind of picture such as a battle scene or a ceremonial procession – and for experiments in the new art, or science, they were ideal.

63

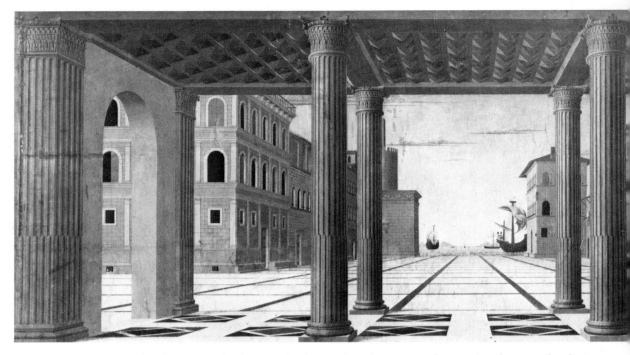

The four panels show 'ideal cities' and anyone determined to study their authorship will have no lack of published material to go on. Two of them are now in Berlin, one in Baltimore and the one most likely to have been painted by Piero himself remains in his city of Urbino. It must have been painted around 1470 and it was sufficiently important to inspire Bramante, the Urbino architect who was also a painter, to build a *tempietto* in 1501 at S. Pietro in Montorio in Rome faithfully following the design of its central building. Here, then, is topographical painting in reverse – the

48 *Ideal City, perhaps by Luciano Laurana,*
4 ft high

architect building the painting instead of the painter painting the building.

The ideas put forward in Alberti's book *Della Pittura* must have been well known by 1470 and Piero's Urbino panel illustrates perfectly Alberti's 'ideal city'. 'The streets within the city,' Alberti wrote, 'besides being handsomely paved and cleanly kept, will be rendered much more noble if the doors are built all after the same model and the houses on each side stand in an even line, and none higher than another.' The buildings should be 'one third the width of the piazza' – just as they are in the Urbino panel

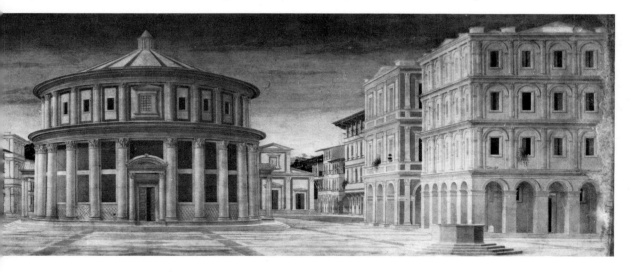

– and 'they must have porticoes in which old men may spend the heat of the day or be mutually serviceable to each other'[1]. The piazza itself was essential as a place 'where young men may be diverted from the mischievousness and folly natural to their age'.

All this came to pass, first in these mysterious panels from Urbino (mysterious because nothing is really known of their origin) and then in realised buildings and the backgrounds of innumerable paintings. From now on whole buildings, seldom before found playing an important part in the background composition of a picture, become more and more frequent, especially among the Umbrian painters.

INTARSIA

An ideal medium for representing the ideal city proved to be the tiny pieces of wood of varying natural colours and textures put together to form a picture, known as *intarsia*. One of the four *cassone* panels from Urbino (now in Berlin) is thought to have been the work of Francesco di Giorgio who worked on the Ducal Palace for the Duke of Urbino around 1476 and who also designed the enchanting *intarsia* panels for the Duke's study. They set a fashion which was followed with varying success in many other cities.

The way in which the artist's work is influenced by the materials at his disposal and the medium in which he is working is always of interest. The early artist painting a huge fresco, large parts of which have to be

[1] Compare Libanius's description of Antioch of 1,000 years earlier (p. 7).

50 *Detail from* intarsia *panel in Urbino*

completed within a few hours while the plaster is still wet, had obviously to think in entirely different terms from the miniaturist with unlimited time for the completion of a single tiny page. The discovery of oil painting later on made artists think of their problems in different terms; they could now contrast thick, dense light paint with thin shadow paint and produce an *impasto* which gave their pictures almost an extra dimension. Canvas, which came into use at the beginning of the sixteenth century, gave an entirely different texture to paintings from that of the wood panels in use before. These were the great developments: *intarsia* was a small but interesting one. The little pieces of wood used for *intarsia* panels could not provide an artist with much scope, but occasionally a limitation itself brings out a skill; the worker in this elusive medium had to find the most suitable subject for it. He found it in *trompe l'œil* effects of open cupboards and shelves with musical instruments and other objects on them, and to an even greater extent in perspective views of ideal cities which must certainly have been inspired by the Urbino panels. The natural grains of the wood and contrasting light and shade give an effect of depth and space even greater than painting could achieve.

Francesco di Giorgio's *intarsia* work in Urbino (and in another of the Duke of Urbino's palaces in Gubbio, now in the Metropolitan Museum) were unsurpassable but the school which was set up in Verona, probably as a result of his example, produced some notable work. The choir-stall panels of the Cathedral in Siena, originally in the chapel at Monteoliveto Maggiore, came from this school and are ascribed to 'Giovanni da Verona'. They show round buildings, rectangular buildings, frontal and oblique views, interiors and shelves with domestic objects on them – one wonders for a moment what they can possibly have in common and then realises that every panel is an exercise in the new art of perspective.

Giovanni da Verona also collaborated in the most remarkable of all the series of perspective panels, those in the sacristy of St Mark's, Venice, which also have associated with them the names of Giovanni's master, Fra Sebastiano da Rovigno and the brothers Antonio and Paolo da Mantova. Generally missed by the most voracious tourist, as the sacristy is not normally open to the public, these consist of 21 imaginary scenes, all inspired by Venice and some with reminders of well-known existing buildings. They take the visitor on a tour of a Venice which is at times even more magical than the real city and they have the additional merit of being kept in good condition by constant restoration; *intarsia* is a perishable form of art and five centuries of exposure has sadly damaged many of the panels to be seen elsewhere. A number of the panels show scenes in the life of St Mark (who was taken to Venice only after his death) whereas in others

67

there are no figures, only a series of Renaissance palaces, bridges, canals and an occasional glimpse of the mainland in the background.

Giovanni da Verona was in Venice in 1489–90, by which time the work is thought to have been nearing completion. Two or three years later he began the panels above the choir and in the sacristy of Santa Maria in Organo, Verona, another superb set of ideal city views accompanied, as is the case with the St Mark's scenes, by *trompe l'œil* cupboards with open doors exposing everyday objects on their shelves.

Workers in *intarsia* by no means confined themselves to townscapes although these provided the most satisfactory subjects for the art. Some of the most ambitious and best-preserved examples are to be seen at Bergamo in Santa Maria Maggiore and the Colleoni chapel adjoining it, and the visitor who descends from this charming old hill city to the less ancient city below it will find a later series of panels in the church of S. Bartolomeo, very similar to those of Giovanni da Verona. These are by Fra Damiano who was born in 1490 and who also did work in Bologna which was noted by Samuel Pepys in his diary. A pleasant story was told of Fra Damiano

being visited by Charles v and the Duke of Ferrara who questioned the possibility of their being done entirely without the aid of artificial colouring. The artist proved his point in the most convincing way: he planed over one of his panels and showed that the subject remained quite unaffected.

MANTUA

It is very easy to fall in love with *intarsia* work and anyone who decides on an *intarsia* pilgrimage will soon find himself in Mantua where Isabella d'Este, wife of Francesco Gonzaga, commissioned a splendid series in 1520 for her music room. On his way to the Palace of the Gonzagas to study the panels he will be struck by a profusion of postcards showing the Piazza Sordello, in which it stands, both as it is today and as it was when an unusual kind of battle was taking place.

The battle, which seems more elegant than bloodthirsty, took place in 1328 and was between the reigning family of Bonacolsi, whose palace is seen on the left looking towards the cathedral, and the Gonzaga family

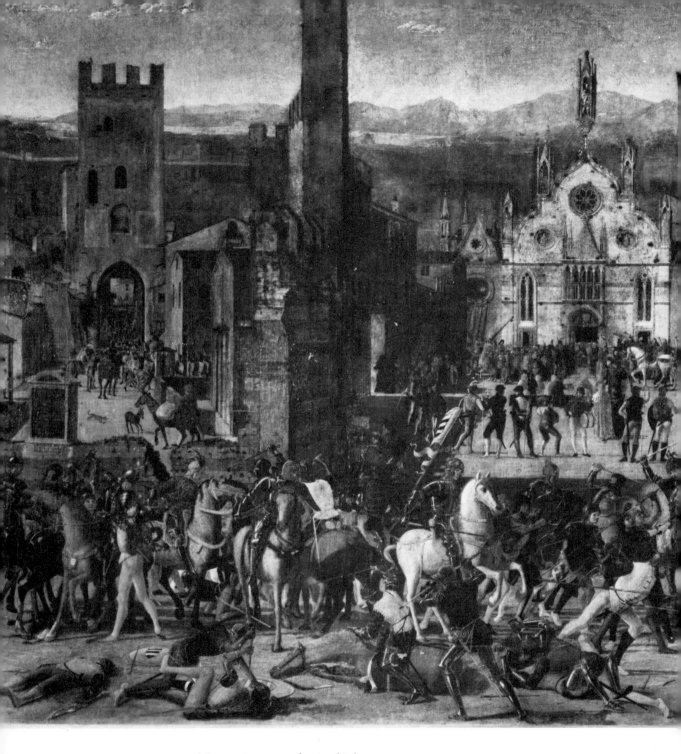

54 *Mantua in 1494, 5ft 7 ins high*

70

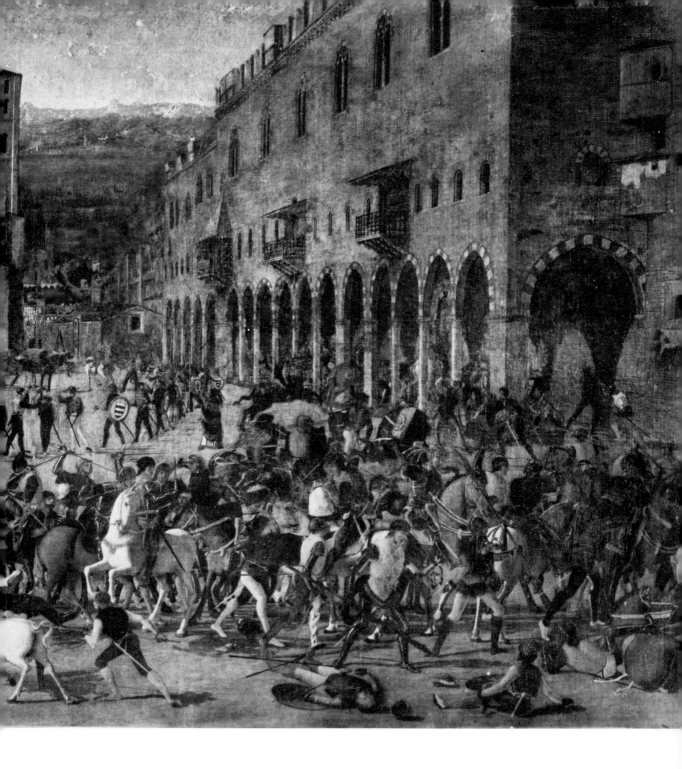

plate 54

who threw them out of Mantua and remained in command themselves for 300 years. In 1494 Francesco Gonzaga commissioned Domenico Morone to commemorate the event and this he did with a huge painting which still hangs in the palace.

Morone showed Mantua as it was in his own time rather than a century and a half earlier when the Bonacolsis were expelled. Except for the cathedral, which then had a Gothic façade instead of its present classical one, nothing seems to have changed at all, every detail of the Gonzaga palace today corresponding with Morone's painting. It seems surprising that the palace should have stood unchanged for almost 500 years, but the explanation is a simple one – what one sees today is a restoration of the 1940s based on Morone's painting. In only one respect did Morone depart from the facts and that was in bringing the Porta Moline from the outskirts of Mantua and putting it on the left of his painting beside the Piazza Sordello. For this he paid a price, as almost all reproductions of his picture (and all the postcards) destroy his composition by cutting the Porta Moline out.

Isabella d'Este's *intarsia* panels do not rise to the heights of some of those elsewhere but they have great charm. There is a musical connotation to most of them and when the artist turns away from musical instruments to show a country palace he still invites the spectator to join in a song and manages to find the right-shaped pieces of wood in which to write his score at the bottom of the picture.

55 Intarsia *panel in Mantua*

III THE FIRST TWO CENTURIES OF PRINTING

THE FIRST VENICE VIEW-PAINTINGS

The first townscape paintings of the Renaissance had already been commissioned in Venice by 1494 when Francesco Gonzaga commemorated his ancestor's victory in Mantua.

The Renaissance came late to Venice: the Gothic Cà d'Oro was still being built when most of the Florentine palaces in the new style were already completed and her first Renaissance palace, the Vendramin Calergi, was not begun until 1481. By this time the political fall of the Republic, prophesied by Doge Tommaso Mocenigo some 70 years earlier, was pursuing its long, slow course. Constantinople, won in 1204 through Doge Enrico Dandolo's great crime against humanity, the 'Crusade against Christians', had been lost to the Turks in 1453 and, worse still, Diaz was about to round the Cape of Good Hope and deprive Venice of her monopolies by opening the sea route to the Indies. Soon all Europe was to unite to destroy the rapacious Republic and, although such rare unity was to last only briefly, the days of material prosperity for Venice were ending. On the other hand, her great artistic achievements had scarcely begun. Giorgione, Titian and Sansovino were children and Tintoretto, Veronese and Palladio had not been born; only the Bellini and Lombardi brothers foreshadowed what was to come in painting and architecture.

About 1490, the Scuola di S. Giovanni Evangelista commissioned a series of paintings telling of the Miracles performed by their Holy Cross – which is still in the building which was theirs until their suppression by Napoleon and which looks on to the most exquisite Renaissance courtyard in Venice. The paintings are now in the Academy of Fine Arts.

73

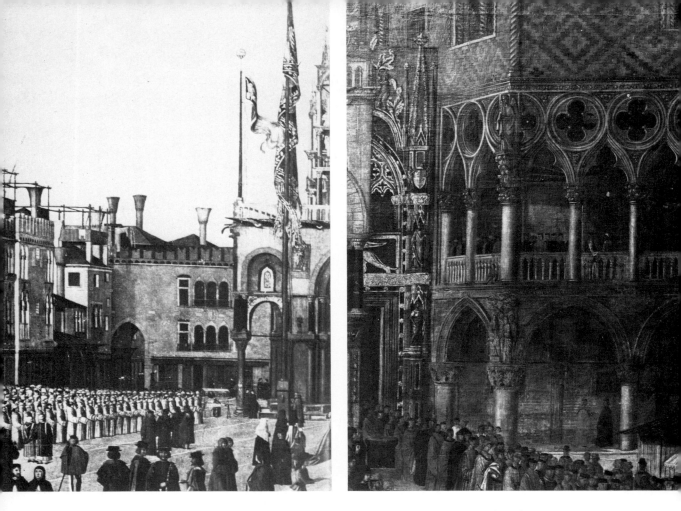

56 *Piazza S. Marco, Venice, in 1496, Gentile Bellini, 12 ft high*

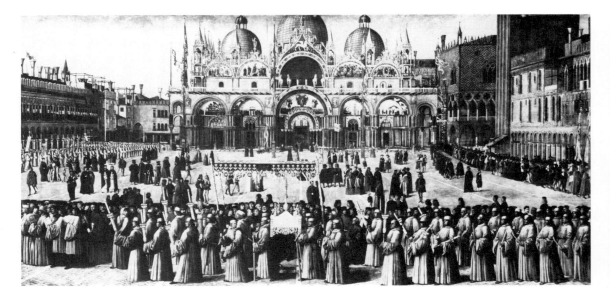

The members of the *scuola* must have known that Gentile Bellini and Vittore Carpaccio were going to provide them with views of Venice which might even distract attention from the stories the pictures were to tell. Ruskin called them 'a series of pictures of street architecture with various more or less interesting transactions going on in the streets. Large Canalettos, in fact; only with figures a little more interesting than Canaletto's figures'. Whether or not the second description is true, the first certainly is.

For his contribution to the series, Gentile Bellini chose (or was allocated) as subject *The Procession of the Holy Cross in the Piazza S. Marco.* For the purpose of his picture he wanted to show St Mark's frontally, with the main arch in the centre of the main dome and the side arches[1] and pinnacles receding towards a central vanishing point; he also wanted to show as much as possible of the north-west corner of the Doge's Palace and of its main entrance, the Porta della Carta which had been completed half a century earlier. Such a scene presented itself to the artist, but from the extreme left of the Piazza, under the arcade of the twelfth-century palace shown in the painting. Gentile Bellini therefore drew the whole of his background from this point but the principles of good composition demanded that the picture should appear to have been painted from the middle of the Piazza and that the buildings on the left, invisible from the original viewpoint, should be included together with those on the right (the Orseolo hospital, then flush with the Campanile and now replaced by the Procuratie Nuove which is set back). The artist therefore moved

[1] Note the old mosaics in the arches of which the only one to survive is the portrayal of St Mark's itself, reproduced in Pl. 6.

57 *Detail from Plate 56, compare with Plate 6*

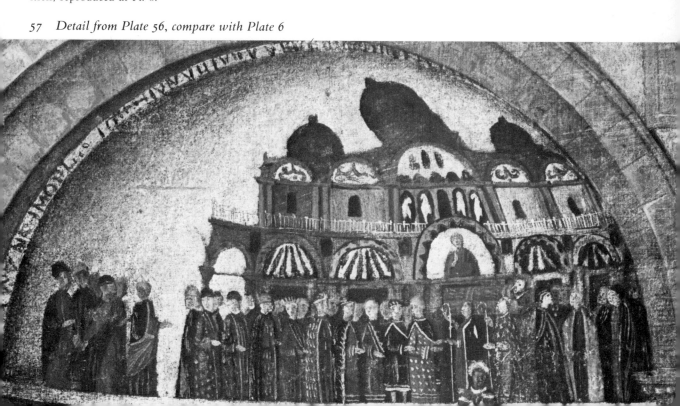

to this spot and, so that there should be no mistake about the purported viewpoint, the white marble lines of the paving are seen to converge towards the centre. The background scene was now quite different (the true one will be seen in Pls. 85, 127, 135 and 174) but the combining of the two, and of additional viewpoints for other details, presented no problem either to Gentile Bellini's competence or to his conscience. Thus was founded the tradition which has enabled all subsequent topographical artists to move their viewpoints at will, although few have ventured to move them quite as far from one another as the originator of the practice – for this is

58 *The Rialto Bridge, Venice, just before 1500, Carpaccio, 11½ ft high*

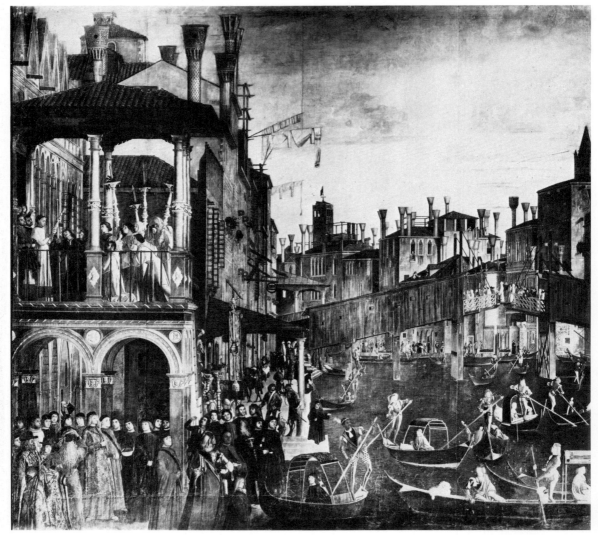

certainly the earliest topographically accurate painting to have survived and in the absence of Brunelleschi's Florentine views Gentile Bellini must be given credit as an innovator.

At this time Gentile Bellini was of greater repute in Venice even than his brother Giovanni, a reversal of present-day values. Both were elderly men in the 1490s and it was almost certainly from Gentile Bellini that Vittore Carpaccio learnt the art of telling a story in painting. In this he soon surpassed his master but, whereas the work of the Bellini brothers led directly to the triumphs of Giorgione, Titian and their fellow artists, Carpaccio, almost two generations younger, really ended an era which had begun with the Flemish painters. He was above everything a reporter and within 20 years his kind of painting was carried away by the new Renaissance ideas so that he died in obscurity.

But what a reporter. Fascinating as it is to us today, Gentile Bellini's Piazza is a stage set and is filled with figures rather than with people. Carpaccio's *Miracle of the Holy Cross* is very different. It took place near the Rialto Bridge and no detail seems too trivial for him to remark on. We see the signs outside the old inns, the rotting timbers of the bridge itself painted almost with *trompe l'œil* effect and people of endless variety and interest.

When it came to buildings Carpaccio was more than a reporter. The loggia in front of the palace, where the Patriarch of Grado is healing a madman with the aid of the holy relic, was of Carpaccio's own invention. This was the time when Venice was being transformed from a city of red brick to one of white marble and there is good reason to suppose that Carpaccio gave as much inspiration to the architects by his imaginary buildings as he received from their real ones. The most sumptuous of these appear in the series illustrating the St Ursula legend, painted for the *scuola* named after her and now occupying the room in the Accademia next to the Holy Cross paintings. It would have been intriguing indeed had Carpaccio visited England before painting the scenes of the legend which were supposed to take place in that country. Instead of topographical accuracy he chose to show the Court of England with a background which might have been designed by the great Venetian architects working at the time – but which were in fact designed by Carpaccio himself.

To return to the miracles of the Holy Cross, these did not take place only in such centres as the Piazza and the Rialto Bridge. The Cross fell into the S. Lorenzo canal but, as Gentile Bellini shows us in another painting, it stayed miraculously on the surface of the water from which it was recovered by one of the brothers of the *scuola*. The buildings on the *fonda-menta* beside the canal are perfectly recognisable, at least in form, today,

plate 59

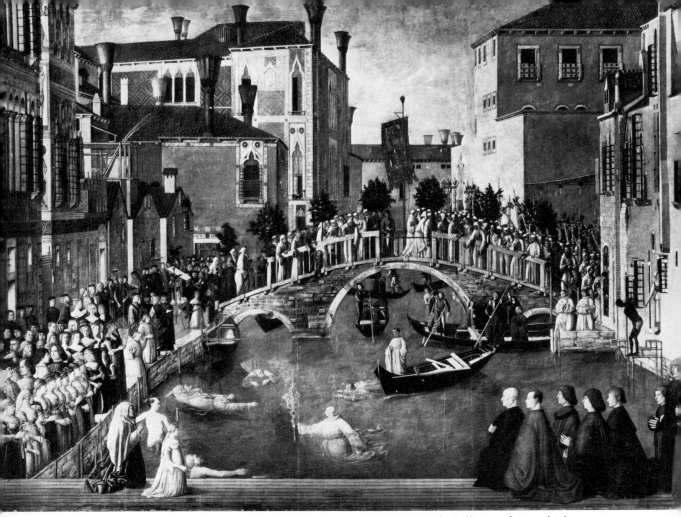

59 *The S. Lorenzo canal, Venice, in 1500, Gentile Bellini, 12ft 2 ins high*

but again we have a stage set rather than a living portrait of medieval Venice such as Carpaccio would have provided.

We have every reason to be grateful to the brothers of the Scuola S. Giovanni Evangelista for having the Venice of their day perpetuated in accordance with their commission. It was an original idea so far as painting was concerned but, whether or not they had seen and been inspired by it, a book had recently been published in which the city of Venice also played an important part.

THE FIRST TRAVEL BOOKS

When Carpaccio was a young man and Gentile Bellini in early middle age, the ancient Chinese invention of printing from wooden blocks came to Germany and within 25 years, that is to say by 1476, there were printing presses in Italy, France, the Netherlands, Switzerland, Spain and England[1]. The illustrated book did not follow the book of printed words; both came at the same time. It was no more difficult to carve pictures from the wood blocks than letters and the oldest surviving printed book, the Buddhist Diamond Sutra of 868, has an elaborate illustration as its frontispiece. It was therefore not surprising that one of the first printed travel books, *Peregrinationes in Terram Sanctam*, should have been profusely illustrated; what is surprising is the high quality of the illustrations.

This book was first published in Mainz on 11 February 1486 in latin and was immediately followed by German and Flemish editions. It recorded the pilgrimage to the Holy Land of Bernhard von Breydenbach, Dean of Mainz, which took place in 1483–4 and in which the Dean was accompanied by somewhere between 50 and 150 persons (he names 50 in his book but a fellow pilgrim of another party writes in his book that the Breydenbach party was 150 strong; Venice was so thronged with pilgrims awaiting passage to the Holy Land at this time that it was difficult to know to which party all of them belonged). It is one particular member of the party with whom we are most concerned and that is Erhard Reuwich of Utrecht, a 'skilful painter', in Breydenbach's words, who was responsible for all the 'embellishments' in the book. Nothing is known about him nor about any other specimens of his work, although there must be other, unidentified, examples for which he was given no credit.

Since Reuwich was obviously a skilful draughtsman to all who saw the reproductions of his work and since the authenticity of his descriptions of cities could be vouched for by his presence throughout the journey, it was only natural that later artists and publishers should copy him. Anton Koberger, a celebrated printer of Nuremberg, published in 1493 the *Weltchronik* which became known as the Nuremberg Chronicle since it was planned, written, illustrated and printed by men of that town. The writer was Hartmann Schedel, a doctor, and this strange conglomeration included the history of the world up to 1493, a glimpse into the future, accounts of the invention of chess and printing and a vast number of

[1] Like most innovations, printing had its detractors, led no doubt by the vested interest of the scribes (there were then 10,000 copyists in Paris and Orleans alone). As late as 1482 it was said that the Duke of Urbino 'would be ashamed to have a printed book in his library'. A work written on parchment, the scribes pointed out, could be preserved for 1,000 years whereas a book printed on paper could not be expected to last two centuries.

61 *Venice in 1483–4*

60 *Jerusalem in 1483–4*

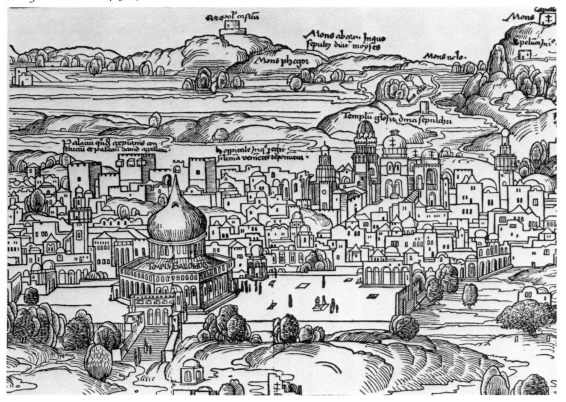

illustrations of cities, genealogical trees, portraits and maps. Many of the
views of German and central-European towns were authentic and original
but Reuwich's illustrations for *Peregrinationes* provided too rich a source
to ignore. Koberger borrowed Reuwich's frontispiece and his drawings of
Rhodes, Venice and Rome. He also took his drawing of Candia, but he
retitled this 'Mainz' (he was not over scrupulous about titles, using the
same plate for the cities he called Damascus, Ferrara, Milan, Perugia,
Siena, Naples and Mantua, and the same one for England as for Pisa).

Koberger was not alone among contemporaries in making good use
of *Peregrinationes*. Even Carpaccio found the book valuable; in his painting
of *The Triumph of St George* for the Scuola di S. Giorgio dei Schiavoni of
1507–9 he relied on Reuwich's drawings of Saracens and Abyssinians and
also of Solomon's Temple and the Church Tower in Jerusalem. Why not?
Had not Reuwich been there whereas Carpaccio had not?

In addition to the drawings showing the costumes of the people of the
near East, which Carpaccio found so useful, Reuwich provided drawings
of strange animals and various eastern alphabets. It was the views of places
visited by the pilgrims, though, which made the book of such superlative
interest and value, and particularly the panoramic views. These showed
Venice, Parenzo, Corfu, Modon, Candia, Rhodes and Jerusalem, the
panoramas of Jerusalem being over four feet, and of Venice over five feet
long when unfolded (the pages are about ten inches high).

81

plate 61

Interesting as Reuwich's woodcuts are, their descriptive value is surprisingly limited in view of what was to come within a few years in this direction. In the drawing of Venice, for example, there is little indication of the city's real shape and the hills of the mainland to the north, generally barely visible from Venice, are shown as within a stone's throw. The columns of the Doge's Palace have bases (which they have never had) and there are only 11 of them instead of 17. On the other hand, the Palazzo Dandolo looks astonishingly like the Danieli Hotel which it has now become, and the wings of the lion of St Mark on his column are drawn accurately enough to have given Ruskin much pleasure. 'Without doubt his first wings were thin sheets of beaten bronze, shred into plumage; far wider in their sweep than now', he wrote in *St Mark's Rest* and then he added a footnote, 'I am a little proud of this guess, for before correcting this sentence in type, I found the sharp old wings represented faithfully in the woodcut of Venice in 1480, in the Correr Museum. Dürer, in 1500, draws the present wings; so that we get their date fixed within twenty years.' By the woodcut of 1480 he meant the Breydenbach-Reuwich woodcut of 1486 and by 'Dürer' he meant Jacopo de' Barbari's famous woodcut of Venice, then thought to be by Albrecht Dürer.

MAPS AND BIRD'S-EYE VIEWS

The oldest and purest form of topographical delineation is of course the map, and map-making is probably the oldest of the graphic arts. The most primitive people drew admirable maps of their own localities and the most ancient peoples, such as the Babylonians of the seventh century B.C., drew maps of the whole world as they knew it. By A.D. 150, Ptolemy was producing maps which influenced geography for 1,500 years. But these are not works of art and so they have no place in the discussion of topographical art; they belong to the world of cartography, even when, as in the case of the *mappae mundi*, carried around by medieval ecclesiastics, their intent was religious rather than practical.

By the second half of the fifteenth century the use of the woodcut had extended to the printing of maps as well as, in a few cases, to views. In Italy the copperplate, with its finer and more delicate lines, was already in use but elsewhere the woodcut remained the medium for printing both maps and views until the middle of the sixteenth century; by then the use of the copperplate had spread throughout Europe. Between the mid-fifteenth and mid-sixteenth centuries cartographers were experimenting

with a more vivid form of presenting their descriptions of places than the conventional map or plan.

There are, broadly speaking, three points of view from which a building or street can be depicted. There is the overhead view (the map or plan) which shows the shape and direction of the street accurately but only the roofs of the buildings. There is the frontal view (such as Reuwich's, Pls. 60–1) which shows only the elevations of the buildings and nothing of the streets. Thirdly, there is the oblique view from the top of an imaginary tower or the eye of a bird as it approaches the city. This gives a realistic impression of the buildings but involves foreshortening of the orthogonals, that is to say the streets running directly towards or away from the observer; they are therefore distorted to the extent that they appear shorter than streets of the same length running across the scene. The three viewpoints can of course be combined and this was often the practice followed by cartographers who wanted to show the façades, or as nearly as possible the whole, of their buildings while retaining the more accurate map or plan form for their streets. Only the true bird's-eye view, though, carries real conviction and shows the city exactly as it would appear from the air; it is therefore the form most likely to appeal to an artist, whether draughtsman or painter, and it is at this point, when it has developed from cartography to art, that we regard it as appropriate to the subject of this book.

In the last quarter of the fifteenth century, when interest in the portrayal of cities in one form or another was developing throughout Europe, several maps and engravings were produced which might fall on either side of the line we have, perhaps rather arbitrarily, drawn. There are views of Florence in the so-called Ptolemy, dating from 1469, where all the best-known buildings of the city are grouped together in roughly topographical order and they are seen obliquely, as in a bird's-eye view; nevertheless they are maps rather than townscapes for the buildings are not seen in their streets. Fouquet had included a plan or view of Rome of this kind in the *Très Riches Heures*, very close to a fresco by Taddeo di Bartolo of 1413–14 in the Palazzo Pubblico of Siena. However, the earliest true bird's-eye view is perhaps one of Florence, with a curious chain frame, of which the only known copy exists in Berlin.

This engraving, sometimes called the Catena view, dates between 1470 and 1480. There is no point outside Florence where exactly the view of plate 62 the engraving would present itself but every building is in its place and there is some indication of the streets in which they stand. The Piazza del Duomo, with its cathedral, campanile and baptistry, and the Piazza della Signoria, with its Palazzo Vecchio, dominate the centre of the city, both chosen by Brunelleschi as subjects to demonstrate perspective in his two

lost paintings. Many churches can also be identified as well as the Ponte Vecchio leading across the River Arno to the Pitti palace. Minor buildings, though, are shown as formalized boxes with roofs.

This engraving was naturally 'borrowed' by Koberger for his Nuremberg Chronicle in 1493, as were Reuwich's illustrations from *Peregrinationes*. With minor alterations it went on being used by various publishers for at least 100 years after its original publication. At least one contemporary painter followed the unknown draughtsman in a panel which was probably painted about 1490: he added the cupola to S. Spirito, which was finished only in 1482, and the Palazzo Strozzi, which had not been finished by 1490 (he may have seen a model of the project). He also included a group of hills (Monte Giovo, behind Fiesole) omitted from the Berlin engraving. The painting was therefore, to some extent, an original work and is the earliest known bird's-eye view painting.

The well-known painting of the *Burning of Savonarola*, of which there are several replicas, must have derived to some extent from the engraving, or from the panel: the viewpoint is much the same and so is the box-like appearance of the houses. It must, though, be somewhat later in date –

plate 64

84

62 *Florence about 1475*

63 *Florence about 1490*

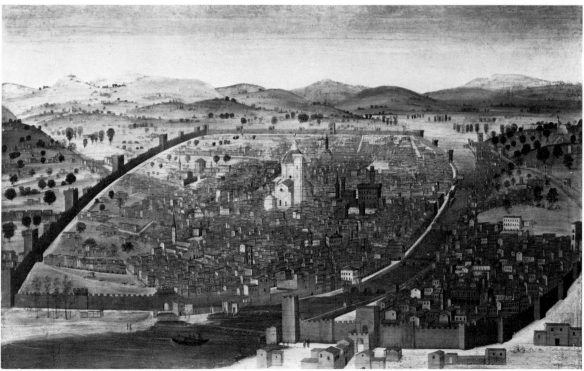

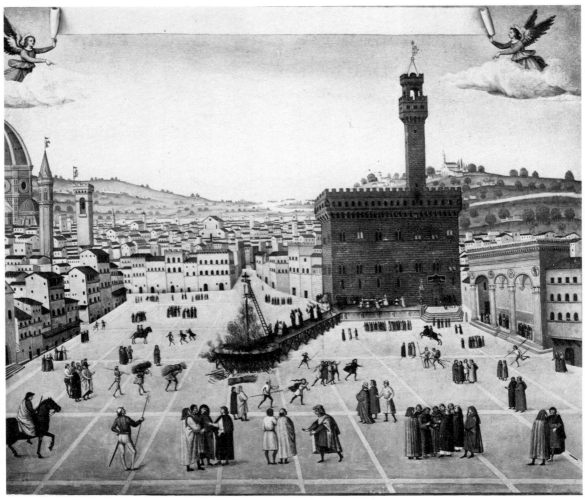

64 *The Piazza della Signoria, Florence, about 1500*

Savonarola suffered his cruel death in 1498. It may well have come from the same workshop as the panel and the name of Francesco Rosselli has been associated with both; Rosselli, however, is little more than a name at present.

There can be little doubt that it is in Florence that we find the first bird's-eye view and, in the Savonarola picture, as early a view of a city from within as is likely to exist anywhere. But it is to Venice that we must return, for it was there that the bird's-eye view, so tenuously born in Florence, suddenly developed into a masterpiece by de' Barbari that was not surpassed for centuries – if, indeed, it has ever been.

JACOPO DE' BARBARI

The earliest-known view of Venice, if anything so inaccurate can be called a view, is in the Bodleian Library version of Marco Polo's *Il Milione* (Pl. 17), painted about 1400. There does not appear to be any other illustration showing the city as it appeared to the visitor until Reuwich's view of 1486 in Breydenbach's *Peregrinationes* (Pl. 61). The art of describing places pictorially had not advanced significantly between the two or, indeed, since the days of the Limbourgs. Nothing shows better the revolutionary step towards realism which it took, in common with much other art, at the end of the fifteenth century than the difference between Reuwich's view of Venice in 1486 and de' Barbari's of 14 years later.

plate 65

Jacopo de' Barbari was born in Venice, probably between 1440 and 1450 and possibly of German extraction. As a painter he was of no importance at all and the languid, drooping figures of his 30 engravings do not seem to put him in the front rank either of the Italian or the German school. Yet he was the first Italian of the Renaissance who had a direct influence on the development of Northern art. This he achieved first by the admiration he inspired in Dürer and later by travelling through the German towns and the Netherlands carrying with him the new ideas of Italy. He died in 1516 in the Netherlands. The *View of Venice* was drawn directly on the wood and, in the absence of anything like it in Italy at the time, it must be assumed that the cutting was assigned to a German craftsman. It had been commissioned and published by Anton Kolb, a German merchant and acquaintance of Dürer's, who had settled in Venice. Kolb's enterprise was well rewarded; for a number of years prints of the view continued to be distributed throughout Europe for the enlightenment of the many business men who needed to visit Venice and find their way around it.

The view is four feet four inches high and nine feet two inches wide and the original wood blocks can be seen in the Correr Museum, Venice, beside a print taken from them, published, as the $1\frac{1}{2}$-inch-high 'MD' in the top right corner indicates, in 1500. It was soon after publication that de' Barbari left for the north.

The more intimately one knows the Venice of today the more fascinating it is to explore the streets of de' Barbari's masterpiece; the sense of *being* in the city in 1500 is perhaps most marked when examining the wood blocks themselves, in spite of their being reversed. An aerial view of today taken from above S. Giorgio Maggiore, from which de' Barbari's view purports to be taken, shows a quite astonishing likeness to the 500-year-old drawing of a man who can never have climbed higher than the Campanile; the information to be gleaned from it all is prodigious.

plate 66

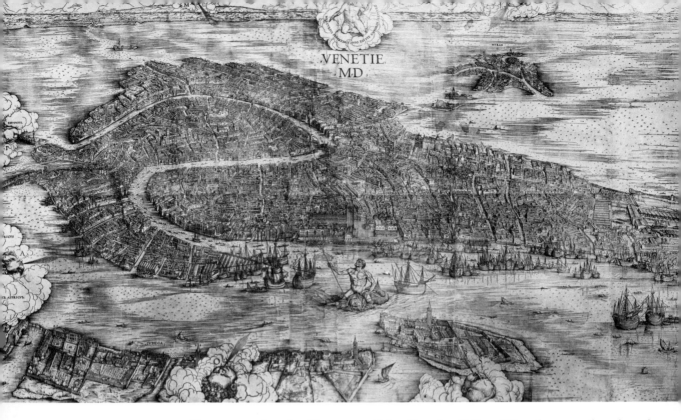

For example, the Oratory of the Scuola di Sant'Orsola near the church
of SS. Giovanni e Paolo is shown in the space of a little finger nail, yet the
proportions of the chapel and the position of the doorway have made it
possible to reconstruct the position of each of Carpaccio's series of paintings
of the Life of St Ursula which he painted on commission for the decoration
of the Oratory. Again, the Campanile in the Piazza S. Marco caught fire
in 1489 and it was necessary to put a flat, temporary roof on it while repairs
were being carried out: de' Barbari shows what this roof looked like and

65 *Venice in 1500. De' Barbari's woodcut*
66 *Below left: The Piazzetta etc*
67 *Below right: The Riva degli Schiavoni*
68 *Above: SS. Giovanni e Paolo*

when the repairs were completed a new edition of his View was issued showing the newly restored high roof. Only de' Barbari's View enables us to reconstruct Marco Polo's house, on the site of which the Malibran theatre was built, to wander in the gardens of the houses now replaced by the Fondamente Nuove, one of which Titian lived in and lovingly described, in short to see Gothic Venice before its first Renaissance palace had been built. Since 1500 there have been hundreds of bird's-eye views of cities but there has never been one of such endless interest as de' Barbari's *View of Venice*.

DÜRER IN VENICE

It was no wonder that Albrecht Dürer pursued de' Barbari from town to town in 1505. Ten years earlier, on his first visit to Venice, Dürer had been completely absorbed with Giovanni Bellini and his friends. Later, when de' Barbari was in Nuremberg, Dürer met him but paid him no attention. Now, in 1505, de' Barbari happened to be back in Italy and Dürer was convinced that de' Barbari, and only he, could teach him the secrets of perspective. Eventually, he tracked de' Barbari down in Bologna, ignored Michelangelo who by chance was also at Bologna, found de' Barbari for the moment obsessed with mathematics rather than perspective and disappointedly returned to Nuremberg, having refused de' Barbari's pressing invitation to meet Leonardo da Vinci and Piero della Francesca.

The incident throws a little light on the character of this most unusual man. Born in Nuremberg in 1471 of a Hungarian father who wanted his son to follow his own trade of goldsmith, Dürer was determined from an early age to be a painter. As a compromise his father apprenticed him to Michael Wohlgemut, a neighbour whose principal occupation was producing woodcuts for book illustration. Breydenbach's travel book was but one of the influences in the vogue for illustrated books which came so soon after the invention of printing in Europe; in 1493 Wohlgemut himself made the woodcuts for another, the Nuremberg Chronicle. This, as we have already seen, was a far more ambitious effort than Breydenbach's but much less successful topographically. Where there were reasonably good existing townscapes, as in the case of Reuwich's Rhodes, Venice and Rome, or the anonymous Berlin engraving of Florence, Koberger, the publisher, took them; where, as in most cases, none could be found he included *some* drawing of a town with little concern for its accuracy. It is hard to believe that while it was being published de' Barbari must have been working on the drawings for his *View of Venice*. The extraordinary advance which this displays over anything that had gone before makes it understandable that for a long time the name of Dürer was associated with it; it will be remembered that Ruskin referred to it as 'Dürer in 1500' when comparing the lion's wings with those of Reuwich (p. 82).

Dürer was determined to leave his mark on the world and travelled restlessly to learn whatever he could from other artists and from the new ideas of the Renaissance which were but slowly spreading north. He travelled to Colmar in Alsace in the hope of meeting Martin Schongauer, a famous painter and engraver, but found that Schongauer had recently died. He found work from publishers in Basle and Strasbourg and then in

69 *Detail from* La Pietá, *Giovanni Bellini*

1494 his parents, hoping no doubt to see him settled down at home, insisted
that he return and be married to Agnes Frey, the daughter of a rich friend.
Dürer assented – but left for Italy alone immediately after the wedding.
In Venice he met Gentile Bellini and was actually in his studio while he
was painting the *Miracle of the Holy Cross*. But it was Giovanni Bellini
who completely captivated Dürer.

Giovanni Bellini, son of a successful painter, Jacopo, younger brother
of Gentile and brother-in-law of Andrea Mantegna, towered not only
above his relations but above all fifteenth-century painters in Venice. It is
the simplicity of his figures which gives them the power to move one so
deeply – that, and the conviction of his backgrounds. The mystical figures
move in a world which seems to be made up of real places and which some-
times were. Thus in his *Pietà* he sees his figures with a poet's vision but to
convince the spectator of their veracity he paints behind them the buildings
of Vicenza – the pre-Palladian Basilica, the tower of the Piazza dei Signori
and the Cathedral; then, perhaps so that it should not be a pure townscape,
he adds S. Vitale and the campanile of S. Apollinare from Ravenna. This
combination of the visionary and the realist, so unlike the wholly natural-
istic Flemish painters, was bound to have an influence on Bellini's followers
and some of them fared better with the realism than the vision. Certainly
few towns are more inviting than that before which the *Madonna of the*

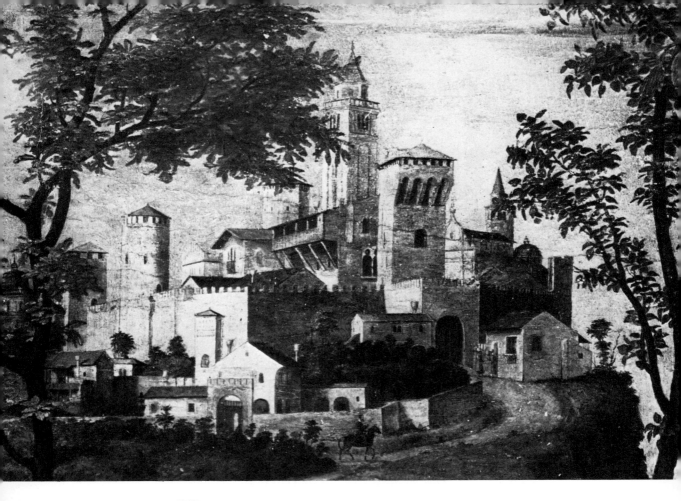

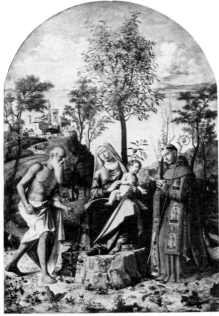

70 *Madonna, Cima da Conegliano, with detail*

Orange Tree sits. It was painted by Cima da Conegliano, a pupil of Giovanni Bellini, and represents Collalto, a neighbouring town to Conegliano where Cima was born.

It was to be expected that Dürer should be impressed by his first meeting with the great Giovanni Bellini, but Bellini, too, was impressed by the work Dürer showed him. Well he might be, for Dürer had recently painted a series of topographical water colours unlike anything that had been seen previously. The views of Innsbruck from the distance and of Nuremberg, done just before Dürer left for Italy, are examples of them. It is hard to realise that they are drawn, not by a nineteenth century Romantic painter, but in 1494 and that they are among the first watercolour landscapes, or townscapes, ever drawn.

plate 72

Dürer learned all he could from Giovanni Bellini, making himself a temporary pupil. Then he returned home in 1495 to settle down with his wife as a professional painter, engraver and wood cutter. In ten years of work at Nuremberg he established his reputation, producing several great series of woodcuts, a vast number of prints and some notable paintings. In 1505 the lure of Venice became irresistible and he returned, this time for

71 *Innsbruck in 1494, Dürer*

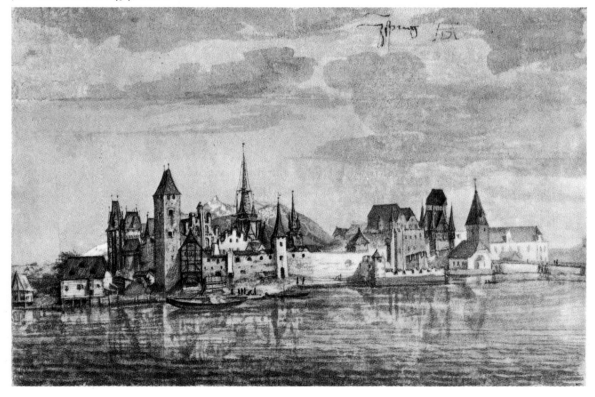

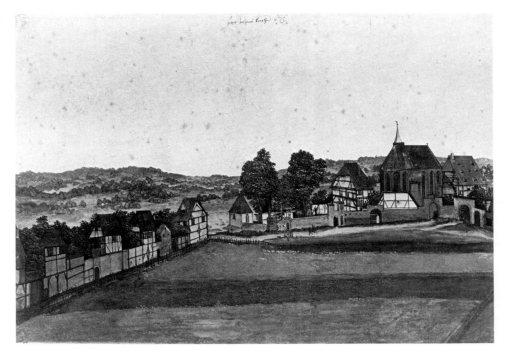

18 months including the trip to Bologna to learn de' Barbari's secret of perspective.

While in Venice Dürer was commissioned to paint an altarpiece for the church of S. Bartolomeo which the Germans had taken over on account of its proximity to their national centre, the Fondaco dei Tedeschi (at that time being rebuilt after its fire and being frescoed by Titian and Giorgione: did Dürer lend a hand?). Unfortunately for us, he left no topographical water colours such as he had drawn wherever he paused on his journey ten years previously but he wrote frequently to a friend at home with news of life in Venice. These letters, together with his diaries, tell us more about Dürer the man than we know about any other artist of the period and have contributed much to his abiding fame.

After his return to Nuremberg he concentrated first on painting, then on engraving and drawing, then on theoretical studies of proportion and perspective, on both of which he published books. He died in 1528 and if there was one quality which drove him on to his massive achievements it was curiosity, a curiosity which was unequalled by any artist other than, perhaps, Leonardo. His topographical water colour drawings were a mere by-product of this ever attractive quality, but a precious one.

94

THE DAWN OF THE SIXTEENTH CENTURY

'The sudden and universal Naturalism, or inclination to copy ordinary natural objects,' wrote Ruskin, 'which manifested itself among the painters of Europe, at the moment when the invention of printing superseded their legendary labours, was no false instinct. It was misunderstood and mis-applied, but it came at the right time. . . . That instinct was urging every painter in Europe at the same moment to his true duty – the faithful repre-sentation of all objects of historical interest . . . representation as might keep faithful record of every monument of past ages which was likely to be swept away in the approaching eras of revolutionary change.' Then Ruskin went on to reflect: 'what amount and kind of general knowledge might by this time have been possessed by the nations of Europe, had their painters . . . painted with absolute faithfulness every edifice, every city . . .' and had all these records been placed in museums.

This book would perhaps have been a more interesting one, and certainly a much longer one, if it had so happened but it did not. The 'legendary labours' of the artists which the invention of printing had taken off their shoulders were, of course, the carrying of the word of God, and it was reasonable to suppose that, with the printed Bible available to an increas-ingly literate population, the artists would have turned to 'copy ordinary natural objects'. At first they did, as we have seen in the case of Carpaccio and others; later they turned to the ideas of the Renaissance, ideas which have no place here. In Ruskin's opinion, they abandoned the 'truth of form', the 'vital truth', and they failed to replace it with the topographical accuracy which he regarded as a valuable, though inferior, form of art.

There is room for more than one opinion as to what did happen and whether it was for the ultimate good of art. There is no doubt, however, that it was in the sixteenth century that the art of landscape as an end in itself was born. Townscape had to wait another century before it was accepted by the bourgeoisie and two centuries before it was to attain full respectability. Perhaps the reason was that artists who were really interested in buildings did not want to paint those which had been designed by others. They preferred to design their own and put them into their paintings – or, better still, build them; this was still a world in which painters and architects were not separated but were both just 'artists'. At this point of history townscape painting cannot be considered apart from landscape; the two have merged and so they remain for a century or two until they part again and go their separate ways.

Landscape painting, as we have seen, was born with Ambrogio Lorenzetti and the Limbourgs but this was not 'pure' landscape. The idea of landscape

95

as an end in itself had not been born at all in Italy (unless one believes in
those two mysterious panels in Siena which Lorenzetti may have painted –
see p. 18). When Leonardo da Vinci was 21 he had drawn a river landscape
in ink, now in the Uffizi Gallery, and inscribed it 'Day of Holy Mary of
the Snow, August 1473', but he never returned to the idea of just drawing
or painting a landscape for its own sake any more than did Dürer after his
miraculous water-colours of 1494 (E. H. Gombrich has suggested that
Dürer regarded his water-colours as 'studies which he could not sell for
honest money'). Italian patrons wanted Christian subjects, portraiture and

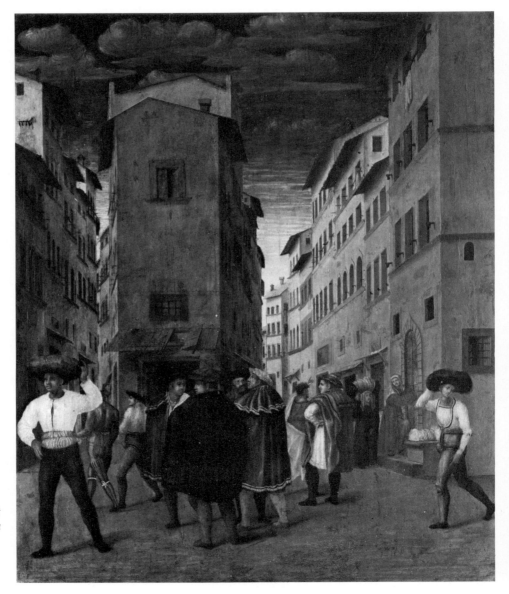

73 *Florence about
1540, Bacchiacca*

mythology and these were what they got. As for townscape, it is only by
good fortune that we occasionally find an incident taking place in a street.
Bacchiacca's *Sheltering the Pilgrims*, for example, shows us travellers with
packs on their heads being directed to their shelter[1] at the crossing of the
Via della Spada and the Via delle Belle Donne in Florence – a rare and
rewarding glimpse of Florentine street life of about 1540.

It was in northern Europe, not Italy, that the painting of 'pure' landscape
began in the sixteenth century and, if we are looking for the most influential
leader of the movement towards it, we must probably turn to Joachim
Patinir. The tiny figures in his intoxicating landscapes may have provided

[1] According to the Rijksmuseum catalogue. But are the pack carriers not more likely to be
inhabitants and the men in cloaks pilgrims?

74 *Landscape, Patinir, with detail
of sea-port, actual size*

plate 74

the titles but it was obviously the country, and the buildings set in the country, that interested Patinir. Hardly anything is known about him except that he was born in about 1480 near Dinant in the Netherlands and died in Antwerp, where he was a member of the Guild of Painters, about 1524, and that Dürer invited him to dinner in August 1520, attended his second wedding, and called him 'the good landscape painter' (using the word landscape for the first time in this context). In the 19 paintings which comprise the whole of Patinir's authenticated work he really tried to put space in his landscapes, and he succeeded to such an extent that he can claim to have been the first painter to grapple with the problems of aerial perspective in a practical way. As we have seen, the Boucicaut Master had practised it tentatively a century earlier (p. 29 and Pls. 21–2) and Leonardo had written in some detail about the changes of colour with distance (p. 59). Patinir's contemporaries, too, were already using a predominantly reddish brown foreground, a green middle distance and a blue distance where they

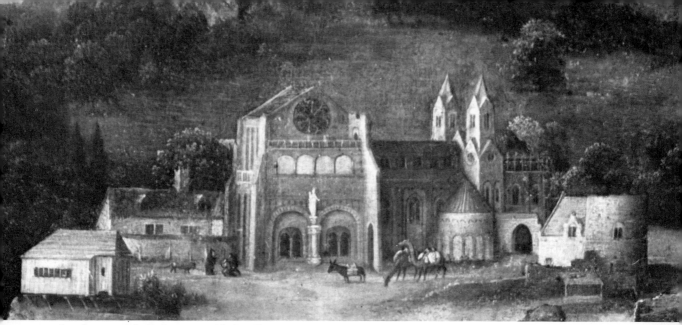

75 *Landscape with St Jerome, with detail*

included landscapes in their paintings. Patinir himself, though, went much further in this direction, largely because he was far more interested in the landscape itself than in his 'subject'.

Just how much the 'subject' meant to him is arguable. R. A. Koch in the definitive monograph on Patinir[1] concludes that he 'never created a landscape without an identifiable religious subject that was planned from the beginning' but one twentieth-century opinion as to a sixteenth-century artist's intentions is worth little more than another. Patinir may well have planned his religious subjects from the beginning but they certainly appear incidental and few of us looking at his paintings can feel that this was anything but intentional. He may or may not have been the first painter of 'pure' landscape but seldom after Patinir's time would an artist leave the landscape background to be filled in by his apprentices, like the drapery, as had quite often been the practice (even Titian, whom Count Algarotti, the great critic of his time, called 'the Homer among landscapists', kept Flemings in his workshop to paint landscape backgrounds). Landscape had become art and gradually the Italians realised that it was quite possible to paint a picture and still do without a 'subject'.

Ruskin's view was that the instinct of the Bellini brothers and Carpaccio to 'copy the ordinary natural objects' they saw round them in Venice was later misunderstood and misapplied, as was that of the other artists of the late fifteenth century whose work we have considered. Kenneth Clark's view is that the 'landscape of fact' disappears, from Italy[2], after the death of these artists. Both, perhaps, are saying that during the century of the High

[1] *Joachim Patinir*, Princeton University Press, 1968, p. 66. [2] *Landscape into Art*, p. 25.

99

Renaissance the Italians were apt, to use Ruskin's phrase, to paint in angels they could not see.

In the north it was a little different. There had been vast political changes. The Habsburgs had begun marrying themselves into an Empire and the grandson of the last Duke of Burgundy, instead of holding court in small

76 *The Marriage at Cana, Gerard David, detail*

Flemish towns, found himself King of Spain and Holy Roman Emperor as Charles v. Flanders had become part of greater Europe and could no longer stand aside from the international rivalries. With all its disadvantages, this also brought prosperity – but to Antwerp, the new centre, not to Bruges which had by now silted up and ceased to be a port of much use to anyone, least of all to the great new ocean-going ships which were following the discoveries of the explorers.

In addition to material prosperity, the new regime also brought closer contact with Italy and the art of the High Renaissance. The Netherlands gave more to Italy, though, than they were able to take from her; the grandeur of high Renaissance painting was far more alien to the Flemish painters than that of the previous century and its meaning was never fully to be grasped. The successors of van Eyck and Memlinc such as Gerard David (1460–1523), the last of the old tradition, painted strictly what they saw, as did their successors Quentin Matsys (1466–1530) and Mabuse (*c.* 1478–1533–6), the first of the new. It was seldom that any of them saw angels.

Gerard David had a feeling for buildings in his backgrounds and there is no shortage of his pictures in which they may be studied. *The Marriage at Cana*, in the Louvre, was probably a late fifteenth, rather than sixteenth, century painting but in style so was most of David's work. The buildings are lovingly painted and it is surprising that they have not been firmly identified. There seems some agreement that they include the chapel of St Sang in the church of St Basil at Bruges, the Place du Bourg and perhaps the town hall at Audenarde. Whatever they may be, there can hardly be any doubt as to their veracity and it was to be a long time before any painter would represent buildings with greater conviction.

Michelangelo contemptuously said of these Flemish artists that they painted 'only to deceive the external eye. . . . Their painting is of stuffs, bricks and mortar . . . bridges and rivers, which they call landscapes . . . done without *reason*, without symmetry and proportion.' Indeed, it had become rather mannerist – but who was Michelangelo to complain of that? It was a century of mannerism, and townscape painting stood still in the background while artists played with architectural backgrounds and 'pure' landscapes and learnt what it was necessary for them to learn if their successors were to become the artists they did become.

No picture can better illustrate the ending of one tradition and the beginning of another than Mabuse's *St Luke Painting the Virgin*, a subject we have already seen in the versions painted by Roger van der Weyden (Pl. 40). Mabuse, who was born a dozen years after Roger's death, went to Italy on a mission to the Pope in 1507, stayed a couple of years, and was so

captivated by what he saw that soon after his return to Antwerp he latinized his name and called himself Malbodius (his real name was Gossaert and Mabuse was the Flemish form of Mauberge, where he was born). Roger's background was a little Flemish market place with shops such as those who saw his picture must have passed every day of their lives. Mabuse's St Luke, on the other hand, had to have an Italian background and a thoroughly pompous and inappropriate one it is. The visitor to the Prague National Gallery finds it in the same room as the altarpiece the Germans commissioned from Dürer while he was in Venice (p. 94), and St Luke seems to have one eye on his sitter and the other on Dürer's picture. One thing he has no temptation to look at is the scene behind him; if he were to do so, he

77 *St Luke Painting the Virgin, Mabuse*

78 *Battle between Carnival and Lent, Breughel*

would hardly have known whether he was in a Gothic or a Renaissance
world or just having a nightmare that he had lost one world and quite
failed to find another.

The exception in the sixteenth century, when few artists seem to have
known quite which direction they were headed in, was Pieter Breughel

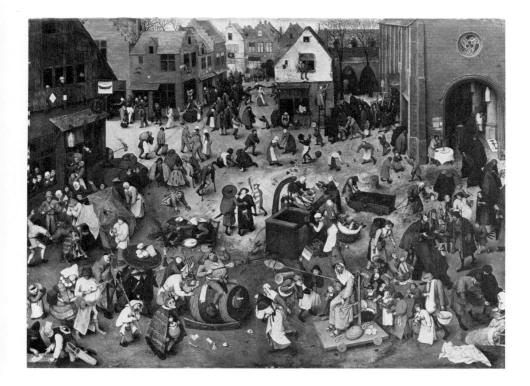

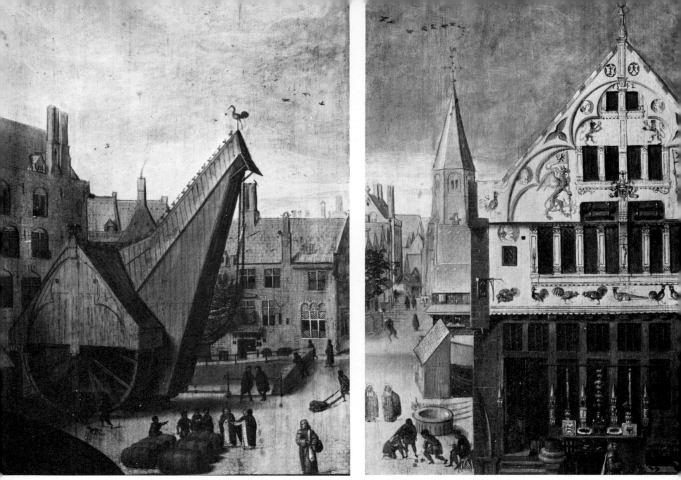

79 *Bruges in 1551, Pourbus*

(1525–1569) who knew exactly. He was the exception Kenneth Clark had in mind when referring to the disappearance of the 'landscape of fact' from Europe. Breughel lived when the Netherlands were throwing off the yoke of Spain and he saw misery and brutality wherever he looked. He also saw simple people in their few moments of happiness, sometimes heightened but more often spoilt by too much drink, and everything he saw he set

plate 78

down on his canvas with all his genius. Indeed it may be doubted whether any artist before him had ever painted the world he saw around him with such veracity and, uncomfortable though his people make us feel, we know that Breughel must be telling us the truth and that that is what they looked like. Similarly, we know that a Flemish village street of the mid-sixteenth century must have looked exactly as Breughel tells us it looked.

A minor contemporary of Breughel's, Pieter Pourbus (1524–84), born in the north but working in Bruges, must have longed to paint the beautiful

104

city of his adoption as a subject but the idea was not yet acceptable. To the best of our knowledge, the nearest he ever came was in the enchanting backgrounds which play a subsidiary, but compelling, part in his portraits of Jean Fernaguut and his wife. On the left is the public weighhouse with the brothers of the Hospital of St Jean supervising the unloading of some wine in the Place de la Grue – the *grue* being the enormous crane which we shall see again. On the right is the other side of the *place*, an identified house in the foreground, and the tower of the church of St Jean in the background with a house on the corner which exists today.

Breughel painted peasants and Pourbus portraits and both lingered on their backgrounds. Patinir would have had none of this: he painted land-scapes and then put the figures in so as to provide a title. Pourbus is almost forgotten and Breughel will always be remembered for his people rather than the world he places them in. It was Patinir with his 'non-subject' picture who was to have the greatest influence of anyone in the sixteenth century on the future direction of landscape painting and so, although he never really practised it himself, perhaps townscape painting as well.

DE' BARBARI'S LATE FOLLOWERS

Although cities were of ever-increasing importance in the sixteenth century, and more families than ever before took to living in them, their pictorial representation was slow to develop[1]. Nothing approaching de Barbari's

[1] There were models, such as those of wood in Munich (Pl. 80) or those of Dubrovnik which its patron, St Blaise, always carries, whether in paint, metal or stone, but they do not seem to have led anywhere.

81 London about 1550, detail

view of Venice of 1500 was produced throughout the following century anywhere in Europe. As for illustrated travel books, Reuwich's drawings for Breydenbach's *Peregrinationes* proved to be far in advance of their time; they went on being copied for many years, just as Koberger had copied some of them for Schedel's Nuremberg Chronicle, and nothing took their place except crude views of towns sold as broadsheets.

The earliest known representation of London can be dated between 1543 and 1550, the end of the reign of Henry VIII or the early years of the short reign of the child Edward VI, one of the most inglorious periods of English history. It is a bird's-eye view by Antony van den Wyngaerde, of whom hardly anything is known except that he probably came from Flanders. When his drawing was made London was the capital of a country plagued by State debt and religious feuds of revolting ferocity; Elizabeth I

106

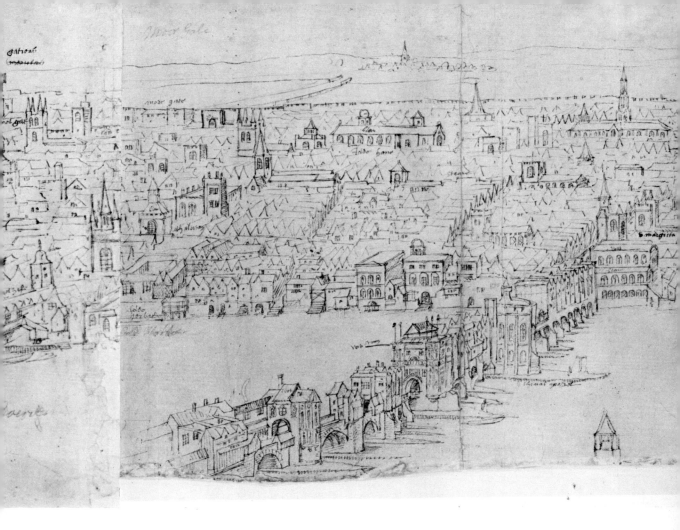

was a child, like her half-brother Edward, and Shakespeare not yet born. The first Renaissance building in London, Inigo Jones's Banqueting House, was not to be built for three-quarters of a century, so it is not surprising that Wyngaerde saw the city as one of gabled houses, all very much the same, an already decaying London Bridge and the medieval St Paul's (which was to lose its steeple within a very few years). His drawing is of the highest topographical interest but it falls a long way short of de' Barbari's example of 50 years earlier.

Fifteen or 20 years later, in 1562, a more ambitious attempt was made to show Bruges in the form of a bird's-eye view. Marcus Gheraerts (there are a dozen ways of spelling his name) was born in Bruges about 1525 so he must have been a comparatively young man when he received this commission. Forty years later he was appointed painter to Queen Elizabeth I

107

82 Bruges in 1562, detail

whom he had shown in a well-known picture of a procession to attend a
marriage ceremony at Blackfriars; there are portraits by him in the National
Portrait Gallery, and by him, or in his style, in many English country
houses. His view is on ten plates and almost as large as de' Barbari's view
of Venice. The principal buildings are drawn with care and accuracy and
there is consistency between the ground plan and the angle from which the
buildings are drawn. You cannot wander through the streets of Bruges,
though, quite as de' Barbari allowed you to wander through the streets of
Venice. The fault cannot lie in the city itself for Bruges is today one of the
few European cities which compares in beauty with Venice and it must
have been even more entrancing in the sixteenth century. However, it was
Gheraerts rather than Wyngaerde who took up the torch lit by de' Barbari
and left where it was for over half a century. All subsequent bird's-eye

108

views stem from these two artists, who themselves had developed the early, crude engravings of Florence into an art.

It was not until 1572 that the challenge made by Breydenbach and Reuwich a century earlier was taken up and a serious attempt made to show what the cities of Europe looked like – not, as in Breydenbach's case, just those passed in a journey to the Holy Land, but all of them.

Braun and Hogenberg's *Civitates Orbis Terrarum* was published in five volumes between 1572 and 1598 with a sixth volume in 1617, each with a different title. With the exception of the first two volumes the 'Cities of the World' were entirely in Europe. They contained over 400 views (600 in later editions), 100 of them being of Germany, which is hardly surprising since Georg Braun, the editor, and Franz Hogenberg, who did the engravings, both lived in Cologne. Braun was a German priest and Hogenberg a Flemish engraver who was banished from Antwerp by the Duke of Alba and took up residence in Cologne. The original drawings for the engravings were mostly by Georg Hoefnagel, a wealthy traveller, also from Antwerp, who later became a partner in the firm.

In addition to Hoefnagel's drawings a number of engravings were taken

83 *Venice in 1570*

Detail from Plate 83

plate 83

from already existing – and already published – sources. There was nothing improper about this; it was the usual practice at the time and Braun and Hogenberg's own engravings were themselves copied by other publishers for more than a century after their publication. The bird's-eye view of Venice, for example, which appeared in the first volume published in 1572, was copied from a view by Zalterius which had been published nine years earlier. Some (but not all) of the shipping was changed to give it some claim to originality and the drawing showing the robes of the Doge and his staff was new. For the rest, Zalterius was followed meticulously, even to the surrounding decoration purporting to be the mainland and the references to buildings and places (about 150 of them) which kept the same numbers. Connoisseurs of Venetian topography may care to compare the Molo section of the view with de' Barbari's (Pl. 66) for changes. The Zecca (Mint) appears in place of the simple Gothic building in the earlier view but there is no sign of the Library which Sansovino started to build about the same time (1536). The upper storey of the Procuratie Vecchie on the north side of the Piazza has been added but the Procuratie Nuove on the south side have not yet been begun. The Granaries beside the Zecca are lower than in the 1500 view but as Canaletto was to show them two centuries later much as de' Barbari did in 1500 we may safely trust de' Barbari rather than Zalterius. Five years later the great fire which destroyed the Piazzetta side of the Doge's Palace occurred and the next edition of

110

the book included a vivid portrayal of the scene by Hoefnagel together with a view of the Piazza (with the Procuratie Nuove now completed); this was the first purely topographical view of Venice to be published showing a part of the city seen from within.

Zalterius's view of Venice was by no means the only one which was copied, and in the case of Zurich there may have been a protest. The earlier editions used a drawing by a well-known Zurich artist named Jos. Murer but by the time the French edition was begun in 1598 the view had been dropped.

In the index each engraving is referred to as either a plan or a perspective view. In the case of the plans, the ground plan is accurate and without distortion but the buildings are generally shown obliquely. Braun explained in his preface that by this method the reader could see not only the buildings as they were but also the streets – and it must be admitted that there is really no other way to achieve such a result. The London view, which opens the whole series of volumes, is a good example. The plan is quite accurate plate 86

84 *Burning of the Doge's Palace, 1577* 85 *The Piazza, Venice*

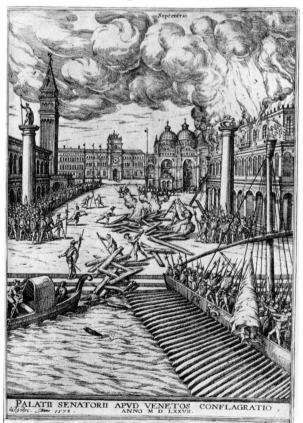

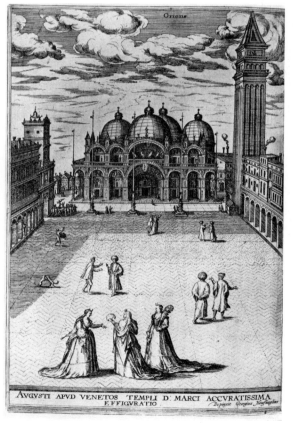

86 *London about 1570*

and all the streets are proportionately the right length (in the centre, at any rate: towards the edges there is some distortion to give a 'bird's-eye' effect). The observer is assumed to be directly overhead and the engraving could be used as a map by a stranger to the city. On the other hand, the façades and roofs of the buildings are also shown so that one sees such features as the steeple of old St Paul's (which, incidentally, had fallen in 1561, 11 years before the engraving was published). Braun and Hogenberg may have copied their view of London from an existing one but there is no evidence whatever that they did so and, apart from Wyngaerde's sketchy view, theirs is the earliest-known map of London to exist. From this, the magnitude of their achievement may be judged and their occasional copying of existing views condoned.

Turning from the maps to the 'prospects' we find a vast number of topographical works of art of varying quality, perhaps, but many of them of a high order; for later editions artists of the fame of Matthew Merian were called in. By this time the plates were becoming worn, having passed

112

from one hand to another, and Merian's engraving of Basle stands out, not only by reason of its quality as a drawing, but even more so on account of the excellence of the impression as opposed to the thinness of most of the others. (Merian was a seventeenth-century figure but we may anticipate a little by mentioning that he became the most considerable of all the topographical engravers of his day, producing one of the best early views of London.)

Braun and Hogenberg's 'own' artist, Georg Hoefnagel, did not always lag behind these imported talents. His view of Toledo is dated 1566, although the fifth volume in which it was published did not appear until 1598, two plate 88 years before his death. It is of particular interest, apart from its high quality as a drawing, for comparison with El Greco's famous painting of the city

87 Basle

which we shall soon come to. Some of his other drawings are also of a high standard but in most he is more concerned with portraying the city in a recognisable form than in running the risk of exceeding his own artistic limitations.

Hoefnagel was, after all, an amateur and Braun had no contempt for amateurs. He invited his readers to send him their own drawings of their home town if it had not already been included, and a number of engravings indicate that the invitations may have been accepted.

Civitates Orbis Terrarum was the forerunner of all the books of views. Breydenbach's *Peregrinationes*, with its views of cities so far in advance of its time, was nevertheless primarily a travel book to which illustrations were added, whereas Braun and Hogenberg's was a picture book to which fairly brief descriptions of the cities were added between the plates. More-over it was the first for which copperplate engraving was used, all previous ones having employed woodcuts. Figures in the costume of their country are added to the foreground, often carrying on the pursuits of their part

88 Toledo

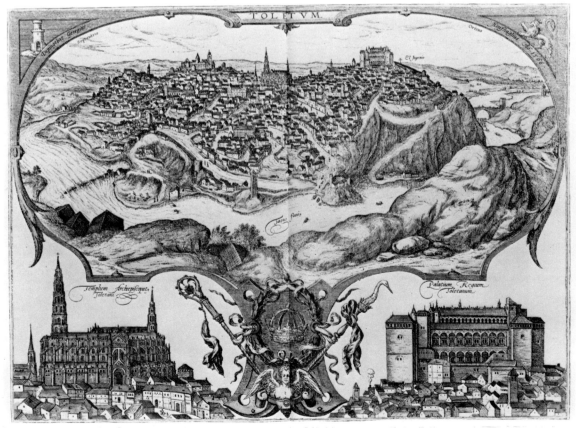

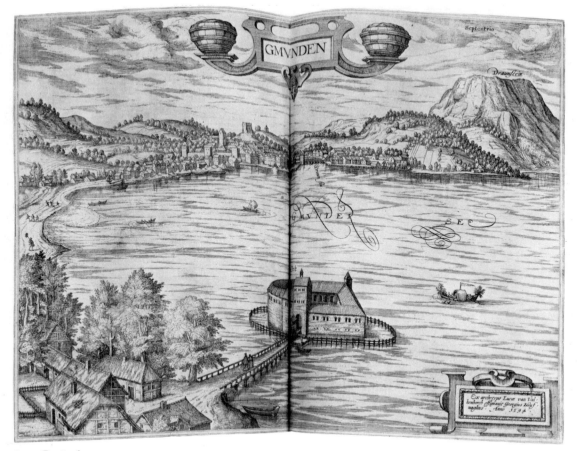

89 *Gmünden*

of the world. Everything was done to convey information and to satisfy the ever-growing interest in the world outside the readers' own territory. To add to the attractiveness of the volumes the earlier editions were hand-coloured, on the whole skilfully, and to add variety a quite unimportant lakeside town such as Gmünden would be included for the sake of the artistic quality of Lucas van Valckenborch's drawing. The number of illustrations assigned to various countries may seem whimsical – 250 to Germany and the Netherlands, 60 to Great Britain and France. These were doubtless dictated by practical considerations as well as the requirements of the public. It must have been difficult enough to find even the twenty views of Africa, India and Mexico. South–east Europe, too, must have presented problems with the ever-growing inroads of the Turks, and Braun often referred in

115

his descriptions to this tragedy which was preoccupying the minds of all Europeans.

Robert Burton paid his tribute in 1621 in *The Anatomy of Melancholy*: 'A good prospect alone will ease melancholy. . . . What greater pleasure can there now be than . . . to peruse those books of cities, put out by Braunus and Hogenbergius?'

EL GRECO

Seventeenth-century townscape painting began with two remarkable pictures by a Greek living in Spain. El Greco, to give him the name he was always called by, was born about 1540 in Crete, which had developed no new kind of art since the Byzantine. At the age of 25 he went to Venice where he worked with Titian and Tintoretto for about four years. He spent the last 40 years of his life in Toledo in Spain. Some individuality in his work is therefore to be expected but that it should be seen with such different eyes by different observers is surprising. To some, El Greco's disregard of natural form and colours makes him the forerunner of the Impressionists and subsequent schools. Others see such a resemblance between his work and some of Tintoretto's that they regard El Greco as little more than a follower. Yet others (and we exclude those who think, and try to prove, that there was just something the matter with his eyes) find his origins in the Byzantine frescoes of Mistra and Mount Athos in Greece; El Greco, they argue, was neither 'modern' nor Venetian; both by name and by the nature of his work he was wholly Greek.

Of the two paintings of his adopted city Toledo, which bring El Greco to these pages, the most famous (now in New York) certainly seems astonishingly predictive of Cézanne and others who were born three centuries after El Greco. It is not topographically accurate; the positions of the cathedral and the castle are reversed and there are other 'rearrangements'. But as a picture it is unforgettable and few who have seen it can see the word 'Toledo' in print without their minds darting back to El Greco's capture of the city the moment before the breaking of the storm which must surely destroy it.

El Greco's other portrayal of Toledo (now in the Toledo Museum) is one of the most extraordinary pictures ever painted. It is a far more detailed plate 91 and factual representation of the city than the one in New York, but an allegorical figure of the River Tagus has been added to the left and in the

116

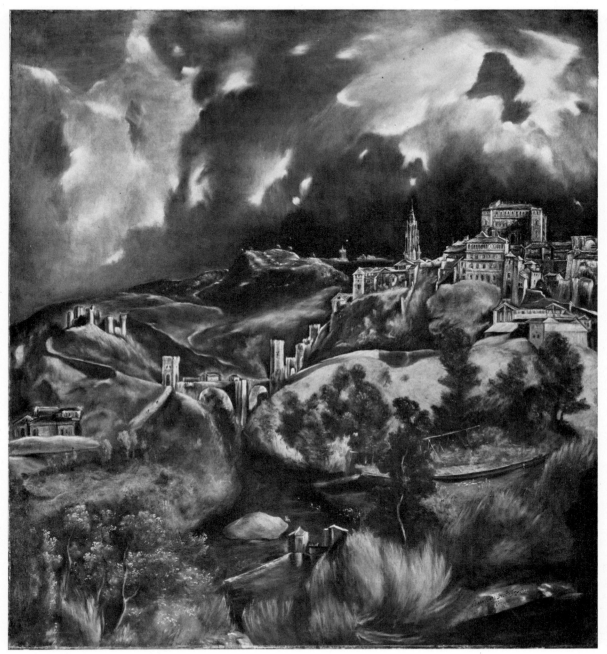

90 Toledo about 1605, El Greco, 4 ft high

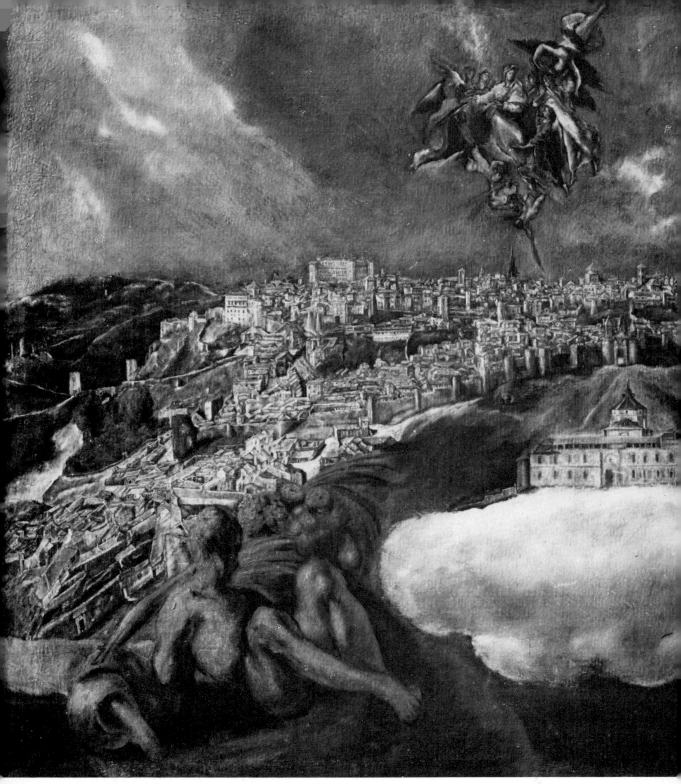

91 *View and plan of Toledo, 4 ft 5 ins high*

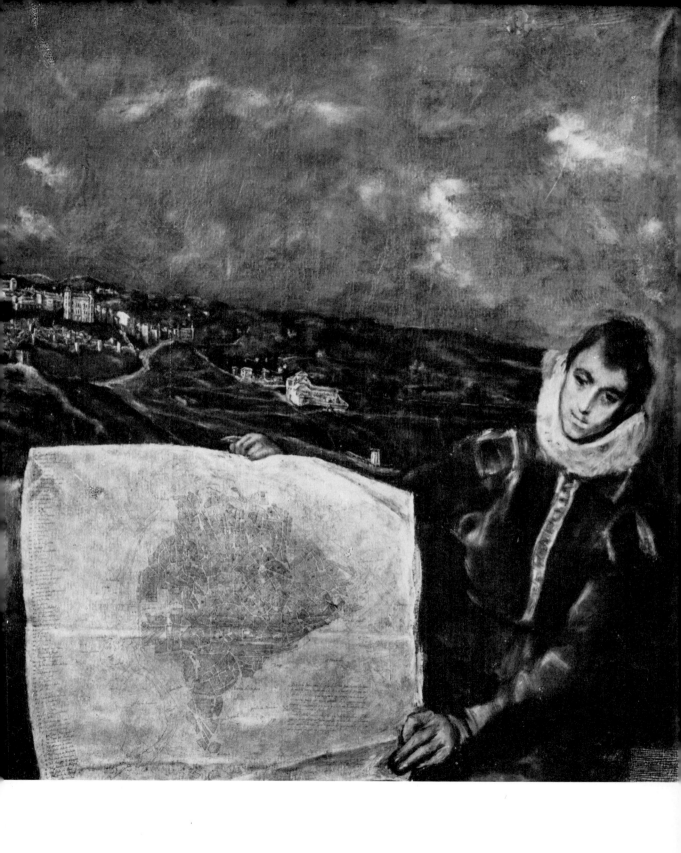

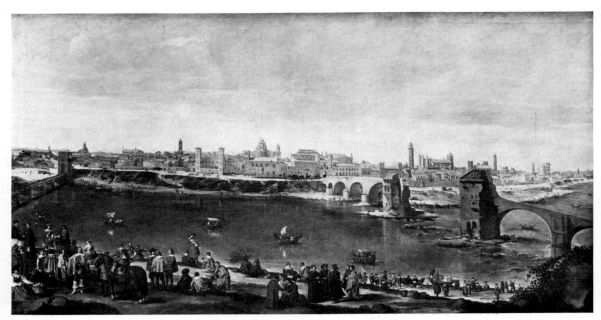

92 *Saragossa in 1647, 6 ft 10 ins high*

sky there is a group showing the Virgin delivering a gift to the city's patron saint. One building has been detached from the city and placed on a cloud in the foreground and on the right a boy (possibly El Greco's son) holds out a map on which is also written an explanation of why this was done.

'It has been necessary', El Greco points out, 'to put the hospital of Don Juan Tavera in the form of a model (that on the cloud), because it not only happened to conceal the Visagra gate, but thrust up its dome in such a manner that it overtopped the town; once put thus as a model, and removed from its place, I thought it would show the façade before any part of it; how the rest of it is related to the town will be seen on the map.' Here is a picture after Ruskin's own heart, an artist carrying out 'his true duty – the faithful representation of all objects of historical interest', and, when he failed in his duty, explaining why.

Everything about El Greco sets him apart from others; his life, his work and his subsequent fluctuating reputation. In the *View and Plan* of Toledo there is a hint of why he was incapable of doing anything in a commonplace way.

The paintings had a sequel. After El Greco's death Velasquez, who had been born in the last year of the sixteenth century and was at this time in

120

his 30s, visited Toledo and studied the huge collection of El Greco's paintings which were then there (as many still are). The effect they had on his later work has been much argued; we are here concerned with only one possibility. In 1646 Philip IV of Spain ordered Velasquez's son-in-law, Juan Bautista del Mazo, to paint a *View of Saragossa* in which Velasquez is said to have collaborated. Some say the figures in the foreground were his work; others, more surprisingly, that he painted the town itself, leaving the figures to his son-in-law; many, it must be recorded, think he had nothing to do with the picture. Whatever the truth may be, it is certain that a townscape painting was in 1646 an extreme rarity – it would have been hard to find half a dozen in all Europe; it is also certain that Velasquez had seen El Greco's two paintings of Toledo and had admired and bought examples of his work. It may be that those who attribute the *View of Saragossa*, in part or whole, to Velasquez have something more than stylistic arguments to support their view.

THE DISTANT VIEW

El Greco's *View of Toledo* was not only an artistic masterpiece: it was the first 'pure' townscape painting. There had been many drawings with the town as their sole subject but as yet no painting. There is not a human figure to be seen in the *View of Toledo*; of how many earlier paintings of any kind could this be said?

The search for the first 'pure' landscape painting is an intriguing, although perhaps profitless, exercise. One is always expecting to find a painting in which Patinir became so concerned with his country and buildings that he forgot about the figures, but one never does. As we have seen (p. 99) he is said to have had his religious subject in mind from the beginning, however incidental it appears to many of us today. Altdorfer, a Bavarian and member of the so-called Danube School, and Herri met de Bles were both born in the same year as Patinir (although Herri is thought to have been Patinir's nephew) and both did much to establish landscape as a subject in its own right; Altdorfer is usually considered the first pure landscapist but this is on the basis of paintings he does not seem to have taken very seriously himself. It is among the works of the next generation of Flemish painters that the true forerunners of the Dutch and late Flemish landscape may be found, those painters born between 1525 and 1550 such as Breughel, Jacob Grimmer, the Valckenborch brothers, Hans Bol, Gillis van Coninxloo and the Brill brothers. Breughel, although he drew landscapes for the engraver, certainly never painted one without human, very human, figures playing

121

a major part in his scene; his youngest son, Jan, would be a member of the group named except that he was not born until 1568, the year before his father died. None of these painters was bold enough to omit the figures altogether in any landscape of importance but they were generally satisfied with 'staffage', which is the word the artist uses to mean the minimum of figures which will still make the picture acceptable to a patron. Often the 'staffage' was left to others to put in, specialists in painting small, busy human beings; gradually it diminished until, by the seventeenth century, its absence ceased to shock. Of all these artists who were so nearly, but not quite, pioneers, we choose a work of Hans Bol to illustrate, not because of his eminence but because, in a humble way, he came near to painting the first townscape.

Hans Bol was born in 1534 at Malines, which became an art centre under the Spanish governors of the Netherlands who made it their headquarters. He achieved quite a reputation as a painter of landscapes, to such an extent that others are said to have copied him, and this, added to a personal blow in the form of a robbery by Spanish soldiers, depressed him so much that he moved to Antwerp. Moreover, he changed his manner of painting altogether and occupied himself with small watercolours in which the workmanship was so minute that he claimed they could not be copied. One of his landscapes to have come down to us is in the County Museum of Los Angeles. This is catalogued as *Landscape near the River Scheldt*, and it bears a date which can be read as either 1572 or 1578. It is more reasonably described by Wolfgang Stechow[1] as a 'town panorama', and the 'staffage', showing Flemish peasants suffering from the cruelties of the Spanish soldiers, is quite incidental.

Professor Stechow selects this painting as one of the forerunners of the Dutch panorama[2], a new kind of composition employing a lower horizon than the distant scenes of such earlier painters as Patinir (Pl. 75), but he points out that the 'modern' panorama really sprang from drawings rather than from paintings. Indeed, the whole idea of a distant scene came from the work of draughtsmen and engravers and was as old as Breydenbach's *Peregrinationes*. Hans Bol's painting was a rarity as a painting but by this time Braun and Hogenberg's massive publication had appeared and under its influence other draughtsmen and printers soon began to publish distant

[1] *Dutch Landscape Painting*, Phaidon, 1966, p. 33.
[2] Strictly speaking a panorama shows the spectator a *whole scene* and the word did not exist until the late eighteenth century when an Irish painter presented a view of Edinburgh encircling a room; the spectator stood in the centre, turning himself round until he had in fact absorbed the whole scene. The word has come to mean a scene taken from sufficiently far away to encompass the whole of a distant subject and it is considered enough for the artist to show all that lies before his eyes without including what is behind him as well.

122

93 A Town near the Scheldt, about 1572, 1 ft 6 ins high

views of towns of variable quality but ever increasing quantity. The names
Johannes Jansson, Frederick de Wit, Francesco Valegio and Eberhard
Kieser are amongst those most commonly found on engravings of the early
1600s, but by far the most influential in the field was Matthew (Matthaeus)
Merian.

Merian was Swiss, having been born in Basle in 1593 (it will be remem-
bered that he contributed a plan of Basle to the later editions of Braun
and Hogenberg). When he was 20 years old he went to Nancy, then to
Paris, Stuttgart and the Netherlands, studying painting and engraving all
the time. At 25 he was in Frankfurt and there he married the eldest daughter
of a publisher and engraver, J. T. de Bry. Five years later, in 1623, de Bry
died and Merian and his wife inherited the business. They were in Basle
at the time, where Merian was not only making bird's-eye drawings of the
city but also oil paintings, and they returned to Frankfurt. Merian then
completed publication of a series of travel books started by his father-in-law,
and followed it up with two other series, both of which were completed
long after Merian's death by his heirs.

123

Soon after his return to Frankfurt, Matthew Merian was joined by Wenceslas Hollar who became his pupil and, although little enough is known on the subject, it may well be that Merian's influence on Hollar did more to direct the future course of topographical art than even his own impressive achievement. By 1642 Hollar had gone his own way and Merian then began his most ambitious series of all, *Topographia*, with illustrations drawn by Martin Zeiller and engraved by Merian and his two sons. This far exceeded even Braun and Hogenberg in conception, containing over 1,200 views in its 26 parts, and it was not completed until 1688 – 38 years after Merian's death in 1650. Even so, it accounted for only half the number of towns of which engraved views were available to appease the constant demand. By this time, from Aachen to Zwolle, they numbered 2,404.

THE LONDON PANORAMAS

Most cities have one or two viewpoints which are favoured by generations of artists and which come to symbolise the city itself. No visitor to Venice can fail to be moved by the constellation of buildings which greets him from the Molo on his arrival by water and the scene has inspired artists for five centuries; much the same has occurred in the case of the view of Notre Dame in Paris from the Pont Neuf (until the nineteenth-century builders fenced it in) or the view of Paris from Montmartre. Curiously enough, the view of London which became the 'standard' for the first century of pictorial representation of the city was one which nobody could ever see: it was from an imaginary point somewhere in the air over Southwark and purported to cover a stretch of the river Thames more than three miles in length.

The first of all London views, that of Wyngaerde in the 1540s, was from Southwark, but from a point below London Bridge and therefore showing the buildings on the east side of the bridge. Some time after this an unknown artist made a woodcut of the scene from a point in Southwark just above London Bridge. A damaged copy of the woodcut was found among Samuel Pepys's papers after his death in 1703 and its great interest is that it shows old St Paul's with its steeple which was destroyed in the fire of 1561. The woodcut was certainly published after that date as it is entitled *The City of London, as it was before the burning of St. Pauls Ste[eple]*; it may have been shortly after or it may have been made from earlier drawings and published towards the end of the sixteenth century. Apart from this, no view[1] of London is known between Wyngaerde's and a series which

[1] Hoefnagel's (Pl. 86) was a map rather than a view as was also a well-known wood engraving by Ralph Aggas of about the same period.

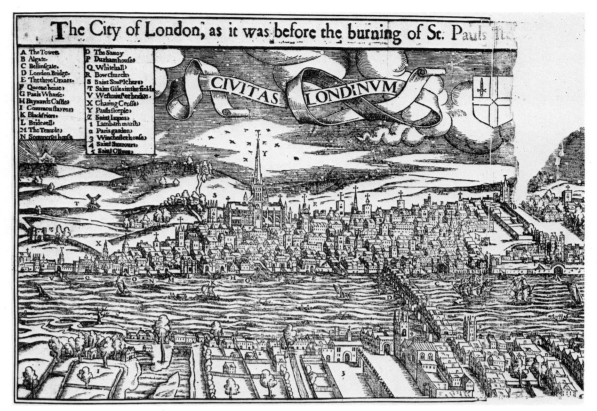

The City of London, as it was before the burning of St. Pauls

A The Tower
B Algate
C Bellinsgate
D London Bridge
E The three Cranes
F Queene house
G Pauls Wharfe
H Baynards Castle
I Common stayres
K Blackfriers
L Bridewell
M The Temple
N Sommerset house

O The Sauoy
P Durham house
Q Whitehall
R Bow church
S Saint Sepulchers
T Saint Giles in the fields
V Westminster bridge
X Charing Crosse
Y Pauls steeple
Z Saint Iames
1 Lambeth marsh
2 Paris garden
3 Winchester house
4 Saint Saueours
5 Saint Olaues

CIVITAS LONDINVM

94 London from Southwark, before 1561

began about 1615; between that date, however, and the Fire of London in 1666 there are 110 different versions of the same view to be found in various collections in England, Holland, Sweden and Denmark. Some may have been engraved from the same plate after reworking but no two are identical. More of them were published in the Netherlands than in England and some were published in places as far apart as Frankfurt, Paris, Venice and Bologna.

The most celebrated and one of the first, if not the first, is signed 'Visscher delineavit' and was published in 1616. It covers much the same area as the Pepys woodcut but in incomparably greater detail, being seven feet long. The artist no doubt ascended the tower of St Mary Overy, now Southwark Cathedral, to make drawings but the church itself is shown in the foreground, together with all the buildings of Bankside including the famous Bear Garden and Shakespeare's Globe Theatre: all this must have been worked out in the studio. The background covers the area from Westminster to a point well east of the Tower of London, and the London

plate 95

125

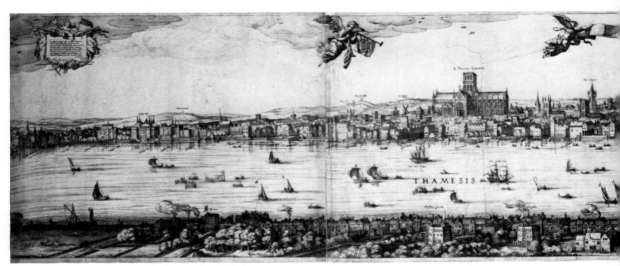

95 *Visscher's View of London, about 1600. Below: the Southwark entrance to London Bridge and the Globe theatre*

topographers, after an exhaustive study of every building shown, conclude that it must be based on the city as it was in 1600 and, except for a number of unimportant details, that its accuracy can be reasonably relied on. Accompanying the etching, which was engraved on four sheets, were eight pages of letterpress copied more or less from Camden's *Britannia* which had been published in 1607.

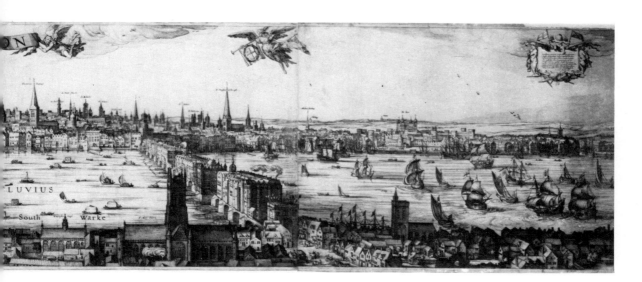

The Visschers were a family of publishers in Amsterdam and Claes
Jansz Visscher was born in 1587. A few years after the first issue in 1616 a
slightly amended version was published by the firm, this time signed
'Visscher excudit', implying that he was the engraver or publisher as
opposed to the draughtsman of the earlier view. Both were freely copied,
as was the custom of the time, the first by Francus Valleggio in Venice
and Claude Chastillon in Paris among others, the second by at least 16
publishers in various countries.

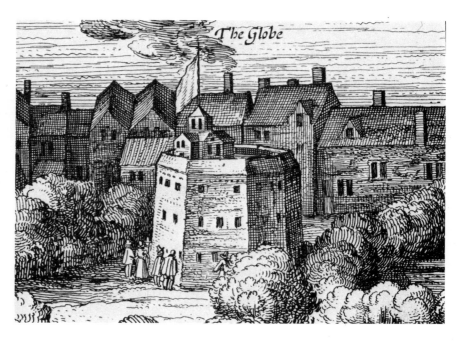

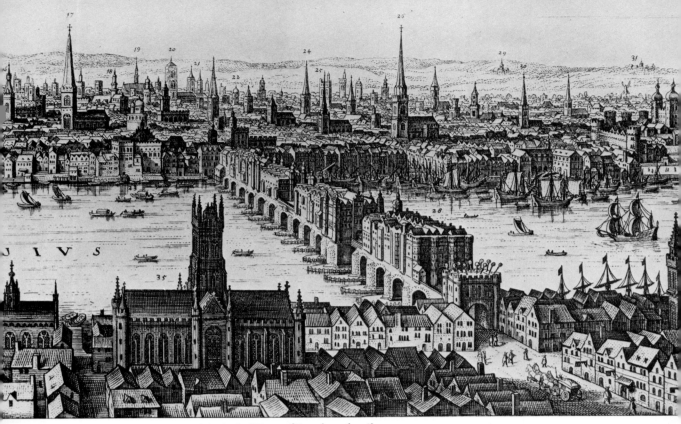

96　*Merian's View of London, detail*

Visscher's most distinguished follower was Matthew Merian who in
1638 included a view of London in his *Neuwe Archontologia* which seems
to be little more than an adaptation of Visscher's work, about half as high
and a third of its length; this was even more favoured by his fellow pub-
lishers, providing the basis for another 35 versions. It was now many years
since the drawings for the first of the London panoramas had been made;
important new buildings had been completed and others had been burnt
down. Merian was content to ignore these changes, so were his many
followers. It was not until 1666, the year of the Fire of London, that the
original view was regarded as too out-of-date for the public and even then
many old plates were used with the burnt area reworked to show the
destruction.

While all these engravings of the view from Southwark were multiplying
there appeared two paintings, their origins wrapped in obscurity. It is even
possible that one of them, or a lost painting of the same scene, provided
the original inspiration for all the engravings. One of the two known

128

paintings is in the Devonshire Collection at Chatsworth Hall and is attributed, on slender grounds, to Thomas Wyck, a Dutch painter who is not known for certain to have visited England until after the Fire. The other is in the library of Tower Hamlets, London, and is attributed, with equally little conviction, to Claude de Jonghe. It is a lively and skilful work but not up to the standard to be expected from the leading primitive of London topographical painting, as de Jonghe undoubtedly was.

He was born about 1600, perhaps in Utrecht, and is best known for his painting of *Old London Bridge*, now at Kenwood. It is signed and dated 1630 and there is a drawing for the painting at the Guildhall, London, also signed, and dated 1627; it is rare to find such useful documentation at this period. Very little is known of the man or of his other work and there is no evidence that he ever lived in England; he may well have visited the country to make sketches which were completed in Holland, then the leading centre of production for views of all European cities. He painted several other versions of the *London Bridge* later in his life and at least one view of Westminster; his masterpiece, however, is certainly the Kenwood painting, a true forerunner of the view paintings which were to come a century and a half later.

plate 98

97 *London about 1630, 1 ft 10 ins high*

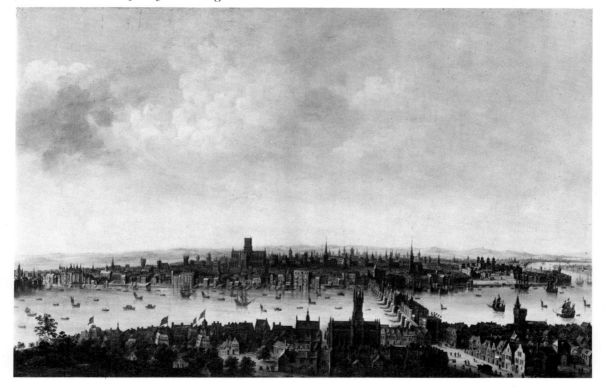

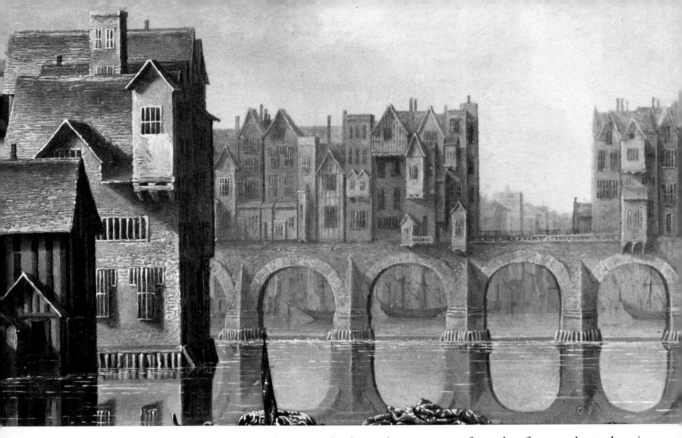

As can be seen, the artist had much to answer for who first took to the air above Southwark in his imagination and gazed down on the theatres of Shakespeare's Bankside and across from Whitehall to the Isle of Dogs. Who he was, even whether he was a painter or an engraver, we do not know. All we do know is that he inspired many others, that the work of each, as was to be expected, was generally an improvement on the last and that the best, that of Wenceslas Hollar, was yet to come.

98 *London Bridge in 1630, Claude de Jonghe, 1 ft 8 ins high*

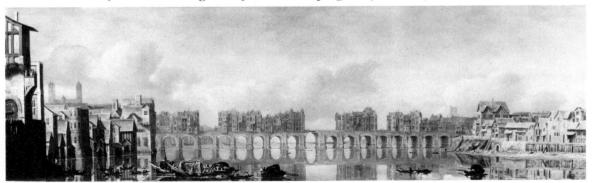

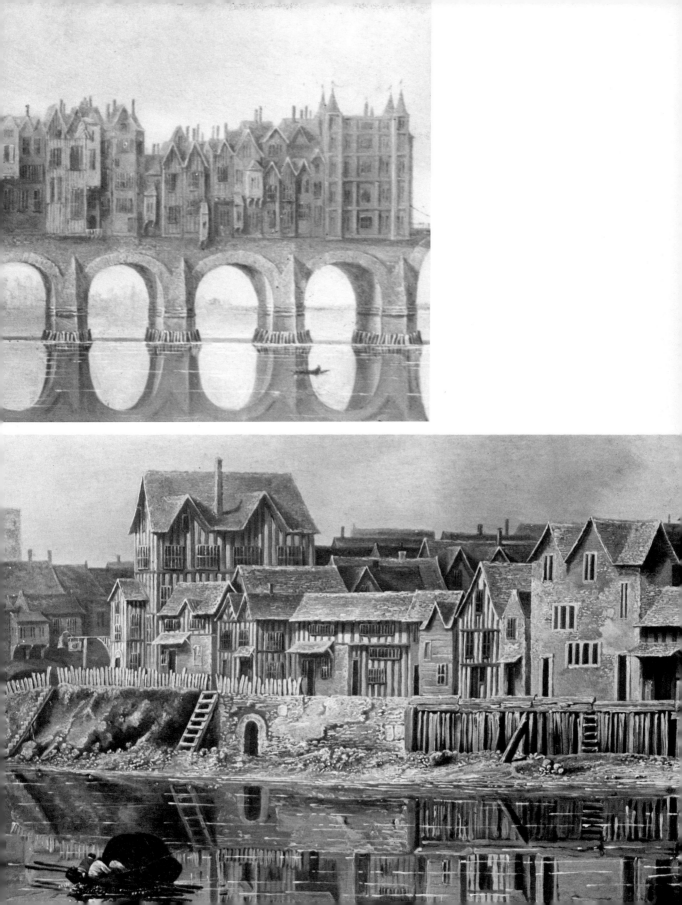

Sala Regalis cum Curia Westmonastery. vulgo. Westminster haall.

99 New Palace Yard, Westminster, Hollar

100 Westminster and Lambeth palaces, from Hollar's View of London

WENCESLAS HOLLAR

Somewhere in the area we are now exploring is to be found the source of what was to become the great river of late eighteenth- and then nineteenth-century English topographical painting and drawing. So far it has been hard to distinguish between the tributaries and the main stream, and many more tributaries were to join it before its waters would be carrying such figures as Girtin and Turner in its flow. One of them, if not the source itself, is to be found in Wenceslas Hollar who was born in Prague in 1607.

Later in life Hollar became a friend of John Aubrey, the great gossip of the seventeenth century, and was included in Aubrey's *Brief Lives*. We therefore know rather more about him than about many of his contemporaries, always assuming Aubrey is to be believed. Hollar loved drawing maps as a boy and when 20 years old he went to Frankfurt where, as we have seen, he learnt etching from Matthew Merian. He then went to Cologne

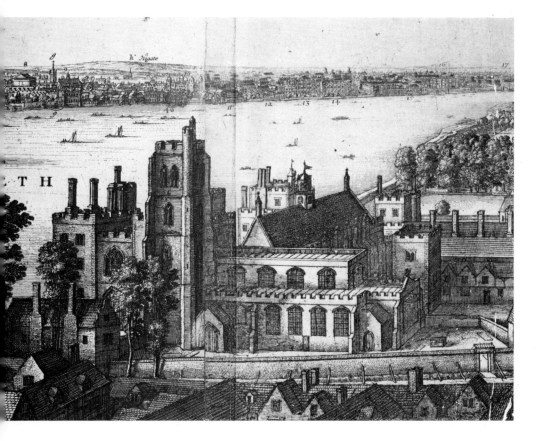

where he worked until 1636 when his great opportunity came. The Earl of Arundel passed through Cologne on his way to an embassy to Ferdinand II in Vienna, saw some small views that Hollar had published, and attached the artist to his suite to commemorate his travels. Hollar seems to have given satisfaction as he returned to England with his patron to draw and etch copies of Lord Arundel's works of art. He was also taken up by the print-sellers and became teacher of drawing in the Royal Household where he taught the young Prince of Wales (later Charles II). All went well with him until the Civil War when Lord Arundel had to escape from England and Hollar was taken prisoner while defending Basing House for the Marquis of Winchester who had enrolled a number of artists under his command (including Inigo Jones). Hollar managed to escape to Antwerp where he remained until 1652 and then returned to England. From then on he found difficulty in getting enough work to live in comfort and he died in 1677 at the age of 70 'having led a painful and laborious life, always attended by difficulties', in Aubrey's words.

As an etcher Hollar was comparable to Rembrandt himself; as a draughtsman he drew such things as shells, butterflies, muffs and a few portraits, all exquisitely. His topographical views, though, were by far the most important part of his output. He drew and engraved maps for Speed's series and many views of London, Westminster and Windsor of which his *View of New Palace Yard* is characteristic. His bird's-eye views included a plan of the west central district of London which is of great topographical value, several prospects of the City before and after the Fire of London and two superb 'long views' or panoramas. The later of these was done from Lambeth either soon after the Fire or just before it; if it was completed before the Fire, parts of the plates were reworked to include new and projected buildings such as St Paul's. The earlier of the 'long views' was Hollar's contribution to the series of 110 panoramas just considered.

Hollar did more than introduce topography as a true art: it was he who introduced the use of wash in pen drawing to England and so in a sense he founded the school of English water-colour drawing with which topography came to be so closely associated. It had a tenuous beginning as Hollar's only immediate successor was his friend, Francis Place (1647–1728), an amateur painter 40 years his junior. Place remained an amateur all his life and claimed that he was nobody's pupil, but he was the only English topographical draughtsman of any consequence between Hollar's death in 1677 and the end of the century and he had a considerable influence on English drawing and painting. It is hard to find any other link between Hollar and Paul Sandby who was not born until the year Francis Place died.

plate 99

plate 100

134

As for painting, there were, by the time Hollar died, a number of Dutch artists in England whom we shall meet after the Dutch school itself has been considered. Until their arrival after the Restoration in 1661 there is evidence certainly of Claude de Jonghe's presence in London and possibly of Thomas Wyck's but of no others. Apart from de Jonghe's occasional picture there are no townscapes in the sense of views of the city from within. There are a few panoramas of cities other than London on the lines of the 'long views' and a few views of noblemen's seats but it was not until the Dutch artists arrived in person that their influence was felt. Meanwhile far more important things were happening in Holland both in the great world of art and in our little furrow of it.

IV THE SEVENTEENTH CENTURY

The Dutch and the Street

THE STREET AS A SUBJECT

We are on the eve of the great period in the development of townscape painting and a pause is necessary to review the situation at this, to us, momentous moment. By the middle of the seventeenth century, as we have seen, the distant view of the city had for some time existed as the sole subject of a drawing or engraving and was occasionally made the subject of a painting. The street or square or group of buildings, the city from the inside as opposed to the outside as it were – this did not exist as a subject for a painting and was rare even in drawing.

It is true that when the Commune of Siena commissioned an Allegory of Good Government or when the Scuola di S. Giovanni Evangelista wanted a series of paintings glorifying the achievements of their Holy Cross Relic in various parts of Venice, both were given street scenes. They had no cause for complaint, though. Their painters gave them the 'subjects' they had been paid to show and the streets were thrown in. Brunelleschi painted a street scene in Florence but it was not at all as a work of art that he proudly displayed it; rather was it intended as a scientific treatise demonstrating his invention of perspective. The street scenes of the Flemish painters occupied a tiny proportion of their panels, merely as backgrounds to their saints and if we remember the scene through the window of van Eyck's Louvre Madonna, rather than the Madonna herself and the Donor (as some of us do), then Chancellor Rolin was not getting his money's worth for it was not a street scene that he commissioned.

An artist must not only paint a picture: he must sell it and there were no buyers of paintings of streets among the princely or religious patrons

136

of the Renaissance. Engraved maps and bird's-eye views, yes. The maps were needed to enable men to find their way through cities and the bird's-eye views were intended to make it easier for them to do so. When an artist such as de' Barbari or Hollar was employed to draw the view it became a work of art but that was not what it was originally commissioned as.

Not unexpectedly, the idea of going into the city and taking a building or group of buildings as a subject was a Dutch idea. In that extraordinary century when there were more gifted artists in Holland than had ever lived in one country since the history of modern art began, there was a constant seeking for new subjects which would satisfy the demands of the new bourgeois patron. In the possession of a painting of a church he could satisfy his desire to be near to both art and God and so churches naturally became the first buildings to be painted.

The Dutch artists who visited Rome had for long been painting and drawing churches, generally in association with ruins rather than as buildings used for everyday worship. Marten Jacobsz van Heemskerck must have been one of the first; he was born as early as 1498 and was in Rome between 1532 and 1536 drawing churches and ruins. At the beginning of the seventeenth century there was a colony of them in Rome including several who were to become highly successful landscape painters such as Cornelis Poelenburgh and Frederic Valckenborch. None of them seemed to have any interest in the city they were living in, only in the Rome of the past, and it is to the artists in Holland itself rather than in Rome that we must turn for the first paintings of contemporary buildings.

Curiously enough it was the inside of the church that attracted them rather than the outside and the church interior picture had achieved enormous popularity before the first exterior came to be painted. If we trace back to find the precursor of them all, we come to Hans Vredeman de Vries.

Vredeman was born in 1527 in the extreme north of the Dutch Netherlands. He was trained as a painter and later became absorbed by the architecture of the Italian Renaissance, which was only at this time beginning to reach the Netherlands. The mid-sixteenth century was a turbulent time for Holland, struggling to free herself from the Spaniards and the Duke of Alba, and de Vries's life was unsettled; he is found at various times in Antwerp, Danzig, back in Antwerp, Prague and finally in his native country again where he died about 1604. He designed triumphal arches and painted perspective scenes in grand houses and is described as a fortress engineer. However, no known building of his has survived and it is as an engraver that he takes his place in history.

He produced a vast number of engravings of many different kinds,

137

almost all with an educational purpose. There were pattern books and architectural books and books on landscape gardening but the most successful was the last, his book on Perspective ('the most famous art of eyesight' as he called it in the sub-title), which was published just before or just after he died at the age of 77. By this time the principles of perspective were well understood in Italy and also, largely through the influence of Dürer, in Germany but elsewhere they were still new. Vredeman's drawings did more than many words could do to explain them lucidly to those who might 'wish to apply themselves to this art with greater pleasure and less pain', as he put it in his preface. Moreover they were the work of an artist as well as a teacher, as the attractive townscape taken from his book shows. Vredeman's ideal city is very different from those from Urbino (Pls. 48 and 49) (which he is unlikely to have seen) but it could hardly fail to stimulate other artists in the north to the idea of using city streets and buildings as a subject for their pictures.

Vredeman's pupil was Hendrick van Steenwyck who was 23 years younger and who died about the same time as his master. He applied the principles he had learnt from Vredeman to the painting of church interiors rather than outdoor scenes. There was nothing new in a church interior as an important part of a painting but to use one as a subject in itself was an innovation. It must have been successful as van Steenwyck taught his new profession to his younger son, also called Hendrick (1580–1650), and to Peter Neefs (1579–1656), who was born in Antwerp and spent much of his life there. Although none of this trio ever became an artist of the first

101 *Imaginary city, Vredeman de Vries*

102 Cathedral Interior, 1587, van Steenwyck

rank, it is to them that must belong the distinction of being the founders
of this most popular school of painting.

The true masters of the church interior school were all born within 20
years of each other, the first being Pieter Jansz Saenredam (1597–1665) to
whom we shall return later. Gerrit Houckgeest was born in 1600, Hendrick
Cornelisz van Vliet in 1611 and Emanuel de Witte in 1617 and, as there
are few church interiors dated before the middle of the century, all of them
were in early or late middle age by the time the art was really in its stride.
De Witte, indeed, was a painter of mythological scenes and portraits until
1652 when he saw the work of Houckgeest and van Vliet in Delft and
immediately gave up all other subjects to become the greatest church
interior painter of them all (with the exception of Saenredam). Sadly
enough it brought him no relief from his miserable life of bereavement,
quarrels and law-suits, and he finally committed suicide in Amsterdam.

139

Sixteen fifty-two was the very middle of the golden age of Dutch painting and Delft at this time was even more full of painters than other Dutch towns. Among them was Carel Fabritius who was then nearly 40 and had been Rembrandt's pupil in Amsterdam; two years later he was to be killed when the powder magazine blew up and destroyed half the town. He is

103 *View of Delft, Fabritius, slightly enlarged*

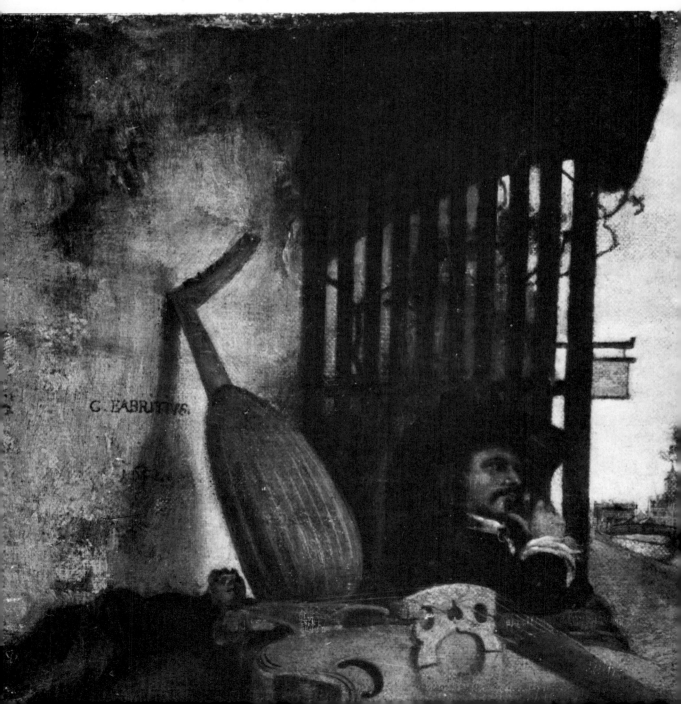

known by half a dozen pictures, most of them tiny and most of them masterpieces which rank him with Rembrandt, his master, and Jan Vermeer who was his pupil. The tiniest, perhaps the most masterly and certainly the most interesting, is the *View in Delft with a Musical Instrument Seller's Stall*, in the National Gallery, London.

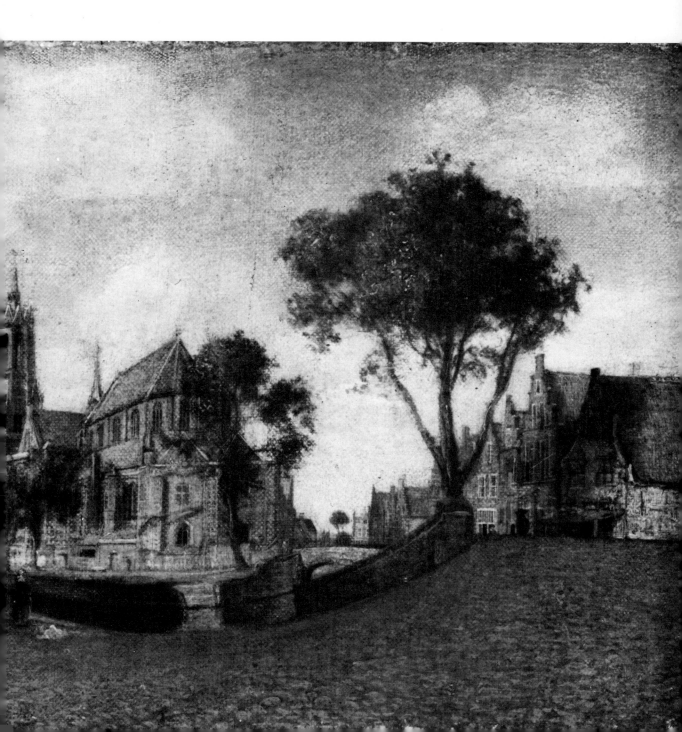

Rather more than half the picture consists of a view at the back of the Nieuwe Kerk with the canal which then ran beside it and the street called Vrouwenrecht with its canal one side and houses the other, all exactly as they stand today (including one house unchanged). The left side of the picture shows the instrument dealer in his stall or tent with two of his instruments, one of which lies so close to the painter that only its upper half is seen and that in steep foreshortening.

Fabritius certainly knew a great deal about perspective and was experimenting with some of its problems in his picture. The church tilts back slightly, although not as much as in a photograph taken from the same spot; the bridge of the violin in the foreground is bigger than the bridges over the canals leading to the church and the road rises sharply as it turns to cross the canal. Yet all this is precisely as it should be and as it would be in a photograph, and it is strange that the picture should have been surrounded by such mystery. It is suggested that it must have been part of a peepshow such as the endlessly captivating one by Samuel van Hoogstraten also in the National Gallery (and Fabritius was a friend of Hoogstraten and fellow pupil under Rembrandt with him), or that it was painted for a curved panel in a cabinet, or that its curved street is a reversion to Fouquet's type of perspective (see p. 61 and Pl. 26). None of this seems at all necessary. If the picture were to be curved its angles would be wrong whereas they are in fact perfectly right; Fouquet was probably painting a straight street as he thought the human eye saw it, whereas Fabritius was painting a street we know to be curved. The presence of the instrument seller and his stock deprives the picture of the claim to be the first Dutch townscape painting; on the other hand, the background occupies more than half the subject and nothing like it had been done before.

104 *Amsterdam Town Hall in 1657, Saenredam, 2 ft 1 in high*

THE FIRST DUTCH TOWNSCAPE PAINTING

In 1651 the old town hall of Amsterdam was burnt down and six years later
it seems to have occurred to Pieter Jansz Saenredam that, if he were to make
a painting of the old building from a water-colour drawing he had done
ten years before the fire, there would be a good chance of selling it to the
City Fathers. He proved right and received 400 guilders for the painting
which they still own – but have lent to the Rijksmuseum.

Nobody could paint a bare wall like Saenredam and he had been finding
satisfaction in this most difficult of tasks for a long time. He used to make a
drawing of his subject, then a cartoon which was to be the size of the

105 *St Mary's, Utrecht, Saenredam*

painting and then the painting itself, all meticulously noted with details of the time he took and any deviations from actual fact in the finished picture. His *Interior of the Grote Kerk at Haarlem* in the National Gallery is not dated but the drawings and cartoon for it were done in 1636 so it is clear that Saenredam was painting church interiors many years before the Delft painters made this their speciality. He never made a replica of his paintings (an excessively rare characteristic) and he never painted another true townscape after the *Old Town Hall in Amsterdam*. He painted St Mary's Church in Utrecht from the outside twice and with wonderful delicacy (it was one of the few Romanesque churches in Holland and Saenredam loved medieval architecture) but otherwise he went back to interiors and 'perspectives' until his death in 1665.

Saenredam would be an artist of high importance if he had never painted the Amsterdam Town Hall, for it was certainly he, rather than the van

144

Steenwycks and Peter Neefs, who showed what a serious artist could do with a church interior as his subject. Whether his adding of a civil building with shops and passers-by to the repertoire made a particularly deep impression on his fellow artists we cannot say. Certainly within three or four years they were doing the same thing themselves. Meanwhile a step forward of even greater significance had been taken in Delft.

JAN VERMEER

Few paintings reproduce more effectively than Vermeer's *View of Delft*; no painting so stuns the spectator who sees it for the first time after a hundred admirable reproductions. Stuns? It would be more accurate to say that it

106 *Delft about 1660, Vermeer, 3 ft 2 ins high*

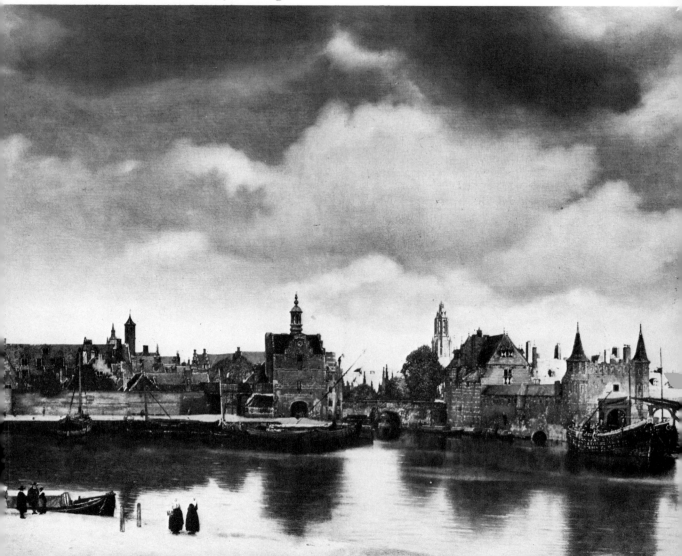

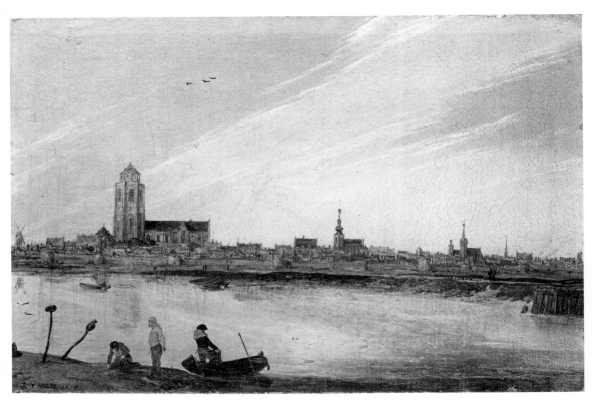

107 Zierikzee in 1618, E. van der Velde

heightens the senses rather than blunts them – but it is a stunning picture all the same.

Its size is the first surprise for it is more than three feet high and most of us think of it as a small picture. And two-thirds of it is cloud – cloud such as had surely never before been painted and never was to be again until Constable's time. Yet there is scarcely another cloud in the 40-odd paintings which were the sum of Vermeer's life work. And the colour – 'when we step forward for a close-up view we can hardly believe our eyes', wrote van Gogh, 'for it is painted in colours quite different from those we saw at a distance.'

In composition the *View of Delft* is the antithesis of the Ideal City pictures from Urbino (Pls. 48 and 49) which draw the eye forcibly into their vanishing point. Here there is no vanishing point and there are no vistas – the only vista there might have been has been closed up by the bridge over the canal leading to it. Saenredam in his *Old Town Hall* (Pl. 104) put his vanishing point on the extreme left of the picture which may account for

146

the reality of the foreground but it left a slight awkwardness in composition. Vermeer just lets the spectator's eye wander at will through the magical town he has turned Delft into.

There is a *View of Zierikzee* by Esaias van der Velde (1590–1630) in Berlin with the same kind of diagonal piece of river bank with figures in the foreground and a horizontally flowing river with buildings reflected in it. Those who cannot believe that Vermeer, the painter of girls reading or writing letters, at the flute or virginals or guitar, could have suddenly created this original masterpiece suggest that he was inspired by Esaias. The reader may not need to compare more than black-and-white photographs of the two paintings to decide for himself. The *View of Delft* seems on the contrary to have come from nowhere and to have led nowhere, for no artist attempted anything like it afterwards.

Not a trace of the scene remains today; at the beginning of this century the people of Delft had the choice of giving up their ramparts or that lovely canal, the Oude Delft, and they chose to let the ramparts go and with them the scene that Vermeer had preserved for immortality. This has led to doubts as to how much of the painting is topographically accurate and how much due to Vermeer's imagination. A water-colour drawing of about a century later than Vermeer's painting, and from the same viewpoint, provides an admirable demonstration of the recording of the same scene on a poet's retina and on that of a competent pedestrian.

108 Delft about 1750, G. Toorenburgh

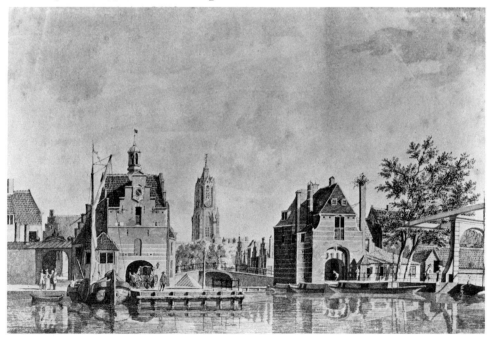

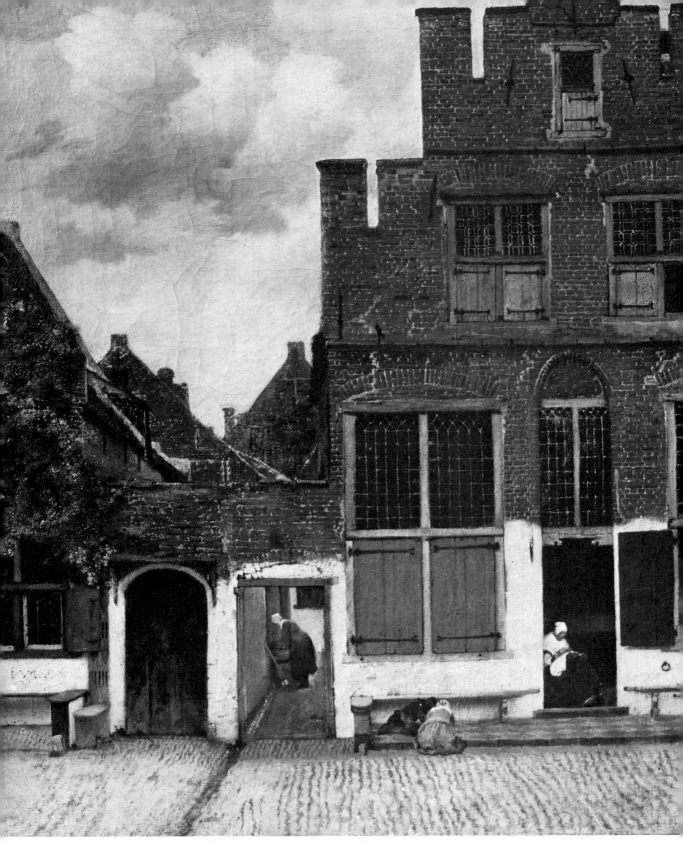

109 The Street in Delft, about half original height

The *View of Delft* was not Vermeer's only townscape. He painted one other, the *Street in Delft*, as different from the *View* as two pictures could be and, unlike the *View*, a picture that inspired many other artists to follow with variations.

The *Street in Delft* may well have been the first *plein air* painting. Vermeer lived at his father's inn on the great market place of Delft and the back windows of the house overlooked a canal lined with small houses and a pavement. The house opposite Vermeer's father's was the municipal home for old people (it is now a bicycle shop) and Vermeer stood, or sat, at his window and painted what he saw outside – an unparallelled thing to do in the seventeenth century. It is one of the great enigmas of art history that an artist could achieve a miraculous performance such as the *View of Delft* and a study of sunlight on brick such as the *Street* and otherwise paint nothing but interiors.

THE FIRST TOWNSCAPE PAINTER

Saenredam painted one townscape and Vermeer two. Jan van der Heyden painted more than 100 identifiable places in Holland, Brussels and Cologne as well as another 100 unidentified but bearing all the marks of veracity. He may therefore justly be called the first townscape painter. He had no known teacher (except a local glass painter in the small town of Gorinchem, where he was born in 1637) and he had no pupils. By 1660, when he started painting townscapes, Saenredam's *Old Town Hall* was in the building which replaced the one it portrayed, and Vermeer's pictures were where three-quarters of his life's minute output was when he died – at home, unsold. They had no relation, anyway, to the type of picture van der Heyden took to painting so if he did see them their influence must have been slight. Van der Heyden was therefore one of the very few artists in history who created a new category of picture. For ten years, from 1660 to 1670, he pursued the path he had uncovered and then left it to be followed by lesser artists[1] and turned his attention to street lighting instead of street painting. In this, and in the improvement of fire-fighting techniques, he was so successful that he died a rich man – another rare achievement for an artist.

Van der Heyden's method of painting was a strange one for a major artist (and he was a major artist, even though he may have been working

[1] The great also painted towns, including, towards the end of his life, one of the greatest of all, Jacob van Ruisdael (1628–1682). They were, however, essentially landscape rather than townscape painters. No-one could call them followers of van der Heyden and they formed no part in the development of townscape painting.

110　*Cologne in early 1660's, van der Heyden, 1 ft 1 in high*

in a minor field; 'first rate in inferior lines' was how Ruskin described him). Every brick of his houses and every leaf of his trees is painted separately; the season, the hour and the weather are all apparent from the picture. And yet he achieved that most elusive quality – atmosphere. An eighteenth-century critic wrote that 'he painted every brick in his buildings . . . so precisely that one could clearly see the mortar in the joints, and yet his work did not lose in charm or appear hard if one viewed the pictures as a whole from a certain distance'[1]. Figure painting did not interest him and he left this to another painter, Adriaen van der Velde. It is a measure of his competence, though, that after Adriaen's death van der Heyden painted his own figures and that they were so indistinguishable from Adriaen's as to cause controversy ever since.

[1] Arnold Houbraken, painter and biographer, writing in 1753.

150

111 Cologne in late 1660's

It was more important to van der Heyden to carry conviction than to be a slave to truth. Moreover, he could be whimsical. For example, he painted a number of versions of his *View of Cologne* and two of them can be seen in London. The National Gallery version shows the Deanery (with the sunlight falling on its façade) as a pinnacled and gabled building which the artist must surely have invented. The Wallace Collection version is duller but much more probable. We ourselves can vouch for the accuracy of another part of his painting, though. We saw that crane on the top of the tower in a picture painted two centuries earlier, Memlinc's *Shrine of St Ursula* (Pl. 41), and it has remained unchanged – as it remained, in fact, until 1868 when it was taken down, having been a Cologne landmark for 400 years.

Two other little paintings in the Wallace Collection show van der

Heyden at his best and most characteristic. One is the *View of the Westerkerk, Amsterdam*, which gives rise to the question: what justification has the catalogue for describing van der Heyden's paintings as 'frequently prepared with the aid of the *camera ottica*' (obscura)? There can be no internal evidence in a painting that such an instrument *has* been used: the Collection's own *Westerkerk* provides plenty of evidence that in this picture, at all events, it could *not* have been used. The buildings on the other side of the canal, the Keizersgracht, facing the Westerkerk make it impossible to get far enough away to see the church as the artist has portrayed it. He must in fact have been so close to the church that none of its vertical lines would have appeared straight in an optical instrument and he was clearly painting it as he knew it would have appeared from a greater distance than he could attain, rather than as it did appear from where he was standing. Having done so, he added the imaginary distance to the foreground by making the narrow canal appear to be a very wide one.

The other painting is called simply *Exterior of a Church* (possibly that of the Carmelites at Cologne) and it is hard to decide in which of the two van der Heyden showed his love of brickwork more keenly. If it were possible to breathe poetry into anything as commonplace and inanimate

112 *Westerkerk, Amsterdam*

as bricks and mortar, it has been achieved in these two little masterpieces and it could well have been some such picture as these that first stirred the Impressionist painters to realise that no subject was too trivial for a great artist.

113 *Church Exterior, detail ⅔ original height*

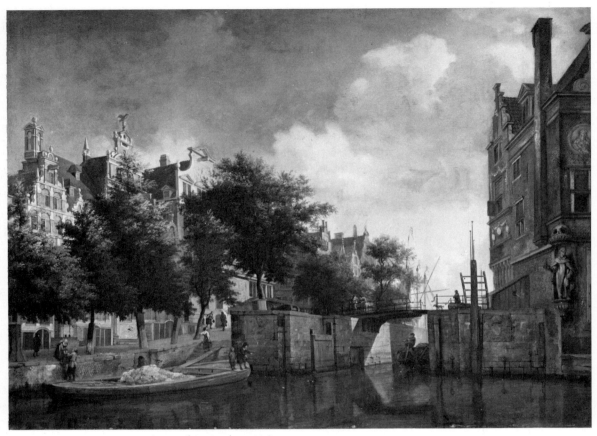

114 Amsterdam in the 1660's

Van der Heyden was a painter of the works of man, and nature was his enemy rather than his friend. One of his most accomplished pictures is the *Martelaarsgracht*, Amsterdam, now in the Rijksmuseum, and one wishes the trees had not been there to screen the buildings when he painted it. There were planty of tree painters in Holland at the time but very few painters of buildings. The trees have gone now and so has the canal, and the Martelaarsgracht is a street in the more conventional sense than it was when the traffic was water rather than asphalt borne. Many, many trees, though, have replaced them in other parts of the city and the wanderer in search of the scenes of the seventeenth-century Dutch townscape painters sometimes finds himself wondering whether trees in cities are not the enemy of architecture as well as of painting.

154

THE TOWNSCAPE SCHOOL

When, around 1670, van der Heyden diverted his attention to street-lighting and fire-fighting, and so to making his fortune, he left something which had not existed ten years previously – a school of townscape painting. The leaders were the Berckheyde brothers, van der Heyden's contemporaries – one of them, indeed, being older than van der Heyden himself.

Job (1630–93) and Gerrit Berckheyde (1638–98) sound an engaging couple who so loved one another (and their unmarried sister who lived with them) that each praised the other's work more than his own. They were born in Haarlem and, except for one long journey up the Rhine, hardly ever left it until they died.

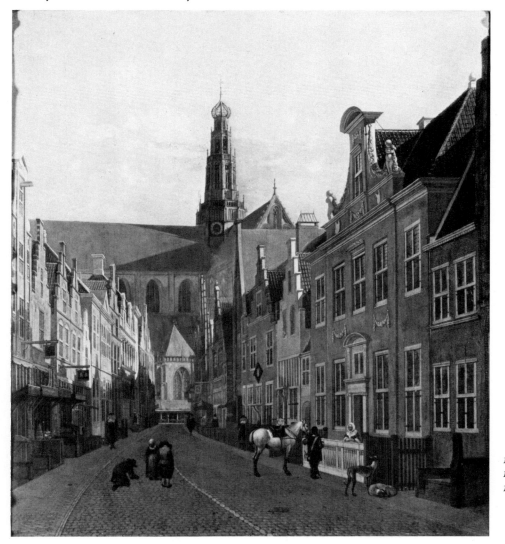

115 *Haarlem about 1680, G. Berckheyde, 1 ft 5 ins high*

plate 115

Although Job was perhaps the better painter, or at any rate the better colourist, it is more often Gerrit's townscapes that we meet. We seem to meet them everywhere as well, of course, as in Holland. London, Paris, Dresden, Leningrad, Florence – all have their Berckheydes, often slightly apologetically referred to in their catalogues, always arousing interest from the spectators. The *Street in Haarlem* for example is just a street in Haarlem – but it seems to echo the value placed on security so newly found in a town which had been through as troubled times as any in Holland. A century earlier, in 1573, the son of the unspeakable Duke of Alba had taken Haarlem after a siege and executed all the clergy and 2,000 of the citizens. Even when prosperity came half a century later it brought ferment, for Haarlem became the centre of the 'tulipomania' which resulted in the price of a single bulb being excitedly bid up to 13,000 florins, only to fall to 50 florins when the Government declared that all tulip bulb contracts were illegal. Speculators and solid bulb growers were thus ruined at one stroke but eventually there came stability – and with it Franz Hals and Jacob van

116 Market-place, Haarlem

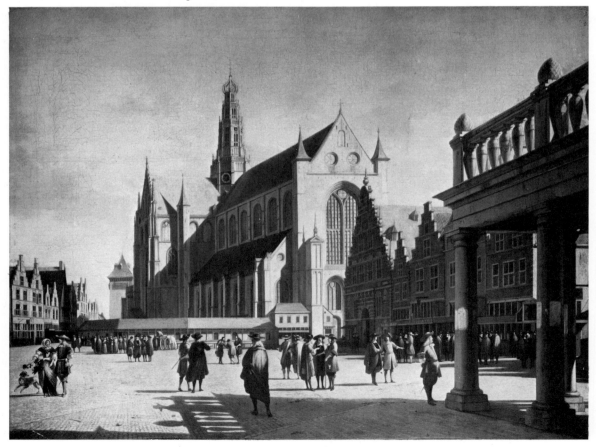

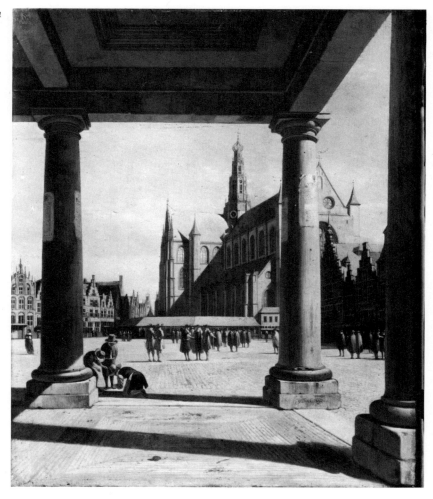

Ruisdael with whose memory Haarlem is associated today as well as with tulips.

Gerrit Berckheyde portrayed the beauty and dignity of his home town without much imagination, perhaps, but he was resourceful and professional as an artist. He painted the Market Place at Haarlem many times and a version in the National Gallery, London, may be compared with one in the Fitzwilliam Museum, Cambridge. In the first he took up his position beside the Doric portico of the town hall, close enough for it to provide a foreground proportionate to the size of St Bavo's which dominates the square. Then, to prevent the sunlit west front of the church being too overwhelming he cut across it with the jagged façade of one of the buildings

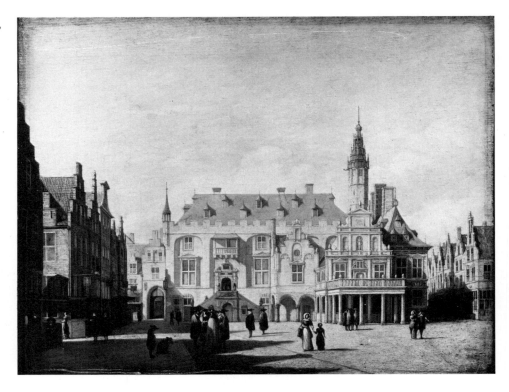

118 *Market-place,*
Haarlem

of the meat market. In the Fitzwilliam picture he experimented with a
different solution to the bulk of St Bavo's. This time he went under the
little colonnade and exaggerated its size so as to make St Bavo's seem far
away and moderate enough in size to give an entirely different impression
of the square. To make the colonnade seem even bigger, he placed three
figures just outside it, making them far smaller than they would in fact have
been in that position. In another National Gallery picture he shows the
Market Place from the St Bavo end so that we see not only the colonnade
but the whole fourteenth-century town hall, originally built as the palace
of the Counts of Holland and rebuilt in Berckheyde's own lifetime.

On another occasion Berckheyde painted the scene from the main
bridge over the Spaarne, as one enters the city. In the left background is
the tower of St Bavo and in the foreground is the quay with a strange but
nevertheless familiar object beside the canal. Like the crane on the tower
of Cologne cathedral we know we have seen it before and then recall
Pourbus's portrait of Jean Fernaguut with its background showing the
unloading of wine by the public weighhouse (Pl. 79). Evidently this
monster was a familiar sight in the Netherlands streets for a long time.

158

Occasionally Berckheyde left his beloved Haarlem and ventured the 12 miles to Amsterdam. Once he stood on the Vyzelstraat Bridge and painted the *Bocht* [bend] *of the Heerengracht*, the street which was pre-eminently the mark of solidity among the great Dutch merchants. It gives us an interesting glimpse of Amsterdam when most of its houses, each an inch or two from its neighbour, were still new and before parked cars screened the lower storeys and the heavy foliage of elm trees those above.

plate 120

Dutch townscape painting as an art never travelled further than its innovator, Jan van der Heyden, had taken it. The Berckheydes were but his followers, and the followers of the Berckheydes, who continued throughout the eighteenth century and even into the nineteenth, were mostly men of slender talent. They kept within such talent as they had been endowed with, gave pleasure to the many who bought their paintings and earned an honest living for themselves. By the end of the seventeenth century both the Berckheydes were dead and Dutch townscape painting as an original art had withered away – as, indeed, had virtually all the Dutch art which had blossomed, flowered and died in that marvellous century.

119 The Spaarne at Haarlem

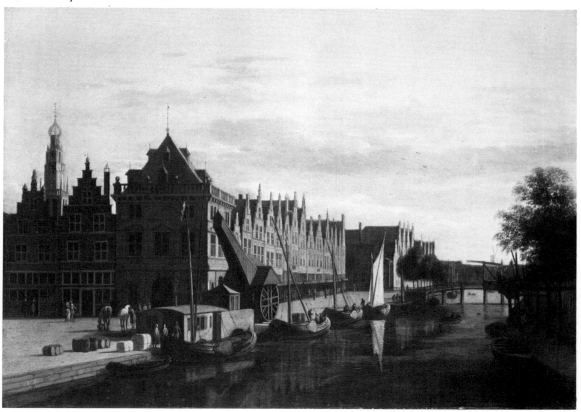

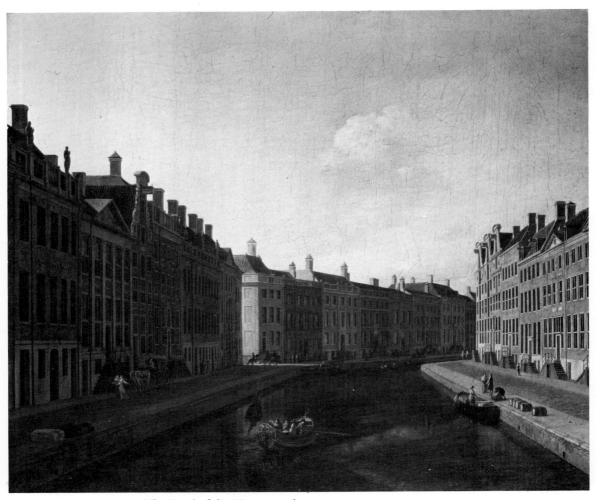

120 *The Bend of the Heerengracht*

One of these minor artists, Gaspar van Wittel (1653–1736), followed the example of so many of his predecessors and, when 19 years old, set off for Rome. Unlike his predecessors he took with him the heritage of the golden age of Dutch painting. By the time van Wittel left Holland, van der Heyden had done all his best work and the Berckheydes were at the height of their more limited but not inconsiderable powers. We shall never know just how great an influence van Wittel had on Italian view painting but he provides the bridge between Holland and Italy and we must certainly accompany him to Rome.

V THE EIGHTEENTH CENTURY
Townscape Respectable

THE BEGINNING OF ITALIAN VIEW PAINTING

We left the view painters of Rome with Frederic Valckenborch, who died in 1623, and with the conclusion that their contribution to the development of our subject was a small one. To begin with, they worked with pencil, pen or engraver's tools rather than with the brush and when they did paint they very rarely chose the city as their subject; moreover they were concerned with the survivals of the past, the famous monuments, rather than with the buildings and life of the Rome they were living in. It is true that the Dutch started with church interiors and seldom portrayed the outside even of a church until the second half of the century. They were, however, experimenting with the portrayal of brick, stone and whitewash throughout this period and the work of Jan van der Heyden seems, with hindsight, an inevitable outcome of what they were doing. Endless drawings and etchings of the Forum, the Pantheon and St Peter's in Rome were unlikely to lead to anything but endlessly more and this is all that they did lead to, with but a handful of exceptions. Typical of their outcome was a series of drawings by a Flemish priest, Lieven Cruyl (*c.* 1640–*c.* 1720), published in three volumes of engravings with 30 years between them, and there were many more.

Joseph Heintz from Augsburg, who inevitably became Giuseppe Heintzius after he settled in Italy, has perhaps more claim to be considered as an important influence than any of the Dutch who settled in Rome or of the native Italian artists. He was born about 1600 and settled, not in Rome, but in Venice where he painted large festival pictures, the organised fights on bridges which the Venetians never failed to enjoy and record, and an

161

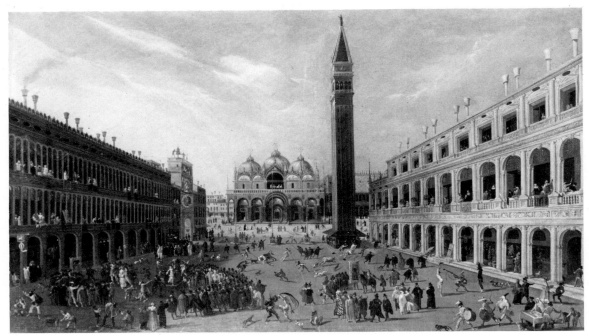

121 *The Piazza, Venice, Joseph Heintz, 3 ft 9 ins high*

122 *Piazza Navona, Rome, Vanvitelli, 1 ft 7 ins*

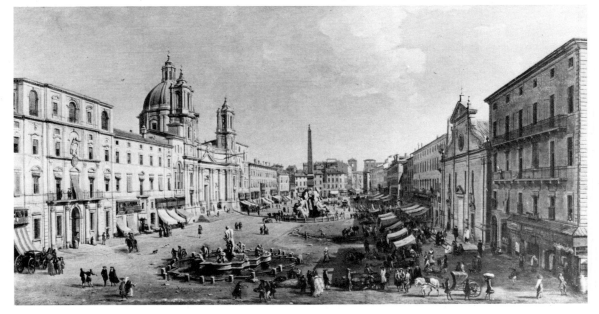

occasional 'pure' topographical exercise. In all these he made the background of the city as important as the scenes he was portraying and, as he was well regarded in Italy as a serious painter of figures, his interest in topography contributed to its acceptability – although not yet its complete respectability. His paintings of Venice are so distorted and so lacking in anything approaching the atmosphere of the city that one shrinks from attaching to his name the credit that may well be due to him as an innovator.

Gaspar van Wittel, who of course had now become Vanvitelli, was quite different. Most of his time was spent in and around Rome and he soon threw off any of the heavy-handedness which might be associated with the Teutonic North (which Heintzius, the German, never managed to do). Vanvitelli's *Piazza Navona* was painted in 1715 but it is really an enlarged version in oil of a tempera he had painted as long before as 1688 – before Canaletto was born. One could be forgiven for dating these pictures half a century later and yet they are typical of Vanvitelli's townscape painting in which the figures are entirely subsidiary to the main subject. They are luminous, sunny and accurate; only in his later work, just as with Canaletto, did they tend to become 'tight' and even scratchy.

His Venice pictures pose an intriguing problem. He painted several versions of two scenes, both from the water, one facing the Piazzetta and plate 123 the other looking up the Grand Canal and taking in the Giudecca Canal as well, with the Salute in the middle. Then there is one painting of S. Giorgio Maggiore and one looking north from the Fondamente Nuove. Except for the last, the sketches for all the paintings could have been made from a boat which hardly had to move its position – or even from the island of S. Giorgio itself. Finally there is a drawing of the Piazzetta from the opposite direction – looking south from the entrance to the Merceria; this must have been the preparatory drawing for a painting which has been lost or was never executed. One of the paintings of the Molo and Piazzetta is dated 1697 but another is dated 1707 *and* bears the word 'Roma'.

There is no evidence apart from the pictures that Vanvitelli was ever in Venice and the range of subjects seems too small for a stay of any duration. On the other hand there is the Fondamente Nuove painting which indicates a fair knowledge of the city's topography (it is a long way from the Piazzetta) and it is hard to believe he relied entirely on the work of others for his pictures of Venice. Perhaps he was one of those who went to Venice, disliked it and came away quickly.

It would be misleading to present Vanvitelli as a painter of streets, in the sense that van der Heyden and Canaletto were, on the strength of his *Piazza Navona* and a few similar pictures. He painted many more picturesque views on the traditional lines of his contemporaries. Nevertheless in

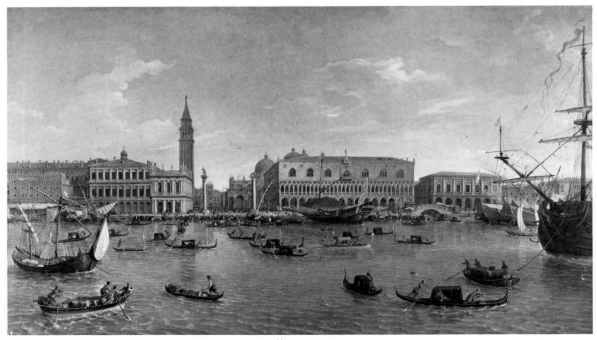

123 *Venice in 1697, Vanvitelli*

style and choice of subject he was closer to Canaletto than any of the other Italian painters and his possible influence cannot be ignored.

There is nothing that we are seeking to be found in other Italian cities. Florence had no ruins such as Rome and the foreign visitors preferred to take back copies of the pictures in its great galleries rather than views of the city. The visitors to Naples wanted views of the bay, or of Vesuvius in eruption, rather than of its streets and buildings. Venice was unique.

The Fall of the Republic, which Ruskin placed as having begun in 1423 with the accession of Doge Francesco Foscari, had by no means been completed; indeed, it must have looked as if it had been deferred indefinitely. 'If you choose Foscari', the dying Doge Tommaso Mocenigo had warned, 'you will always be at war', and so it had proved to be. With the end of material expansion had come the birth of Venetian art but this, too, had lost its impetus since the death of Tintoretto in 1594. In 1669 Venice lost one of her last possessions, Crete, to the Turks, whose empire was as near its end as that of Venice, but no-one would have believed there was anything wrong from the way the Venetians behaved. They were even popular for the first time in their history. 'If you knew how everyone hates you, your hair would stand on end', the Duke of Milan had told the

Venetian agent in 1484, but now Venice had forsaken ambition and chosen the pursuit of pleasure instead.

The whole of Europe seemed to want to take part in this final century of festivity and Venice was wooed by the princes of Europe as she had never been in her days of strength. The crusaders had found the city attractive (many of them, the saying went at the time, never got further east than the Luna hotel). The pilgrims, who succeeded the crusaders, were more fascinated still and many lingered even when their ships were at long last ready. But the eighteenth-century tourists were bewitched by it all. The carnival lasted six months of the year; the cafés and gaming rooms were always open; there was always new music to be heard, new plays to be seen and new girls to love. It was irresistible and no-one who set foot in Venice could fail to want a record of that most marvellous city.

Whether Vanvitelli's influence from Rome was great or small, it was in Venice that townscape painting was, after its flickering and decline in Holland, born as an art in itself and there was no more logical place for it to be born.

CANALETTO'S FORERUNNERS

Every artist we have considered was, in a sense, a forerunner of Canaletto, from Ambrogio Lorenzetti, or even the unknown mosaicist of Antioch, onwards. No-one knows what influence they had on his work any more than Canaletto could have known himself. We do not even know whether he ever saw the work of Vanvitelli, who lived until Canaletto was almost 40. Certainty comes only with Carlevaris with whom there was even said, unreliably, to have been a master-pupil relationship.

Luca Carlevaris (1663–1730) was the father of all Venetian topographical art but it was not in his lifetime that it was accepted as art – not, at any rate, by other artists in Italy. Carlevaris was a gentleman, an unusual status for artists, and a scholar of sorts who was more proud of his scholarship than his art; late in life he had his portrait painted and engraved and for this he chose to carry a pair of dividers rather than a paintbrush in his hand.

He was born in Udine, some 100 miles north of Venice, and settled in Venice at the age of 26. He seems to have painted a number of ruinscapes and imaginary landscapes but at that stage no known views of Venice. Twenty-four years later, in 1703, he published a series of no less than 104 etched views which ranged throughout the city. Nothing like them in their completeness and endeavours at accuracy had appeared before and

they were still being reprinted half a century later. Nevertheless, they are the work of a talented amateur and the endeavours at accuracy did not always succeed. Several of the scenes are drawn from a viewpoint which it would be impossible for the artist to attain and they give the impression of diagrams, rather than pictures. In spite of the variety of skies and figures in the engravings, the seemingly endless drawings of churches and palaces, mostly from a directly frontal viewpoint, have a monotony which it is almost an achievement for an artist to impose on the miraculous variety of the Venetian architecture, and the book seems at times to have been intended as a pattern book. Unfortunately, that is just what it became and many are the dull eighteenth-century engravings of which the forerunner can be found by reference to Carlevaris. Even Canaletto was guilty and one of his more preposterous drawings of the Piazza S. Marco stems directly from the *Fabriche e Vedute di Venetia*, to shorten its long title.

124 *Entry of the Earl of Manchester, Carlevaris, 1707, 4 ft 4 ins high*

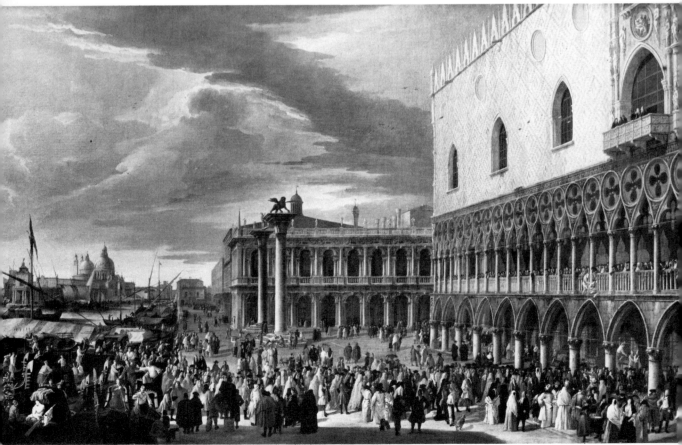

Carlevaris first appears on the scene as a painter with certainty in 1707, although, as he seldom signed or dated a picture, there may be earlier paintings. In that year the Earl of Manchester made his second 'entry' into Venice as ambassador. These 'entries' were a trial to the ambassadors and a heavy expense to the Venetians who had to entertain the ambassadors' entire retinue for three days. For his first embassy Lord Manchester had been willing to take a hint, privately dropped by the Serenissima, that they would appreciate his refusal of his right, provided, as he wrote home, that they formally made the offer and so put themselves under an obligation to him. No such leniency was allowed for the second embassy which was aimed at persuading the Venetians to enter the war against France. Not only was he given full honours but Carlevaris was called in to record the scenes both outside and inside the Doge's Palace (he may have received the commission from Lord Manchester himself, who took the paintings home with him, or they may have been given to the Ambassador by the Serenissima). The Venetians were, indeed, prepared to do anything to please their English visitor – except fight France. Eventually he came to understand how 'dextrous they were at wording a refusal without actually saying "No"' and that 'the chief part they intend to act here is to amuse the rest of Europe and do nothing'. It had taken him a long time to reach this shrewd appraisal but he was right. The Venetians intended to do just that and their view painters became a part of the entertainment.

Once Carlevaris had tried his hand at view painting he followed it up with a number of pictures and was commissioned several times to record festivals and ceremonies. Twenty years after Lord Manchester's embassy, the Ambassador of the Holy Roman Empire arrived and Carlevaris was again called in; he painted almost the same picture with different figures and again the Ambassador took it home with him. Meanwhile he had

plate 125

recorded the *Regatta on the Grand Canal* in honour of the King of Denmark in 1709: Canaletto's eight pictures of the same scene from the same viewpoint, together with Guardi's copy of them, are sufficient tribute to the influence he had on Venetian view painting.

Carlevaris's painting *œuvre* is extraordinary for the restriction of its range of subject. Having walked every *calle* of Venice for *Le Fabriche e Vedute* he seems to have had enough. There was to be no more footslogging and he painted 50 or 60 pictures of the Molo, the Piazzetta and the Piazza, some in several versions, without ever moving more than a few yards from the same viewpoint. Once he went as far as the Salute to paint the bridge of boats put up for the annual festival; twice he went to the Rialto Bridge and once to the far end of the Grand Canal. That was all, though. Otherwise it was the Molo, the Piazzetta and the Piazza again and again and again,

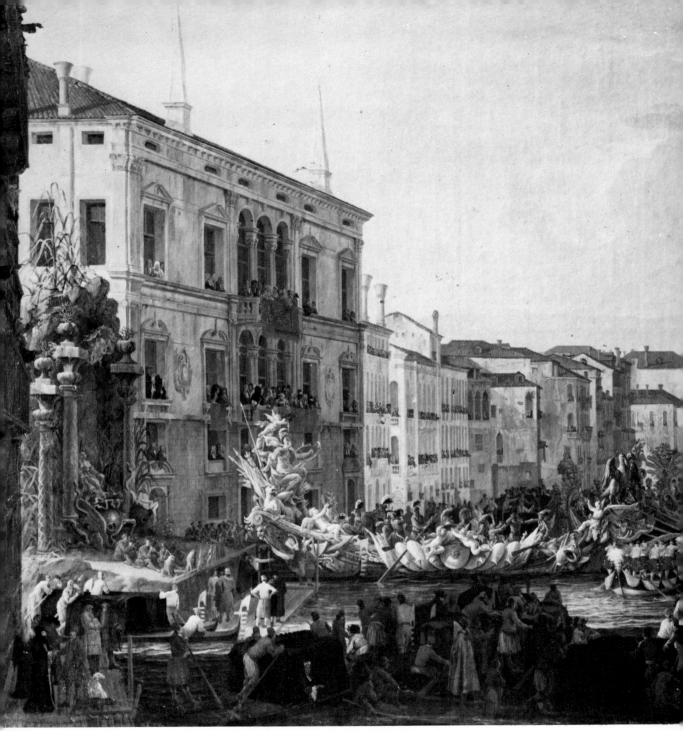

125 *Regatta on the Grand Canal, Carlevaris, 1709*

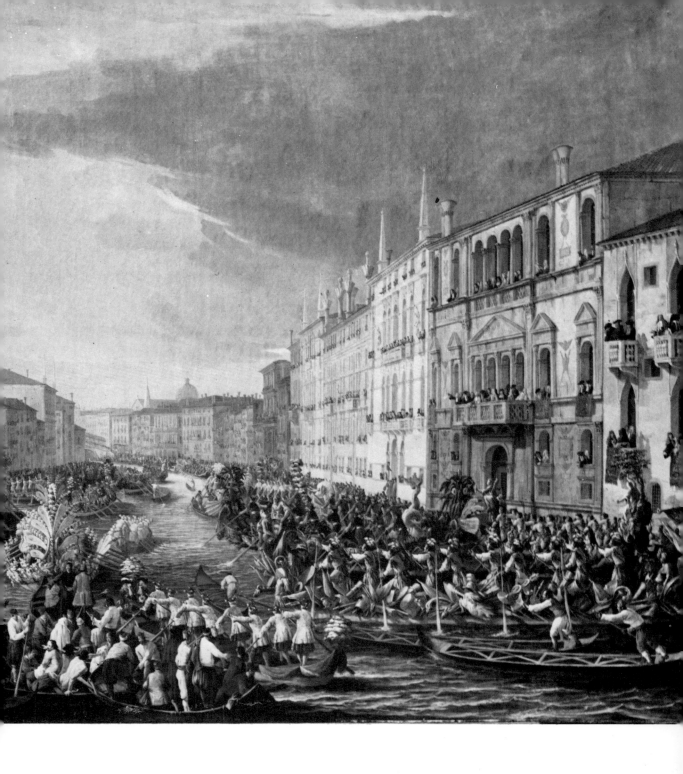

169

always competently, always full of lively people (for whom he made admirable sketches, now at the Victoria and Albert Museum) and always with the same dull, heavy-handed buildings and total absence of true Venetian light.

The influence of Carlevaris was out of all proportion to his talent. Had he not been followed by Canaletto he would no doubt have been as little known now as he was in his lifetime. As it is, the achievements of the Venetian view painters have led to deep research as to their origins and in this he unquestionably plays a large part. He died when Canaletto was 33 and at the height of his powers. A totally uncorroborated story tells that Canaletto's success gave Carlevaris apoplexy. It is most unlikely; Carlevaris painted few pictures in his 77 years and can hardly have lived on their proceeds. What he did live on is unknown as there is no record of his having written a book on mathematics or done anything else likely to produce an income, yet he left his family quite well provided for.

His influence was not confined to Canaletto. Johan Richter (1665–1745) was born in Stockholm, two years after Carlevaris, and took up residence in Venice in 1717. He thus saw Carlevaris as the undisputed leader of Venetian view painting, followed by Canaletto's rise and decline, and he died the year before Canaletto left Venice for England. He was certainly painting views of Venice before Canaletto. So was Hendrick van Lint, or Studio (1684–1763), who was born in Antwerp but spent almost all his life in Rome, painting views of both Rome and Venice (although it is doubtful whether he ever went there). Neither Richter nor van Lint can be regarded as forerunners of Canaletto. Richter was rather a follower of his contemporary Carlevaris and, in any case, there is little evidence to show that he painted many of the pictures now attributed to him. Van Lint's talent was too limited to influence anybody. We have given enough attention to Canaletto's forerunners: it is time to consider the man himself.

GIOVANNI ANTONIO CANAL (KNOWN AS CANALETTO)

The Early Years

Canaletto was a most prolific painter whose work is generally known by a vast number of pictures painted (when they were painted by Canaletto at all) well after 1730. He was then no longer at the height of his powers or, if he was, he preferred to subordinate what he was capable of doing to what his patrons wanted and what it was possible to produce in the time available. When considering his work it may therefore be necessary for some readers to abandon, or at least suspend, the preconceptions which

170

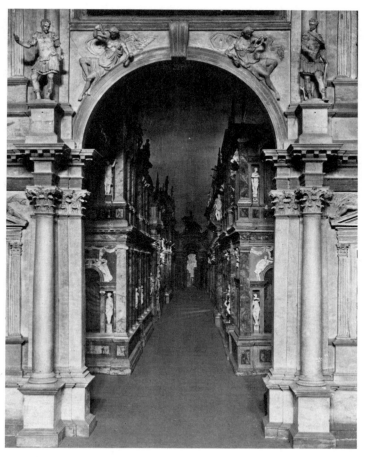

126 *A street in Vicenza, about 1580,*
Teatro Olimpico

are inevitable in the case of an artist whose work has been so over exposed, in original, in reproduction and in copy, and whose masterpieces have to a great extent become so inaccessible.

As is the case with so many artists already considered, very little is known about the man and not very much about his life except the essential facts. His father, Bernardo Canal, was a theatrical scene painter and anyone who has seen Palladio's stage set in the Teatro Olimpico in Vicenza, painted in the century before Canaletto's father was working, will realise that there could be no better training in the art of perspective and will understand why theatrical designers and view painters often borrowed from each other for greater effectiveness. (A more than usually inadequate photograph must suffice for those who have not seen the original. Palladio designed the set and Scamozzi finished it after his death in 1580.) Bernardo Canal and his son visited Rome in 1719 in the course of their profession, the son (little

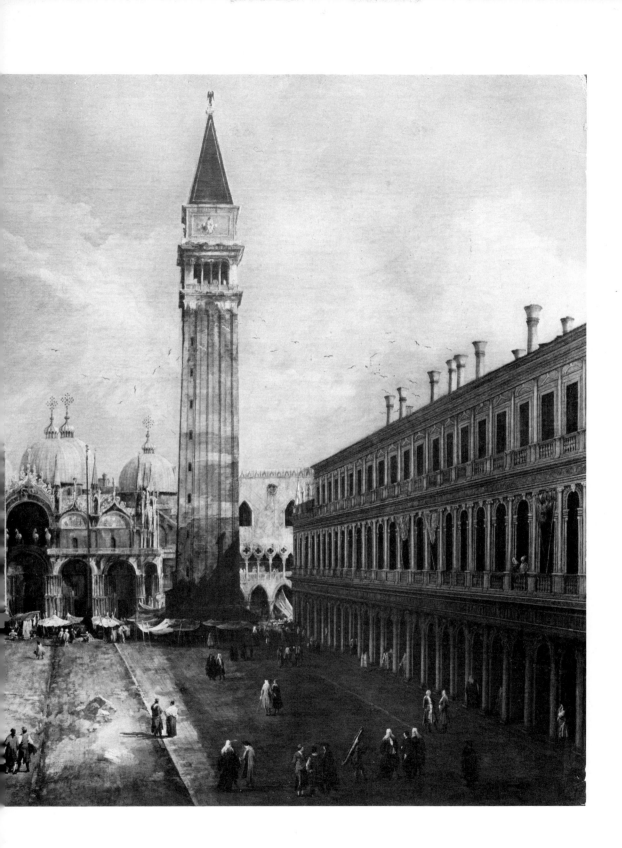

Canal) as assistant, and they did the sets for two of Scarlatti's operas there. What else Canaletto did there is guesswork. Perhaps some drawings, now in the British Museum and Darmstadt; more likely not. Quite possibly some lost sketches which were to provide him with material for work 20 years later. Nor do we know whom they met. The young Pannini, the old Vanvitelli, perhaps; perhaps not.

The following year Canaletto was back in Venice and in 1721 the second major collection of views of Venice (the first being Carlevaris's of 1703) was published, *Il Gran Teatro di Venezia*. The publisher was Domenico Lovisa and some of the engravings are credited to artists such as Vasconi and Valeriani, others presumably having come from drawings by Lovisa himself. There were 62 views of various parts of the city, a folding map and two regatta scenes, all much larger than those of Carlevaris and on a more ambitious scale altogether. The publication of two such albums within 18 years must be some indication of the growing demand for views, a demand which Canaletto must have been increasingly conscious of. Whether Lovisa's engravings themselves had any influence on him is more doubtful. They are of varying quality and, apart from some obvious viewpoints which no artist would avoid drawing from, Canaletto does not seem to have made any use of them in the way he made use of those of Carlevaris. The one exception was Carlevaris's picture of the regatta on the Grand Canal in honour of the King of Denmark in 1709. An engraving by Joseph Baroni of the painting was included as the last view of the *Gran Teatro* and, as it is probable that the original painting was in Denmark by this time (and quite possible that a second version, now in Rome, had also left Venice), it could well be that it was the engraving rather than the original painting that Canaletto found such good use for later on.

Whatever influences might have formed Canaletto's style it was now formed and he was ready to start work. The following year he painted four pictures for the Prince of Liechtenstein which he sometimes equalled but never surpassed. One of them shows the *Piazza S. Marco* as it was plate 127 before being repaved in 1723 and so we have that rarity in Canaletto's work, an approximate date. No-one who has followed the development of townscape painting up to this time can look at the painting without being deeply reflective. If this is what a man in his 20s, who never aspired to become one of the mighty ones of the world of art, could be moved to do with a series of buildings as his subject, how is it that for so long the subject could be ignored?

The Prince of Liechtenstein's collection contained three other pictures of the same size and kind and, although there is no corroboration of the family tradition that they were bought direct from Canaletto, there is no

174

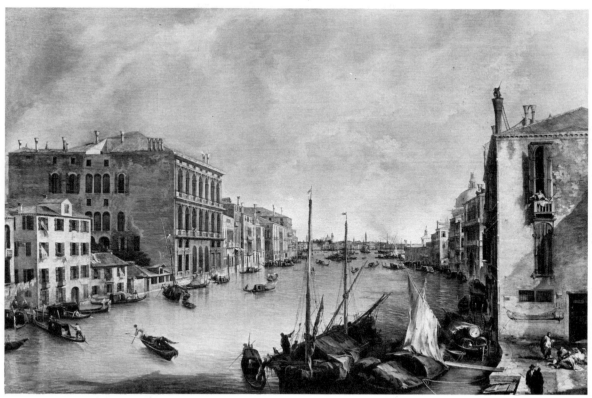

128 Grand Canal from Campo S. Vio

reason to doubt that they were painted about the same time and as part
of the same commission. The Piazza painting and one of the *Grand Canal
from Campo S. Vio* now belong to Baron Thyssen and are kept in Lugano
but are not among the paintings shown to the public. Both are of subjects
Canaletto painted many times and it is instructive to compare this long
series of variations on a theme. The other two now belong to the Mario
Crespi collection in Milan.

About two years after the four Liechtenstein pictures were painted,
Canaletto received another commission and this time there is no need to
consider family tradition or the date when the Piazza was repaved: Canaletto
himself wrote a full description of the four pictures and signed a receipt
for the payment and these documents have never been separated from the
pictures. Two of them were painted in 1725 and two in 1726. The patron
was a merchant and collector in Lucca, near Florence, called Stefano Conti;
they remained in his family for a century, were bought and owned by an
English family for another century until 1928, when they were bought by

175

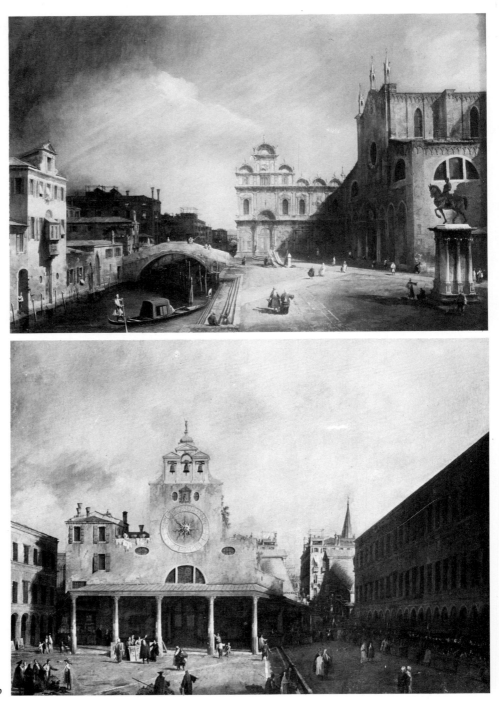

129 *Campo SS. Giovanni e Paolo*

130 *Campo S. Giacomo*

a Canadian and have until very recently remained in a private collection in Montreal. Three are Grand Canal scenes. The fourth is the much photographed scene from the bridge by the Campo SS. Giovanni e Paolo which takes in, as well as the church, the Scuola S. Marco, the Colleoni statue and the little canal running to Venice's northern boundary which Canaletto had painted, in the reverse direction, in one of the Liechtenstein pictures.

These eight masterpieces, none of them in public collections, form a base without which it is impossible for any judgment of Canaletto's stature to be made. Nor can one be made without a visit to Dresden where there are five more paintings bought by the King of Saxony in Canaletto's lifetime, all completed about the same time as the Liechtenstein and Conti pictures. One of them shows the Campo S. Giacomo and the inside of the Rialto Bridge, only repeated once as a subject and then some 20 years later.

With three or four other pictures which were, from their quality and style, almost certainly painted about this time, we have a dozen and a half Canalettos painted before Joseph Smith came into his life. From then on, things were different.

The Transitional Period

Smith was about 20 years older than Canaletto (and out-lived him), a merchant in the sense that he bought and sold things; what he bought and sold is far from clear – probably anything he could find a seller and buyer for. By 1728 all the pictures so far referred to had been finished and Canaletto's reputation was high enough for the agent of the Duke of Richmond to buy two small paintings on copper, send them to the Duke and promise two more. The agent, a bankrupt theatre manager named Owen McSwiney, also left a rare glimpse of the painter's temperament and standing at this time. 'The fellow is whimsical and varys his prices every day', he wrote, 'and he that has a mind to have any of his work must not seem to be too fond of it, for he'll be worse treated for it, both in the price and the painting too. . . . He has more work than he can doe, in any reasonable time, and well.' Anybody who had more work than he could do and who varied his prices every day obviously needed a good man of business between him and his customers. When the commodity he was producing happened to be townscape painting, Joseph Smith was clearly the man to take over. Smith was already a collector of books and paintings himself and, like many good collectors, to some extent an art dealer. The first meeting between Smith and Canaletto is unrecorded; whenever it took place, the result was a commission for six pictures.

They were to be quite different from anything Canaletto had so far painted. In particular they were to be different from the two paintings on

177

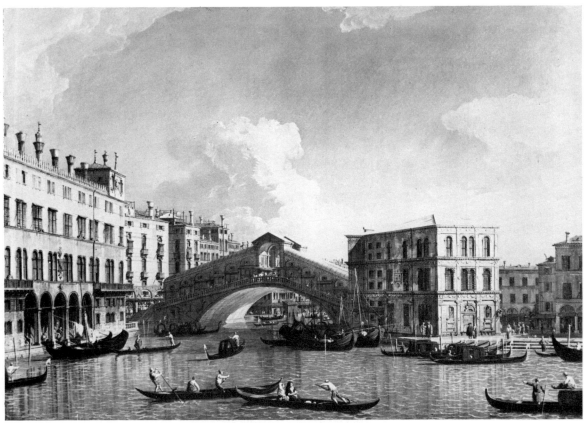

131 *Looking south to the Rialto Bridge (on copper)*

copper bought for the Duke of Richmond. These were small, bright and topographic and showed the view looking north from the Rialto Bridge and south to the bridge, as in the case of two of the Conti pictures. Smith's pictures were to be over five feet high (or broad in the case of two), dark and freely handled and with the emphasis on pictorial rather than topographic quality. To remove them even farther from anything that had gone before, they were all to be of the area in and around the Piazza.

Up to now Canaletto had, with the exception of one Liechtenstein painting, avoided the Piazza area as a subject whereas Carlevaris had virtually confined himself to this area in his paintings. Nearly all Canaletto's work had been done on the Grand Canal and the rest in or near *campi* with churches. Carlevaris never painted either. Why the avoidance of the Piazza up to 1727–8 and why the concentration on it after Smith's appearance? Could it have been that he preferred not to challenge Carlevaris on

178

his own ground and that Smith reassured him? The suggestion does not accord with McSwiney's description of Canaletto's self-confidence but some explanation is called for. Whatever it may have been, the pictures were painted and they now belong to the Queen, together with Smith's 50-odd other Canaletto paintings and 150 drawings; they are even more rarely seen than the pictures already mentioned.

The period during which Canaletto was painting these six large Piazza and Piazzetta pictures, and immediately after, is the most confusing in his whole career. The Duke of Richmond's little Rialto scenes (they are only 18 inches high) must have been painted at this time and they are the forerunners of all his later work. There are half a dozen others, also small, on copper and topographically precise, which must belong to the same period. In addition, Canaletto challenged Carlevaris on the ground he had made his own – festival paintings. Carlevaris, it will be remembered, showed the arrival of the Imperial ambassador in 1727 at the entrance to the Doge's

Detail slightly enlarged

Palace in exactly the same terms as he had shown Lord Manchester's arrival 20 years earlier. Canaletto now painted the arrival of the French ambassador in 1726 and of the new Imperial ambassador in 1729. He chose a viewpoint somewhat further away than Carlevaris's but otherwise he followed the earlier composition faithfully (the pictures were probably both painted about 1729). At the same time he painted pendants to each showing the *Return of the Bucintoro on Ascension Day*. All these are in the style we know so well.

But it must have been during this period that he also painted his masterpiece, the *Stonemason's Yard*, in the National Gallery, an accurate piece of topography and a superb picture at the same time – it shows the view across the Grand Canal by the point where the Accademia Bridge now stands and some of the houses shown in it can still be identified. And he may well have painted two other pictures at this time, *Dolo on the Brenta* in the Ashmolean Museum and the Queen's *View Towards Murano*, both highly controversial in everything except their quality, which is beyond cavil.[1]

[1] Almost. Michael Levey dissents as regards the *View Towards Murano (Later Italian Pictures in the Royal Collection*, 1964, p. 67), which he considers of 'sketchy technique and feeble draughtsmanship'. But five years earlier he found it a 'fine painting' *(Painting in Eighteenth-century Venice*, p. 98).

132 *Arrival of the French Ambassador, about 1729, 6 ft high*

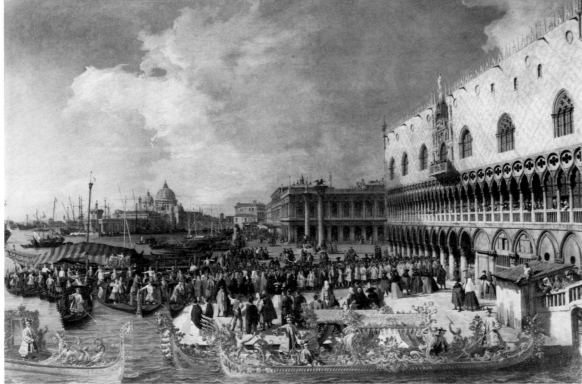

133 The Stonemason's Yard, 4 ft 1 in high

The Prolific Years

From 1730 onwards there is no confusion. Fourteen paintings of the Grand Canal were commissioned by Smith and engravings of them published in 1735 (now in the Queen's collection), 22 for the Duke of Bedford (now at Woburn Abbey), 21 for (probably) the Duke of Buckingham (now dispersed) and several other series as well as a vast number of pictures, some of them commissioned by visiting foreigners and others for 'stock' although there is equally little doubt that they were quickly snapped up. Smith would have seen to that. The exact relationship between the two men can only be guessed at but Smith, as well as being patron, assuredly sold Canaletto's work and solicited commissions for him, no doubt for suitable

134 Grand Canal from Campo S. Vio, H.M. The Queen

remuneration. The variation in quality is amazing – even in pictures belonging to the same series – but they all have one object which is to portray the city of Venice in all her splendour, with her incomparable light, her people, shipping, water and, above all, her buildings, whether church, palace or tenement.

Not one of these views is left in Venice. The visitors took them all – except those that Smith kept for himself. Towards the end of his life Smith sold his books and pictures to George III for £20,000 and the pictures now form part of the Royal Collection. By no means all are views of Venice and several of those that are views were painted when Canaletto had passed the peak of his powers. Fourteen of the views, however, were painted in the early 1730s when Canaletto could certainly have done almost anything he wanted to do. These are the pictures that were engraved by Antonio Visentini and published in 1735 as 'in the house of Joseph Smith, Englishman' and it may be taken that they were painted as Smith wanted them and in what he and Canaletto considered the most saleable form. They are far smaller than the six great Piazza pieces, about 18 inches high, and already the figures have become proportionately smaller – later they were

often to become mere blobs. It is by these pictures that the Canaletto of his middle period is to be judged and, so long as the judgment has to be made by reproductions, there can be no better way than by comparing, say, the Queen's version of the *Grand Canal from the Campo S. Vio* or the Fogg Museum's view of the Piazza with the Liechtenstein-Thyssen versions (Pls. 127 and 128). A sense of reality has replaced the air of mystery but the light is, if anything, even more magical. The *Campo S.S. Apostoli*, in which Canletto turned away from the waters of the Grand Canal or the lagoon, is another example of this period.

plate 136

With this cross-section of the early and middle period of Canaletto's work we should be able to come to some conclusion as to his place in the development of townscape painting. Whatever falling off there may have been in the pictorial quality of his work, or in his stature as an artist, there can be no doubt that as a topographer he stands supreme.

Whether he painted everything himself is questionable; some believe he had a workshop of pupils and assistants whereas others, after discarding the work of his imitators, which Canaletto had nothing to do with, regard the rest as being his own work – with perhaps the occasional help of an assistant such as his nephew Bernardo Bellotto. It is true that his output was phenomenal but much of it was repetitive and it must have been possible for him to

135 *The Piazza, Fogg Museum*

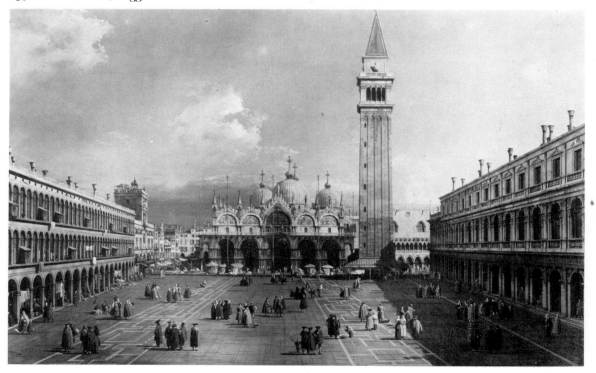

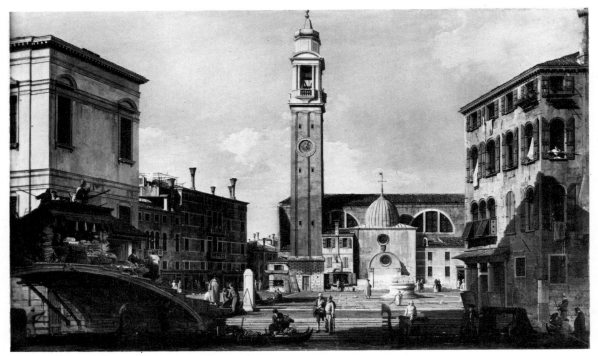

136 *Campo S.S. Apostoli*

137 *The Bacino, 4 ft 1 in high*

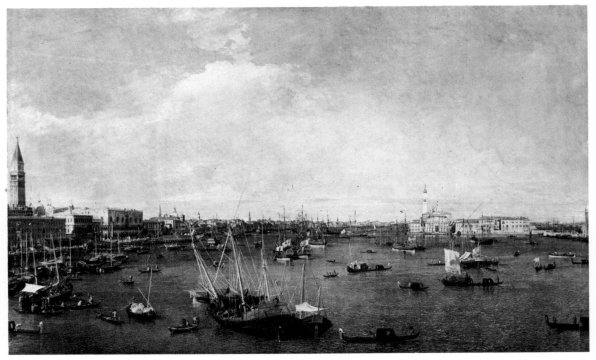

*138 The Piazza,
north–east corner,
pen and ink*

produce good-quality work on mass production lines, with the occasional
lapse into purely mechanical reproduction and the occasional mutational
throwing off of a masterpiece. The Boston *Bacino* is an example of the
latter. It is unnecessary to dwell on the former.

A word must be said about his drawings which were of three kinds.
There were sketches, almost certainly made on the spot, later to be worked
up into finished drawings or paintings or both. Then there were finished
drawings which seem to be intended for copying by an engraver or by
Canaletto himself as a painting. The third category consisted of drawings
made as independent works of art – which indeed they were. Smith owned
150 of Canaletto's drawings, almost as many as are to be found the world
over outside the Royal Collection today, and we must be content with
but one example chosen at random. Anyone who doubts that the Canaletto
of the late 30s was the same man as that of the 20s needs only to examine
his drawings, and if his genius is still in doubt there remains the evidence
of his etchings.

The Canaletto of the 1740s

With the War of the Austrian Succession in 1741 the attractions of Venice
as a tourist centre declined and Canaletto's foreign buyers failed to appear

185

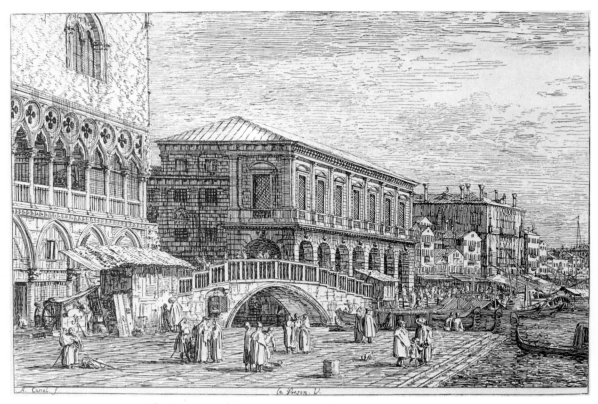

139 The Prison, etching

on the due dates. Smith, who did not manage to find his way to the hearts of many of those who met him, now proved a true friend to the artist who had served him so well – and who had, no doubt in Smith's estimation, been well served by him. Smith commissioned some Roman views, possibly to be done from the sketches made 20 years earlier and not necessitating another visit, and a number of 'over-doors', comprising such antics as the bronze horses removed from St Mark's and placed outside the Doge's palace, or the Rialto Bridge district with Palladio's proposed bridge substituted for the one Da Ponte actually built there. In addition Smith took straight Venetian views which, mechanical as they were, would, in better times, have found ready customers among the English tourists, and some marvellous drawings which Canaletto now had time for.

But Canaletto's genius was still under-employed so, for the first time in his life, at the age of 45 or so, he learnt to etch or, if he already knew how to etch, he made use of his knowledge for the first time. He produced but

one album of etchings, mostly of the area around Venice or of imaginary views, but including four superb Venice views[1]. There were 30 plates, Canaletto's total output in etching, and they would have ensured his place in history had he done nothing else.

The etchings were published about 1744 and were dedicated to Smith. No longer was he just 'Angli', Englishman; now he was 'Giuseppe Smith, Console di S.M. Britanica' for he had become His Britannic Majesty's Consul to the Most Serene Republic of Venice on 6 June 1744. Moreover, things were going well with him financially and he had recently acquired a palace on the Grand Canal and engaged Visentini, who was an architect as well as an engraver, to reconstruct the façade on classic lines.

With Canaletto, though, things continued to go badly. After another two years of depression in the Venetian tourist industry he decided there was only one solution. Since the dukes would no longer come to him, he must go to the dukes, and in May 1746 he arrived in England.

THE OTHER VEDUTISTI

Canaletto had dominated view painting in Venice for 20 years and he can hardly be expected to have had any serious rivals. Nor did he found a 'school'; those inferior to him preferred to imitate his work rather than learn what they could from it and develop their own methods.

Carlevaris had died in 1730 and Francesco Guardi, although 42 when Canaletto left for England, was still assisting his brother Gian Antonio and painting figures on his own. He did not start painting views until his brother died in 1760. Canaletto's own nephew Bernardo Bellotto (1720–80) had been assisting his uncle and remained in Venice for only a year after his departure to London; Bellotto himself then left Venice, never to return.

Michele Marieschi (1710–43) is really the only 'other' view painter to be considered and his career was so short that little consideration can be given to it – particularly since he only once signed a picture and that merely with the letters 'MM'. Nearly all his paintings have at times been attributed, in part or in whole, to someone else – the most spectacular re-attribution being the Louvre *Salute* which was considered a Canaletto in Ruskin's day. Ruskin never missed an opportunity to berate Canaletto although he had

plate 140

[1] Note the Danieli Hotel on the right of Pl. 139 (then the Palazzo Dandolo). Can any other hotel in the world produce illustrations of its virtually unchanged façade in 1486 (Pl. 61), 1500 (Pl. 67) and 1744 (Pl. 139)? There were, of course, many more in between these dates and since – right up to the present day.

187

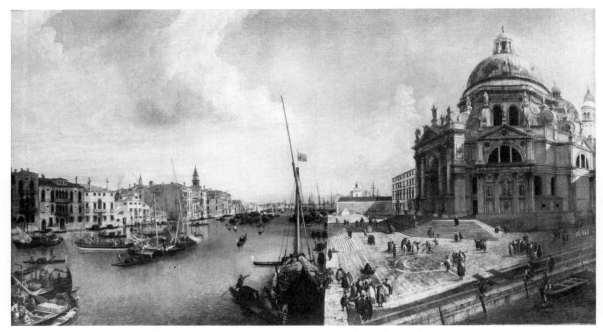

140 The Salute, now attributed to Marieschi, 4 ft 1 in high

seen very few of his paintings and no good ones except, possibly, the *Stone-mason's Yard*. The only two paintings he ever referred to by name were a *Piazza S. Marco*, which has disappeared, and this Louvre *Salute*, of which he wrote *inter alia* (and a great deal *alia*), '. . . a man deserves chastisement for making truth so contemptible. . . . A rascally Canaletti'. Whether Ruskin would regard the reattribution as an embarrassment or a justification is a moot point – but Ruskin was seldom embarrassed and he never needed justification.

Although Marieschi was born in Venice, he was in Germany until the age of 25, painting stage scenery and imaginary landscapes. In 1735 he returned to Venice and in 1741 published a series of 21 etchings, all views of the city. This is really all his fame rests on securely since there is so much controversy over his paintings.

To represent Marieschi's work we reproduce the Fitzwilliam Museum's *Grand Canal* whose attribution does not seem to have been seriously attacked (although that of the pair to it has been). Canaletto had painted the scene from much the same spot (just above the Rialto Bridge, with the fish market on the right) some ten years before as one of a series and it is interesting to compare the two versions. Canaletto's people are about their

188

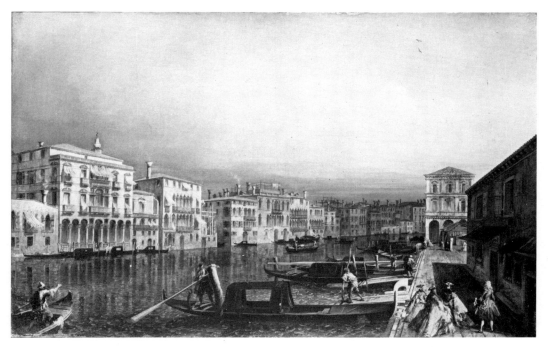

141 *Grand Canal and Fish-market, Marieschi*

142 *Grand Canal and fish-market, Canaletto*

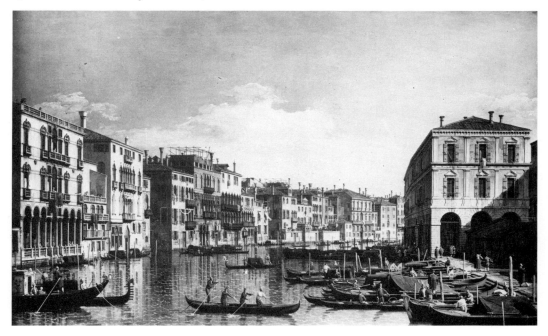

business, doing much the same things as they can be seen doing at this spot today (only the Important Person's decorated barge on the left would be missing). Marieschi's people are posturing and romanticised. Canaletto painted the left half of his picture from a point in the Grand Canal very near the right bank and then went much nearer the opposite bank to paint the right side. Marieschi in this case was more truthful and had only one viewpoint, from a window of a house in the Riva dell'Olio which is identifiable today. We are fortunate he stayed on dry land instead of taking to the Grand Canal. As a result he shows us more of the palaces on the left bank – first, after the two-storeyed house, the Palazzo Michiel delle Colonne with its colonnade and a little annexe beyond; then the Palazzo Michiel dal Brusa. A fascinating detail follows. There is Smith's house, the Palazzo Mangilli-Valmarana as it is called now, newly bought and with the front being reconstructed as would befit a man about to become His Majesty's Consul. Although the work was not finished until 1751, it must have been started soon after Smith bought the house in 1740 for by 1743 Marieschi was dead.

143 *Florence about 1740, G. Zocchi*

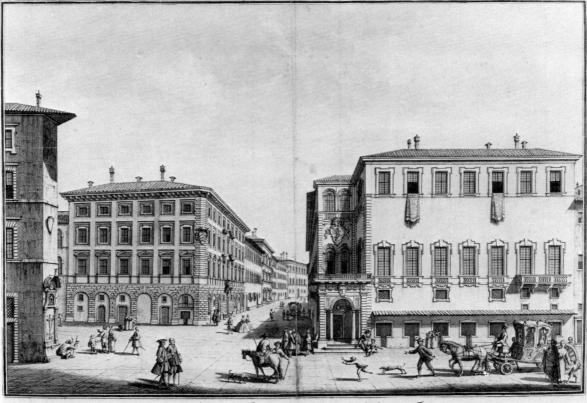

Veduta de Palazzi de' Sig. March. Corsi, e Viviani.

Thus, when Canaletto left Venice, the city which had seen the full flowering of townscape painting was left without a single first class exponent of the art.

There were plenty of second- and third-rate view painters around. It was an age for illustrated travel books of every kind and the illustrators were in great demand. At one end of the scale there was G. B. Albrizzi's 26-volume series published over 22 years from 1740 called *Lo Stato Presente*, inexpensive and conveniently small for the traveller to carry with him, and containing, as well as views of towns and monuments, illustrations of costumes, dances and so on. They covered the world from Europe to China and the Italian volumes were mostly illustrated by Francesco Zucchi (1698–1764). With Giuseppe Filosi he had illustrated a far more elaborate work, *Forestiere illuminato . . . di Venezia*, published in 1740, and which followed the tradition started by Carlevaris and the *Gran Teatro* (pp. 167 & 174). The fashion spread to other cities such as Florence where a rich merchant named Andrea Gerini, envying Venice her view painters and Rome her Piranesi, diverted Giuseppe Zocchi (1711–67) from fresco painting to view paintings of Florence's streets and squares which were published in 1744. As for painters, Jacopo Fabris (1689–1761), who had worked in Denmark and Germany, also produced a number of Venetian views often copied from the engraved views of his betters such as Carlevaris, Marieschi and Canaletto. He is but one of the shadowy figures whose work fills the salerooms and dealers' showrooms today as a result of their having tried to take advantage of Canaletto's success. Of the topographical artists in mid-eighteenth century, only Piranesi merits serious consideration.

GIOVANNI BATTISTA PIRANESI

Piranesi was not a painter and his etchings of Rome were not townscapes in the sense the word has acquired for us in the course of this book. We have been concerned with artists who showed their cities through their own eyes but also approximately as they appeared to others. No-one ever saw Rome as Piranesi depicted it: it was a Rome that never was. However, he was a master in his own field and virtually his only field throughout his life was the city of Rome; he cannot therefore be neglected.

He was a Venetian, and often so signed himself, although born on the mainland near Mestre, not in the city itself. He was a generation younger than Canaletto, having been born in 1720, and was brought up by an uncle in the tradition of architecture and engineering; this included geometry, perspective and, perhaps above all, an intimate knowledge of Palladio's books on architecture, then far more influential than when they had first

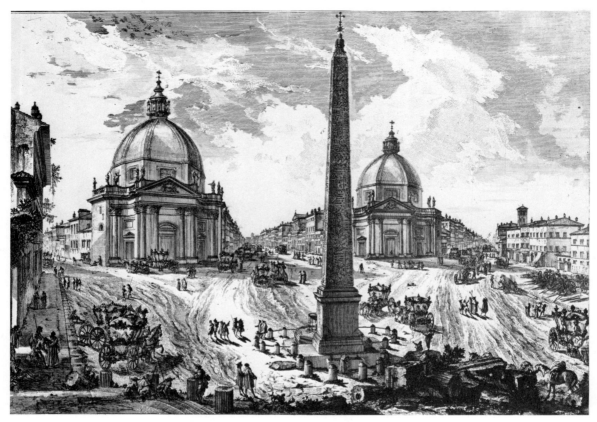

144 Piazza del Popolo, Rome, Piranesi, about 1750

been published 150 years earlier. More than anything he wanted to build, but Venice had no room for new buildings in the 1740s even had she been able to afford them. He managed therefore to get on to the staff of a new Venetian ambassador to the Vatican, confident that in Rome he would find princes or clergy able and willing to give him commissions. He was soon disillusioned and reported: 'I have no recourse except to follow other modern architects and make my ideas known through pictures.' He accordingly learnt how to etch, and published, at his own expense, a series of projects for palaces, squares and temples. This, too, failed in its object of stimulating building commissions and he returned penniless to Venice where he worked with Tiepolo as an assistant. It was probably at this time that Piranesi made his famous series of etchings of *Imaginary Prisons*, considered by some to be his finest work. The magnet of Rome still drew him, though, and the year before Canaletto left Venice for London, Piranesi

192

left it for Rome again. He was 25 years old and, having failed as a designer of new buildings, he turned to the remains of ancient buildings 'either weathering away or being quarried'. He 'resolved to preserve them by means of etchings' and so began a career which was to last for 33 years and make him the most famous Roman of his century.

The engineer, architect and draughtsman now became an archeologist, digging and measuring wherever he turned (he spent six months measuring the details of the Roman water system). He knew nothing of Greek architecture and believed, like all Italians of his day, that Rome had inherited her architectural traditions from the Etruscans and passed them on to Greece after conquering her. It was only after the publication of his major work *The Magnificence and Architecture of the Romans* that the first accurate pictures of ancient Greek building began to appear and the true relationship between Greek and Roman art came to be recognised.

All the time Piranesi was dissecting ruins and producing huge etchings of them for scholars throughout Europe, he was also making *Views of Rome* for the lay public. They were as far removed as possible from the sober drawings of the previous two centuries of illustrators of Rome, many of whom had come originally from the Netherlands (p. 137). Although he never made a painting, every etching of Piranesi's shows the painter's concern with drama and light. For the drama he chose the exaggerated perspectives of the theatrical scene painter and, for the light, high contrasts of sun and shadow. Gradually he learnt to people his etchings with the

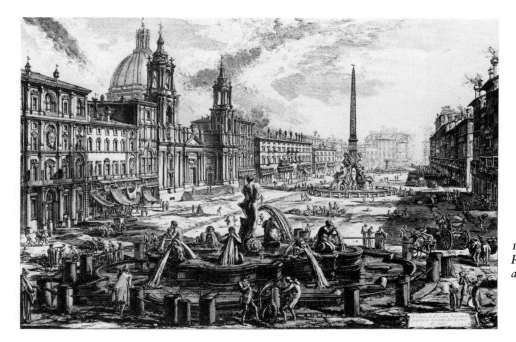

145 *Piazza Navona, Rome, Piranesi, about 1770*

plate 144

characters the public demanded in souvenir pictures, the cripples and beg-bars, the bishops and princes and the tradesmen about their business. But the cripples were more twisted than in real life and as Piranesi grew older they seemed to take over his pictures as if to emphasize the decay around them.

plate 145

Anyone who saw Piranesi's Rome before their arrival must have been sadly disappointed by the real thing. Vanvitelli's *Piazza Navona* (Pl. 122) would recall the famous square to those who had seen it, although the returned traveller might feel wistfully that he must have seen it on an off day. No-one but Piranesi himself ever saw *his* Piazza Navona. 'Study the sublime dreams of Piranesi', wrote Horace Walpole; 'He piles palaces on bridges, and temples on palaces and scales Heaven with mountains of edifices.' An impossible man to live with by all accounts, Piranesi's work achieved enormous fame in his lifetime and then went into almost total eclipse for 100 years. Ruskin never thought him worth mentioning (even to denigrate like Canaletto) yet today he is recognised as the master he undoubtedly was. But in spite of the title he gave them, and masterpieces though they may be, his *Views of Rome* are not really views of Rome.

TOPOGRAPHICAL ART IN ENGLAND

As we have already seen (p. 134), Hollar, the forerunner of English water-colour drawing, was succeeded by Francis Place who soon gave up topo-graphy as an art. Hollar, the topographical engraver, was succeeded by a

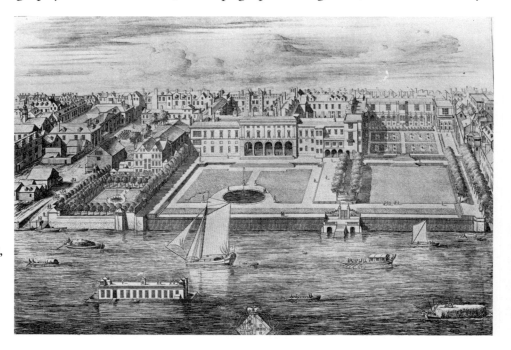

146 Somerset House, London, L. Knyff, about 1720

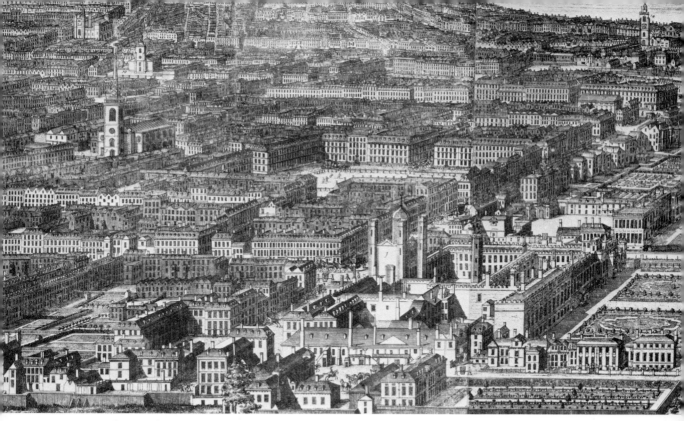

147 *St James's, London, Jan Kip, detail*

vast number of artists and engravers, for the most part mediocre, whose products were published in books and as separate engravings. Leonard Knyff (born in Haarlem, 1650) was perhaps the most distinguished of these topographical engravers although he is known as a topographical artist entirely on the strength of his drawings of 'gentlemen's seats' in both town and country for *Brittania Illustrata* which Jan Kip (born in Amsterdam 1653) engraved and published from 1707. They were almost as varied as Braun and Hogenberg's drawings of cities and there is hardly a printshop today without a sizeable stock of Knyff engravings of which Pl. 146 is typical. This was just a bypath to Knyff who was a successful art dealer and a prolific painter of imaginary landscapes, almost all of which have disappeared and would not be known were it not for the auction catalogues of the period in which they are constantly mentioned.

Soon after he began the publication of *Brittania Illustrata* Kip produced a remarkable bird's-eye view of his own taken from Buckingham House (later Buckingham Palace) and showing the whole of what is now the 'west-end' with St James's Park in the foreground and Westminster on the right. As a work of reference it is invaluable: as a work of art it is of small consequence.

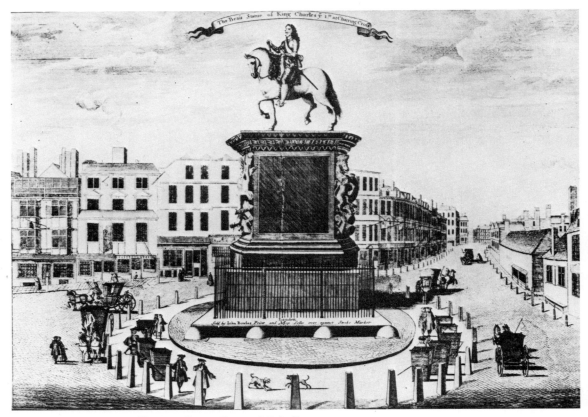

148 *Charing Cross, Sutton Nicholls*

There is a host of other artists and engravers whose topographical work was being published at this time but it is extremely difficult to distinguish which were Canaletto's predecessors and which his followers. The publishers were more concerned with selling their prints than providing data for historians and the liberalism of their attitude towards anything like copyright makes it virtually impossible to chart the sea of publications of the period with any accuracy.

Sutton Nicholls is one of the few other draughtsmen and engravers who was certainly very active before 1746. He contributed most of the 'Views of Several Squares in the liberties of London and Westminster' which, with the Royal Palaces, some hospitals and other subjects, made up *London Described* which Thomas Bowles published in 1731. His drawing of the *Statue of Charles I at Charing Cross* provides an interesting glimpse of a sedan chair 'rank' with the carriers awaiting custom.

196

As for topographical painting in England, we left it (p. 135) in the shadowy and inactive hands of Claude de Jongh, the only Dutch painter who seems with any certainty to have visited England before the Restoration in 1660. Once Charles II was securely on the throne, and Dutch townscape painting had been firmly established, its minor practitioners began to seek their fortunes in England. Thomas Wyck (who may have made earlier visits) (1616–77), Hendrick Danckerts (*c.* 1630–78) and Jan Griffier (*c.* 1642–1718) all arrived at about the same time and all painted views of London. Danckerts was perhaps the most successful, having been invited to England by Charles II and employed by James II. Walpole writes of his working with Hollar, and Samuel Pepys called him 'the great landscape painter' and employed him to decorate his dining-room. His *Whitehall from St James's Park* is full of interest to the lover of London topography showing as it does the Banqueting House, the Holbein Gate and the stairs leading to a gallery which, according to an eye-witness, Charles I climbed on the way to his execution outside the Banqueting House.

149 Whitehall from St James's Park, H. Danckerts

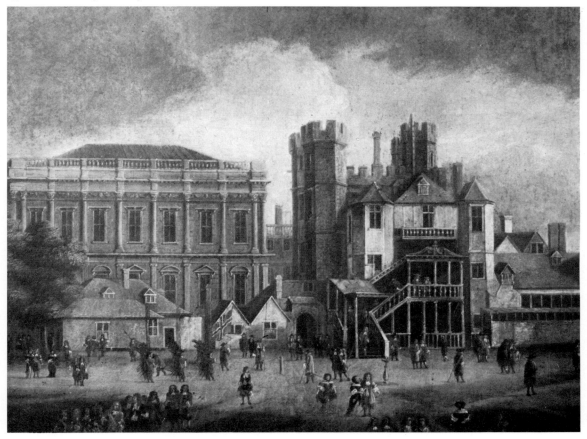

Wyck and Griffier are better known for their distant views of cities such as Leicester (Wyck) and Gloucester (Griffier). They were essentially views of the city from the outside rather than the inside, the city itself being just the middle band of an extensive landscape. Thomas Wyck also painted some London Views and his *Westminster from below York Water-Gate* is of particular interest to any Londoner who knows the watergate as it now stands beside the Embankment Gardens. It remains where it was built in 1626 for the Duke of Buckingham by Nicolas Stone but, instead of leading down to the river, it has now been left, by the building of the Embankment, high and dry 150 yards from any water.

Of the intimate scenes of city life which Canaletto had been painting for so long in Venice, and the Dutch painters before him, there is generally little trace in England. Joseph van Aken produced a rare example in his *View of Covent Garden* in about 1726. It seems to have been the only occasion on which he tried his hand at such a subject although nothing is certain with the van Aken family. There were four brothers, all artists, and Joseph was originally called Francis; he was also called 'drapery' Aken and Walpole wrote that 'every painter's work is painted by Vanaken', meaning the clothes of the figures in them. He can hardly be called Canaletto's predecessor.

Nor can Antonio Joli (*c.* 1700–77) since he had arrived in London only two years before Canaletto. He had studied in Rome with Pannini and had already painted several views of the Thames. He was to paint many more, particularly in the neighbourhood of Richmond and, but for Canaletto's

150 Westminster from below York Water-gate, T. Wyck

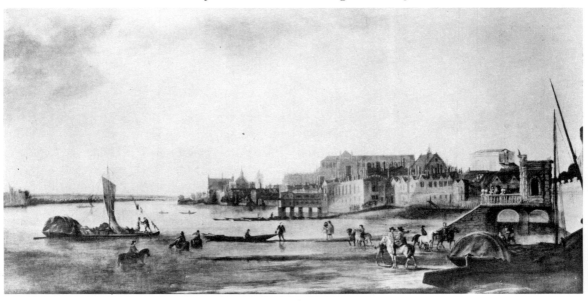

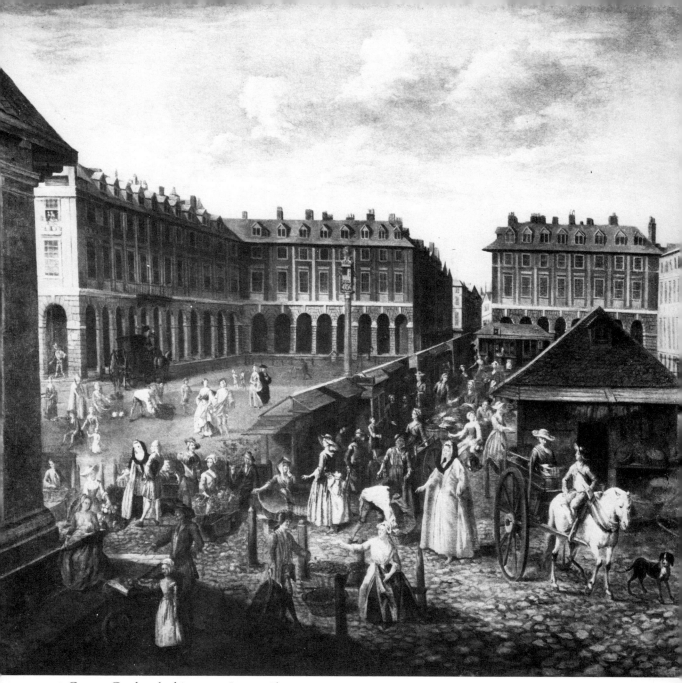

151 *Covent Garden, looking east, J. van Aken*

arrival, he might have had a greater impact; he was a lightweight, though, in spite of a certain charm which is evident from his *Building of Westminster Bridge*.

Hogarth? He was born in the same year as Canaletto and showed the city only as the background to his moralising pictures, never as a subject and seldom recognisable. Paul Sandby? He was only 21 – although he had already been sent to Scotland by the predecessors of the Ordnance Survey to make topographical drawings there.

There remains Samuel Scott (d. 1772), about 44 years old when Canaletto arrived in 1746 and an artist perhaps of almost equal rank. No-one knows where or when he was born – it was probably about 1702 and at the time of writing virtually nothing has been published about him. He was certainly a successful marine painter by about 1735. He owned a great number of ship drawings by William van der Velde the younger who died in 1707 and he became known as 'the English van der Velde'. Much later he was called 'the English Canaletto' but this was long after 1746 and by that time it was the custom to attach the name of either Scott or Canaletto to almost any painting of London or Venice which had any claim to have been painted by a student of either. (The fact that Scott never went abroad, as far as is known, does not discount the possibility of *some* Venice paintings being painted by him from drawings.)

The time has not yet arrived when one can write anything with confidence about Scott's achievement as a topographical painter before 1746,

152 The Building of Westminster Bridge, A. Joli

153 The Temple from Mitre Court, S. Scott

or about his subsequent relationship with Canaletto – or even if there was any. All we can say is that around the middle of the eighteenth century he painted a number of river scenes and a few quite admirable street scenes of which Pl. 153 is an example; one of his Thames views, which we shall come to in a moment, can be dated with some confidence as prior to any work Canaletto did in London. We are therefore left with the situation that Canaletto's English patrons had been carrying off his Venetian work for 20 years and that it must have been seen and admired by a vast number of people in England, including many artists, yet none had attempted to set up as a competitor.

It was clearly time for Canaletto to visit England and study the market.

CANALETTO IN ENGLAND

The second, and dullest, of the four Georges had 14 of his 33 years' reign left to run when Canaletto arrived in England. Sir Robert Walpole had

154 Overleaf: North-west view from the Duke of Richmond's dining-room in 1746, (looking up Whitehall), Canaletto, 3 ft 6 ins (sky reduced)

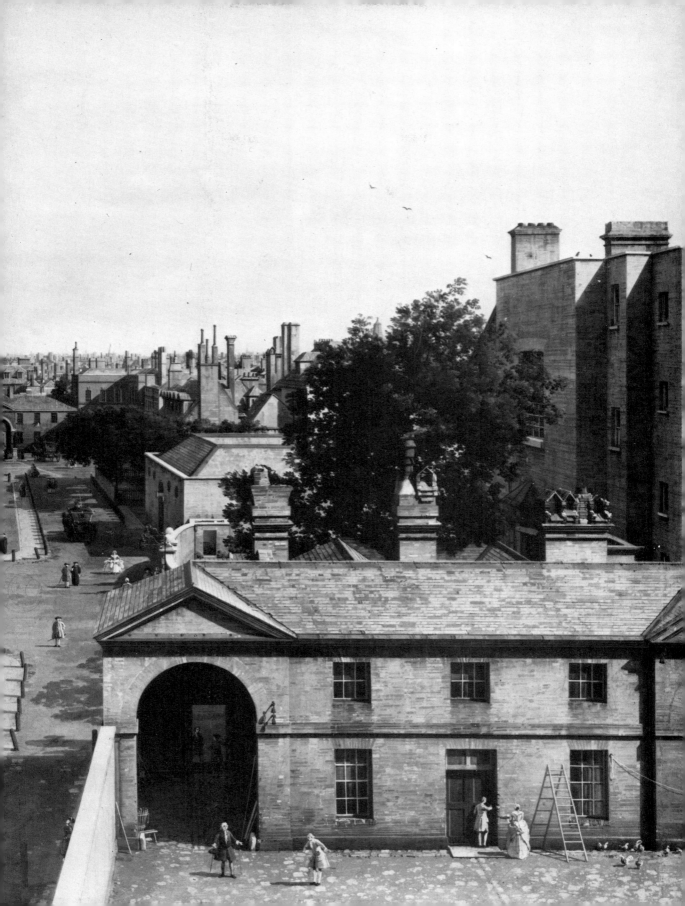

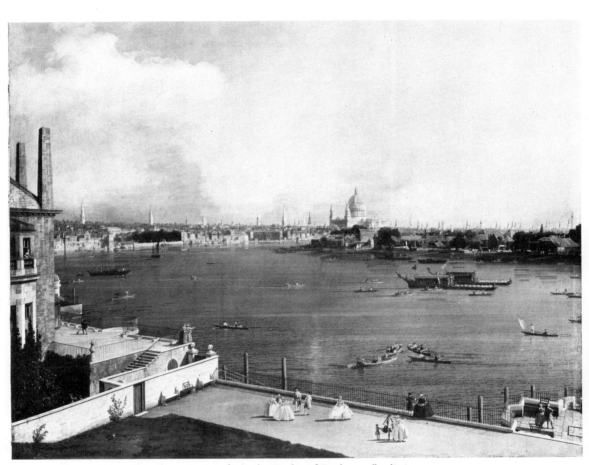

155 *North-east view from the Duke of Richmond's dining-room*

dominated politics, Alexander Pope poetry and Jonathan Swift satire: all had died in the previous two years. Handel's *Messiah* had recently been performed for the first time and Hogarth's *Marriage à la Mode* was just completed. Dr Johnson was on the point of beginning his dictionary. France had declared war on England two years earlier, after 30 years of peace, and the Young Pretender's astonishing exploit had just met its inevitable end at Culloden. The period so many look on nostalgically as England's golden age still lay ahead; cheap gin had more influence on daily life than art or reason. This was the England of 1746.

Canaletto stayed in England for nine years, interrupting his stay for only two visits to Venice of a few months each. It was not an unqualified success

artistically or financially and it seems likely that, so far from finding invest-ments in England for the fortune he had accumulated, which was said to be one reason for his visit, he had to live in part on his savings. Sir Osbert Sitwell remarks knowingly that the fourth Duke of Beaufort, a great patron of the arts, was one of three noblemen responsible for bringing Canaletto over to England and paying his expenses while he lived here. He tantalizingly gives no authority for the statement which one cannot help suspecting is just ducal family gossip. The fact is that Canaletto was a poor man when he died in Venice 13 years after his return although he never stopped working.

He started with a pair of masterpieces, the views of *Whitehall* and *The Thames*, commissioned by the second Duke of Richmond, grandson of Charles II. 'I told him the best service I thought you could do him w^d be to let him draw a view of the river from y^r dining-room,' the Duke's former tutor had written to him, on being asked by Owen McSwiney, at Consul Smith's request, for an introduction to the Duke, one of Canaletto's earliest patrons through McSwiney. The result is almost too well-known to need reproduction yet again. If this really was the view from the Duke's dining-room he was indeed to be envied.

plate 154

The background of the Thames picture shows St Paul's and almost all the City Churches; the foreground shows the terrace of Richmond House and, on the left, the terrace of the neighbouring house of the Duke of Montagu. Between the two are the stairs leading down to the river, shared by the houses. Both terraces have built-out bows, and the Duke of Rich-mond's terrace seems to have been newly constructed. A painting of Samuel Scott's shows it as under construction, and there can be little doubt that, had it been in this condition while Canaletto was at work, this is how he would have recorded it. Crumbling brick and walls with weeds in the

plate 155

156 The building of Richmond House Terrace, S. Scott

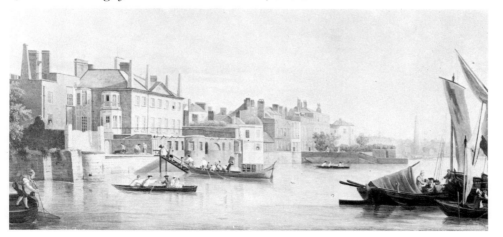

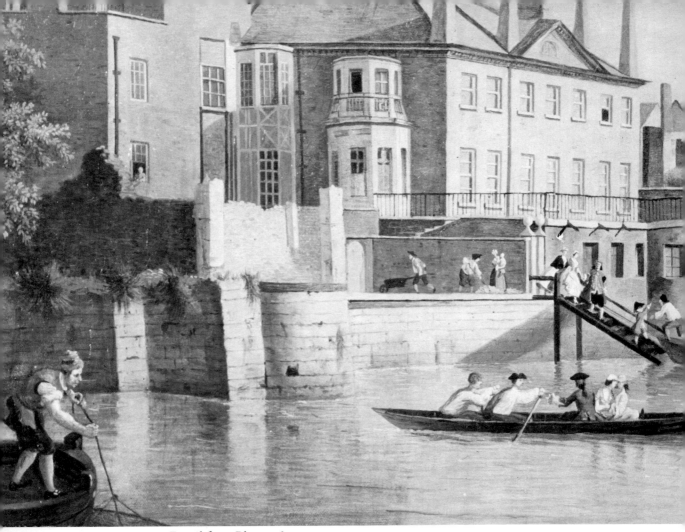

Detail from Plate 156

crevices added to, rather than detracting from, the picturesque quality of a painting. Scott's picture must surely therefore have preceded Canaletto's. If this is so, it must be conceded that, however strong the change of emphasis in Scott's work from marine to topographical painting appears after Canaletto's arrival it would not be true to assume that Canaletto was entirely responsible for his conversion.

To return to Canaletto, it will be seen that, majestic though the paintings are, they are in his late style, when Smith and others were pressing for more and more output, rather than that of the days when every building shimmered in the Venetian heat and every shadow was a new exploration into the mysteries of the fall of light. The lines are too straight, the figures

206

too stylized – yet nobody who has seen the pictures can ever see London with quite the same eyes again.

The detail from the *Whitehall* painting shows an area which is six inches high in the original out of a total height of 43 inches. Still, it is possible to identify every shop, the Golden Cross Inn, and the statue of Charles I where it stands today. There is no interest whatever in the people of London; the blobs of white paint would do as well for them as they had been doing for Venetians during the more recent years. Canaletto was trying only to adapt his Venetian experience to the new city at this stage; he was a professional artist, not a poet.

It was a surprise to the English that this was the great Canaletto. It had been a long time since they had seen the work he was doing and, although none of his earliest pictures was in England nor, of course, were Smith's, the deterioration had barely started when the Bedford or the Buckingham series or the many other paintings of the early 30s had been done. It was these he was known by in England and by 1746 he had painted too much; there were no excitements left to stimulate him, particularly in the northern

157 *Detail from Plate 154*

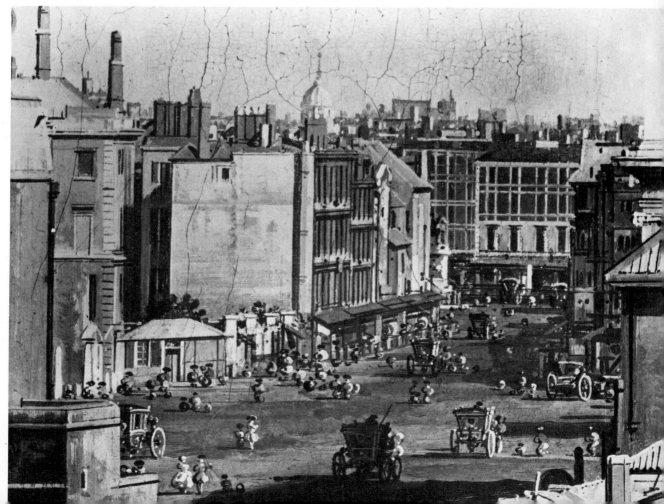

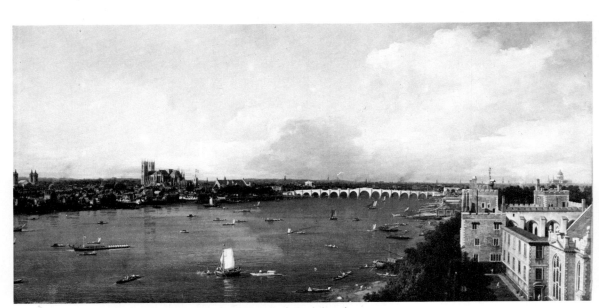

158 *Westminster from Lambeth and details*

light, nothing but the new kind of buildings which he devoted himself to meticulously.

From the Duke of Richmond he went to the Duke of Northumberland-to-be and then to the Duke of Buccleuch, painting Thames scenes for all of them. Then a tourist appeared, just as they had always appeared in Venice. Prince Lobkowitz of Bohemia wanted mementoes of his stay in London and, as the great memento provider happened to be there, who better to turn to? The result was a pair of enormous canvases (nearly eight feet wide) which remained in the Lobkowitz family until they became part of the Czechoslovak National Collection.

The first of the Lobkowitz pictures shows the scene from above the terrace of Lambeth Palace as it would be to anyone with eyes at the side of his head and so able to take in an angle of about 180 degrees. Westminster Bridge is at long last almost completed. (Incredibly enough the watermen and publicans of the City of London, supported by the City Corporation, had obstructed the building of a second bridge in London for centuries although Florence had four bridges by 1480 (see Pl. 63) and we know from Braun and Hogenberg that Paris had five, Rome four and even Verona four by the mid-sixteenth century.) The Prince certainly took home a memento of London which he could study for many hours, for seldom did even Canaletto put such loving detail into his painting of buildings.

208

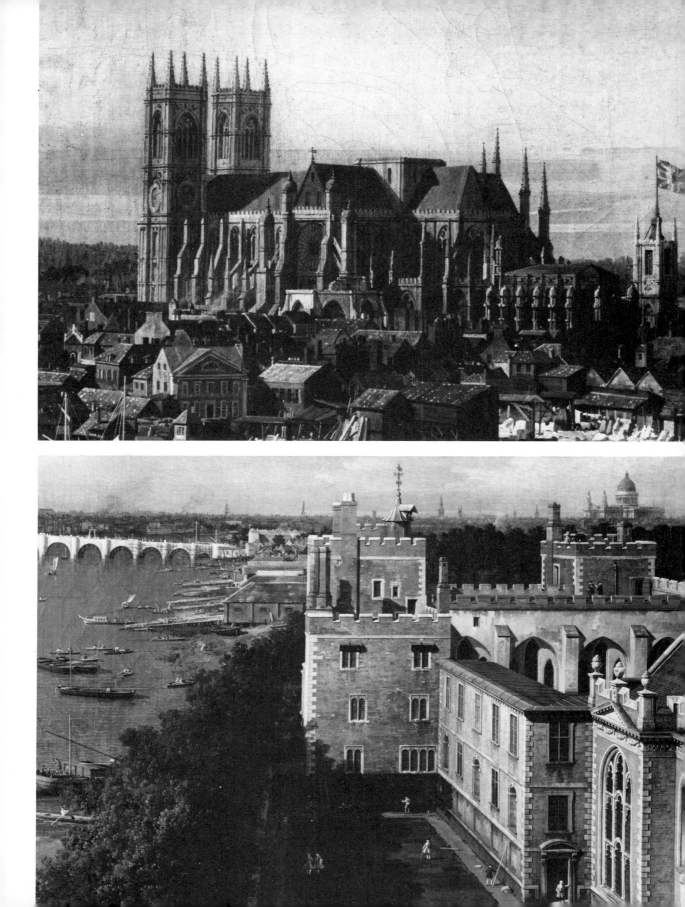

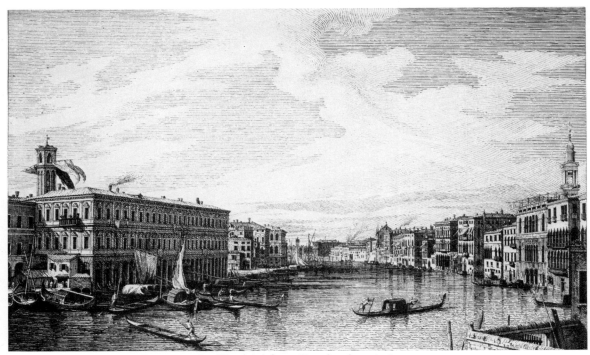

159 *Engraving by Visentini from Canaletto's painting*

The figures are mostly blobs and the water is perfunctorily painted but water and figures are the same in Bohemia as in London; the Prince wanted a record of the cities of London and of Westminster and he was given good value in this and its companion picture, *The Thames on Lord Mayor's Day*.

It may have been Canaletto's early success in getting commissions that contributed as much as the quality of his work to the criticism that soon began to be heard. A newcomer is scarcely welcome to the established artists and dealers. Whatever the cause, criticism mounted. By 1749 the story was being put about (perhaps by the 'art establishment' and certainly not denied by them) that it was not Canaletto at all who was in England but an unknown assistant. The idea that Canaletto's style changed in England to such an extent as to justify doubt as to whether there was an impostor at work persisted right up to the present century. A 'porcelain like quality' was detected which was attributed to his head having been turned by the clear colours of the Dutch artists, particularly Jan van der Heyden. But the clear colour and porcelain like finish had been a characteristic of his work in Venice for years – and, as for van der Heyden, there is

no reason to believe he ever did any work in London or that Canaletto had ever seen an example of his painting.

Canaletto's reply to these rumours was to paint a picture of St James's Park and advertise in the newspapers inviting visitors to come and see it in what is now Beak Street, off Regent Street, where he was living. This may have been successful, as later on he was advertising more pictures he had painted, one of them probably being the combination of the Duke of Richmond's two pictures which now belongs to the Duke of Buccleuch.

By 1751, when the second advertisement was published, Canaletto had been back to Venice and returned after a stay of about eight months, and by 1753 he must have made another visit to Venice as he is recorded as having been there. On one of these visits he probably carried out his strangest little commission.

Consul Smith, it will be remembered, had bought the Mangilli–Valmarana palace on the Grand Canal in 1740 and was having a new and grand façade added to it at the time Marieschi was painting the scene from the fish market (p. 190 and Pl. 141). Canaletto's painting from the Rialto Bridge, which included the palace, had been finished well before 1735, when the engraving from it was published among the first series of 14 engravings of paintings in Smith's collection. Naturally enough, the engraving showed the old gothic façade as the painting must have done. But the painting does not show the old façade now: instead there is Visentini's imposing renaissance building. When was the alteration made?

Detail from Plate 159 *160 Detail of painting after alteration*

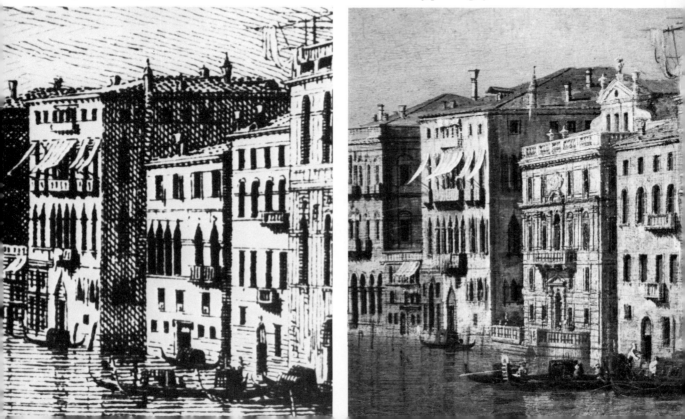

Canaletto was almost certainly in Venice in 1751 and again in 1753 and a third edition of the engravings was published in 1751, the year in which the palace was first unveiled to the public eye. One would have expected Smith to have had the painting altered in time for the engraving to incorporate the change but the engraving never was altered. Probably the work to the palace was finished too late for this to be possible and Canaletto's commission was held over until his 1753 visit. The result was that the engravings failed to show Smith's palace in a state befitting a consul, and indeed for 200 years, while it remained in the Royal Collection, no-one noticed that the painting recorded the true facts. The sharp eye of Mr Michael Levey then observed a different paint and technique on this tiny portion of the picture and Smith's human little conceit was revealed. Did Canaletto enjoy this small return for his patron's many favours? Was he paid? There is much one would like to know about the incident – including the reason why the alterations to the house, begun before Marieschi's death in 1743, were not finished until 1751.

Detail from Plate 161

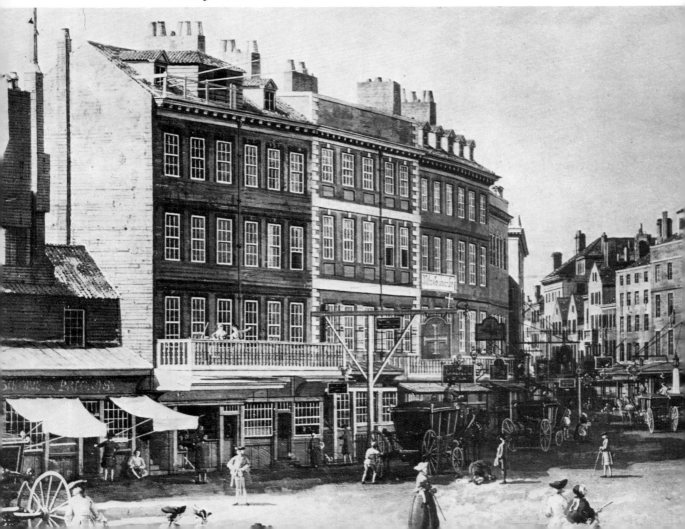

161 Northumberland House

The rest of Canaletto's stay in England is by no means well documented. He painted Warwick Castle for the Earl of Warwick, Badminton for the Duke of Beaufort and for the Duke (then Earl) of Northumberland he painted his seats at Alnwick Castle, Syon House and Northumberland House, London, as well as views of the Thames and Windsor. The Northumberland House picture provided an opportunity for the kind of townscape Canaletto was master of and which one wishes he had painted more often in England.

It must have been painted in 1752 as the façade of the house was reconstructed in that year and by 1753 an engraving of the picture had been published. The left side of the picture shows the houses and shops facing down Whitehall of which a glimpse had been given in the distance of the Richmond *Whitehall* painting (Pl. 154). The London topographers know them all. The coach on the left stands outside Katherine Peronette's Mews Coffee House where you could get an 'ordinary' (table d'hôte) meal for three shillings a head between three and four o'clock. Patrick Cannon's eating house was next door, with sun blinds. Then came the entrance to Woodstock Court followed by the Widow Bignall's saddler's and trunkmaker's shop, appropriately next door to the Golden Cross Inn where so

213

many coaches started from. The free standing sign of the Golden Cross Inn points the way to the passage you entered it by – the inn itself was behind. Two more trunkmakers followed, Nathaniel Gladman and Patrick Hoare, and then John Coggs, the Wax Chandler. His card described him as being 'at the Raven and Sun behind the King on Horseback at Charing Cross' and there is his sign with the Raven and there (in the complete picture) is the King on Horseback (although no rank for sedan chairs as in Pl. 148). A victualler, a jeweller and a hosier complete the directory and then the eye wanders into the street itself with its coaches, carts and people – real people, in this case, not blobs of white paint. This should have silenced those who talked of an imposter.

There are a number of drawings which Canaletto made while in England, some for the paintings, or for engravings after them, and others independently – there is a beautiful drawing, for example, of the Northumberland House picture in Minneapolis. Apart from this one, the only true street scene drawing was one of the Monument. It has never been traced but that has not prevented its having had quite an effect on a minor byway of art history. The drawing shows one of the busiest streets of London, Fish

162 Fish Street Hill, engraving

Street Hill, which then led to London Bridge (it now leads nowhere, the present London Bridge having been built some distance west of the old one). The drawing was engraved by G. Bickham and published by Sayer & Overton in 1752 with the inscription 'Signr Canaleti Delin'. Someone evidently thought it a pity there was no painting of such a lively scene and produced one, dating it 1759. On the painting was written 'C' or 'W' James and from this has born the legend of William James. No-one knows anything whatever about him except that Edward Edwards, a teacher in the Royal Academy, wrote in 1808 that he 'had been a pupil or assistant to Canaletti, while in England' – he also wrote that James's works were 'in general extremely hard and tasteless, little calculated to please the eye of a connoisseur, but had just sufficient merit to answer the purposes of those who sought for paintings as furniture'. Some time ago the name of William James was attached to a set of views at Kensington Palace but no-one knows why and there is in fact no picture which can be attributed to him with any certainty. A contemporary of Canaletto's of whom nothing is known, so that nothing that is said about him can be disproved, is a heaven-sent gift to the fine arts trade. There are many view pictures which obviously cannot be by Canaletto and, although one sometimes doubts it from reading catalogues, there are many which obviously cannot be by Samuel Scott. There is no picture which *cannot* be by William James and so this mysterious figure has become a truly prolific painter in the course of the last few years.

CANALETTO GOES HOME

The Queen's is by far the greatest collection of Canaletto paintings and drawings in the world and it even contains two fine London pictures. The inclusion of these London pictures was not due to the patronage of George II who was in his declining years when Canaletto was in England, nor of his grandson, later George III, who was only in his 'teens. The pictures were bought much later by George III among Consul Smith's collection and it is reasonable to suppose that they were painted during one of the artist's visits to Venice. He did not stay very long in England after returning from his second Venice visit.

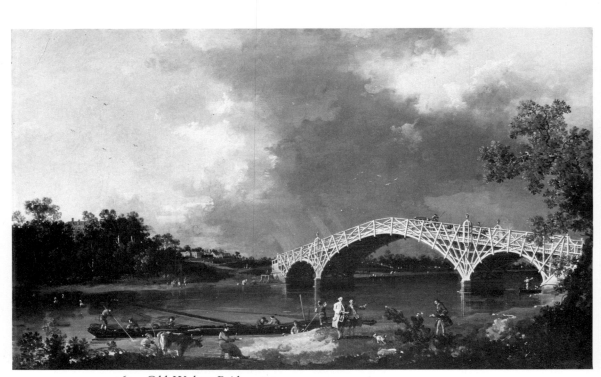

163 Old Walton Bridge, 1754

The attractive picture of *Walton Bridge*, now at Dulwich, may have been his last work before returning permanently. It is dated 1755 and was one of six painted for Thomas Hollis, a collector with American associations. Soon after this he is believed to have been back in Venice and he remained there for the rest of his life.

There are about 40 paintings and 30 drawings to show for his period in England. It was not a lot for a nine-year stay, even with two interruptions – not, at any rate, for Canaletto who painted over 500 subjects in his life-time, a number of them several times. Except for the Whitehall and Northumberland House pictures and the lost drawing of the Monument, there were no scenes of streets and squares such as he had been painting in Venice for 20 years. The work consisted of noblemen's seats, a few interiors and many views of the Thames – admittedly, the Thames was then a street but hardly one in the sense of the Venetian canals.

BELLOTTO

Meanwhile Canaletto's nephew Bernardo Bellotto was pursuing the career of painter of streetscapes in the strictest sense. Born in Venice in 1720, he became his uncle's assistant at an early age; W. G. Constable[1] considers he would have been old enough to take his part in the studio by the middle 30s and that he was probably Canaletto's only assistant. He borrowed extensively from his uncle's compositions for some Roman views but he also painted a few independently as well as views of Verona, Turin and Florence. Venice views are constantly being attributed and re-attributed between Canaletto and Bellotto (a pair of Grand Canal paintings in the Wallace Collection have made five changes) and it would be hard to name an original Venetian view which is certainly by Bellotto.

plate 165

Canaletto cannot have been in London for more than a year when he was invited by the Elector of Saxony to become Court painter in Dresden. He was sufficiently satisfied with his prospects in England to refuse and Bellotto was invited instead. There must have been insufficient work in Venice to tempt him to remain at home, even with his uncle absent indefinitely, and he arrived in Dresden with his wife and son in 1747. He called himself 'de Canaletto' but there is no reason to suspect any wish to deceive by the use of his mother's name; the 'de' can, charitably, be considered a contraction of '*detto*' (called) by those who would not wish to attribute social pretensions to him. He is still known as 'Canaletto' in Eastern Europe.

[1] *Canaletto*, 1962, p. 164.

164 Dresden about 1750, Bellotto, 4 ft 5 ins high

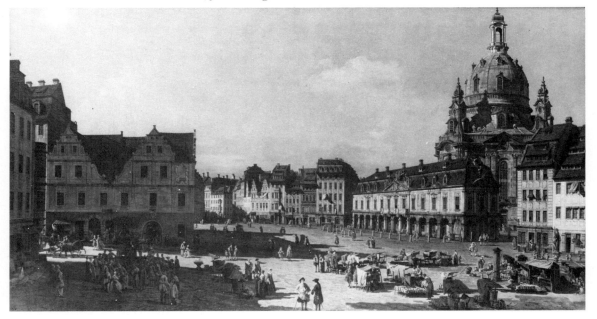

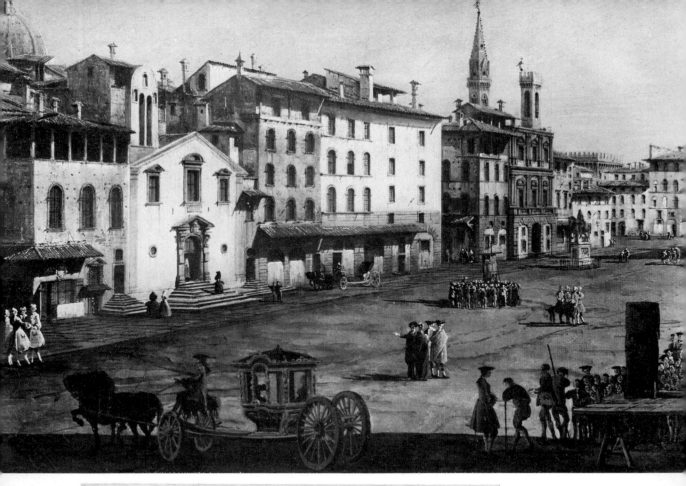

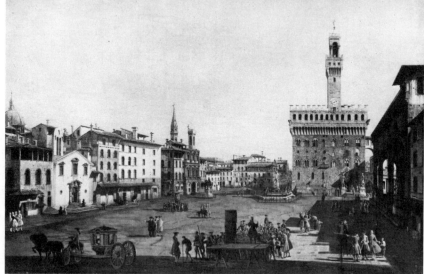

*165 Florence about 1745,
2 ft high, and detail*

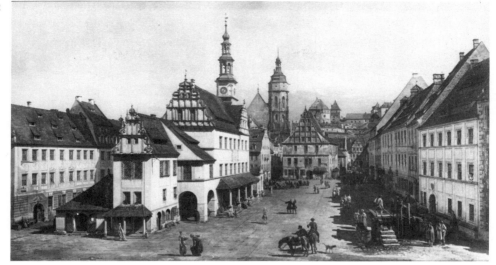

166 Pirna, 1753–4

167 Detail from Plate 166

plate 164

For the first nine years all went well and Bellotto painted large scenes of the beautiful rococo city for his master, slightly smaller ones for the chief minister and smaller ones still for the ordinary paying public. The Seven Year War then broke out and the Elector and his Court moved to Warsaw, capital of his other kingdom, leaving Bellotto behind in Dresden under Prussian occupation. Bellotto remained another two years and then became court painter to the Empress Maria Theresa of Austria where for two more years he painted the baroque palaces and streets of Vienna and its surroundings. The appointment must then have come to an end as he returned in 1762 to a Dresden which had been almost destroyed and where he was able to obtain only a subordinate post as a teacher of perspective.

It was not until 1767 that he decided to seek better things in St Petersburg and even then he preferred to ask for seven months leave of the Dresden Academy rather than burn his boats. On the way to Russia he stopped at

168 Warsaw about 1770, detail

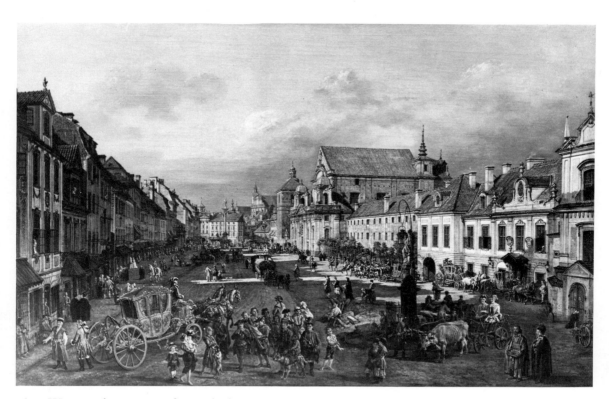

169 Warsaw about 1770, 3 ft 8 ins high

Warsaw where the king who had abandoned him had died and been succeeded by the brilliant Stanislaw August. Bellotto was immediately commissioned to paint murals in a new royal residence and pleased the king well enough to be offered the post of court painter. He moved his family to Warsaw and stayed there the remaining 13 years of his life, during which he painted about 70 pictures including a dazzling series of 26 views within the city.

But almost all Bellotto's views dazzle. For him the sun was always shining (even occasionally on the north façade of a building at midday) and casting deep contrasting shadows in a way one cannot help suspecting he remembered from his Venice days rather than observed every day in northern Europe. For him there were no grey days, no seasons and the light was as penetrating on the horizon as in the foreground; atmospheric perspective was something he disdained as weakening the clarity of his vision. On the other hand he was a master of linear perspective to such an extent that many, including his biographer, have found it impossible to

plate 170

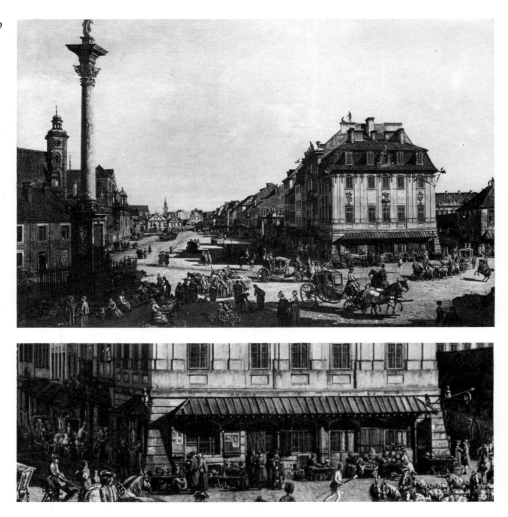

believe such realism could have been achieved without artificial aid. Preposterous things have accordingly been written about Bellotto's use of the camera obscura[1]. He is said to have set it up in the upper rooms of houses overlooking his streets, on movable platforms such as those used by parkkeepers for lopping trees, anywhere in fact which would account for the high viewpoint he was inclined to prefer.

The magical results of Brunelleschi's discovery of perspective are not even yet fully realised and accepted and whenever an unusual effect, or exceptional realism, appear in a painting the camera obscura is called upon to explain the mystery. (In the case of Vermeer it has even been suggested

[1] See Appendix to this chapter.

1 *Warsaw in mid-'70's*
d detail

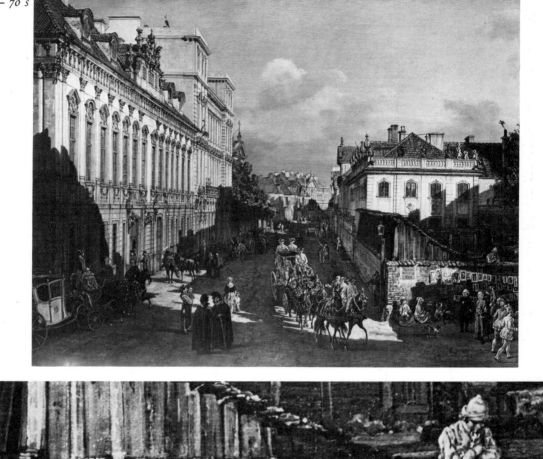

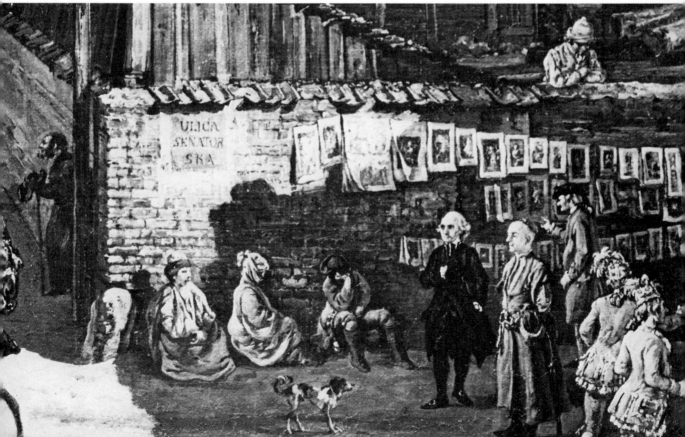

that he painted interiors with a camera obscura – and this by a practising artist of distinction.) In fact, most first-year architectural students would have little difficulty in transposing the actual viewpoint of a drawing to an imaginary one which was higher, lower or to one side or the other; to a Canaletto or a Bellotto it would be child's play. No doubt both used a portable camera obscura when making complicated sketches of buildings; such sketches would often be more quickly accomplished than with the naked eye being constantly raised and lowered. Anyone who has ever used a camera obscura[1], however, knows that such sketches could be of no more use than as an *aide mémoire* and that there could be no question of producing a drawing which was a work of art through its means, much less a painting – apart from the difficulty of having to work in semi-darkness.

In addition to the intensity of his light and the absence of aerial perspective, Bellotto had a characteristic of often making his figures seem stunted, perhaps deliberately to emphasize the high viewpoint he enjoyed, perhaps for other unknown reasons. His foliage, too, frequently has an unusual hook formation. He was a truly individual artist who cannot be said to have influenced topographical art in the way his uncle influenced it. As a recorder of the daily street life of a capital city, of the grand people driving in their gay coaches, the crowds in the market place, the picture sellers, hawkers, jugglers, cripples, Jews, gossips, self-satisfied merchants and proud gentry – of all this and much else, Bellotto surpassed Canaletto himself. An enlargement of a few square inches from the centre of any of his paintings reveals a picture in itself which is apt to be lost in the whole canvas and his paintings (most numerous in Dresden, Warsaw and Budapest but also to be seen in a group in Vienna and, singly, elsewhere) should be examined through a magnifying glass.

[1] Those who have recorded their experience include Martin Hardie (*Water-colour Painting in Britain; The Eighteenth Century*, Batsford, 1966, p. 43), and Terisio Pignatti (*Il Quaderno di Disegno del Canaletto . . .*, Guarnata, 1958, p. 20 ff.).

H. A. Fritzsche devoted a great deal of space in his biography *Bernardo Belotto genannt Canaletto* to Bellotto's use of the camera obscura. The kind of thing he and others have written on the subject is typified in seven lines by Henner Menz, a director of the Dresden Gallery, commenting on Bellotto's *New Marketplace*, Dresden[1] (Pl. 164, showing the original Gallery itself):

> The exaggerated perspective must be laid to the blame of the camera obscura (1), of which Bellotto made use for many of his architectural pictures (2). The lenses of that day allowed little light to pass through, so that the apparatus was useless except in strong sunlight (3). This accounts for the bright light with which Bellotto's pictures are uniformly flooded (4), and their lack of depth. The most distant objects stand out sharply, as though a stone's throw away (5), instead of being wrapped in the poetic mist of which uncle, Canaletto, was so fond (6).

1 A camera obscura cannot alter perspective. The exaggerated perspective, if it exists, can be due only to the artist's viewpoint being closer to the subject than the observer would expect it to be.

2 No real evidence of this has ever been produced, nor could evidence exist in the artist's work itself.

3 Eighteenth-century camera obscuras project a perfectly visible image on a dull day, if viewed in darkness; if viewed in full light the image is hardly visible irrespective of weather.

4 Is it suggested that Bellotto *painted* by means of the camera obscura? That he could paint sunlit streets only while the sun was shining? And only by looking at the streets through a lens?

5 Distant objects stand out much less sharply through a camera obscura lens, when the atmosphere is clear, than when seen by the naked eye. If they are in fact 'wrapped in poetic mist' they cannot be seen at all through the lens.

6 Almost every biographical reference to Canaletto refers to his use of the camera obscura, in spite of his 'poetic mist'.

[1] In *The Dresden Gallery*, Thames & Hudson, 1962, p. 64.

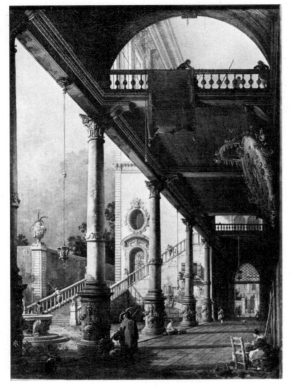

CANALETTO – THE END AND THE BEGINNING

In 1756, the year the Elector of Saxony was driven out of Dresden, leaving Bellotto behind, and the year after Canaletto's probable return to Venice from London, the Venetian Academy was founded and the number of members was fixed at 36. Canaletto was not invited to be one of the founder members. It might have been thought that his absence from the city was the cause of the omission but this would not have been at all true. Nor would it be true that he did not want to be a member. He wanted the honour very much and in 1763 he had his name put up for election to one of the three vacancies which had occurred. He was 58 years old, the most celebrated view painter in Italy, indeed in all the world, and he was still drawing and painting, albeit without the fervour of his early years. But he was not elected. Zuccarelli and two artists called Gradizzi and Pavona, who soon sank without trace, were elected instead. Townscape painting may have been successful but it was not respectable.

In September of the same year there was another vacancy and this time

226

Canaletto was elected – though by no means unanimously. Of course no claim can be made that the turning point in the status of view painting came between January and September 1763. It is more probable that the irony of the Academicians' intransigence had been pointed out to them and that they reluctantly relented. Anyway, Canaletto was in but he had the good sense not to provoke his brother artists by depositing as his election piece the kind of painting which had brought so much fame to him. He gave them an *Architectural Caprice* which now hangs in the Venice Academy of Fine Arts (and, in replica form, in many, many other places). There is still no view of his to be seen in Venice.

Three years before Canaletto's election to the Academy, Gian Antonio Guardi died and his brother Francesco was left to stand on his own feet. He was 15 years younger than Canaletto and evidently saw a promising career open to him in view painting. It is hardly surprising that in the early

173 Rialto Bridge, F. Guardi, 2 ft 6 ins high

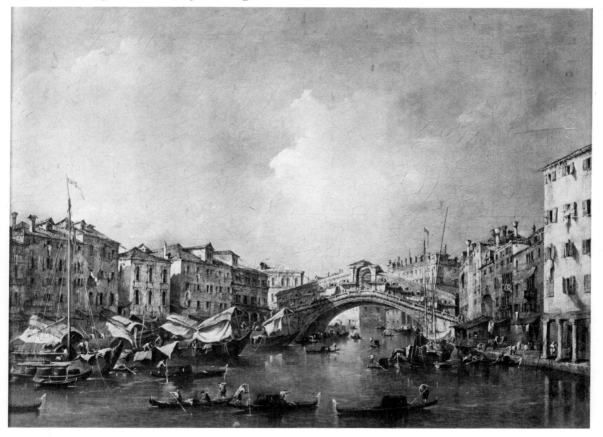

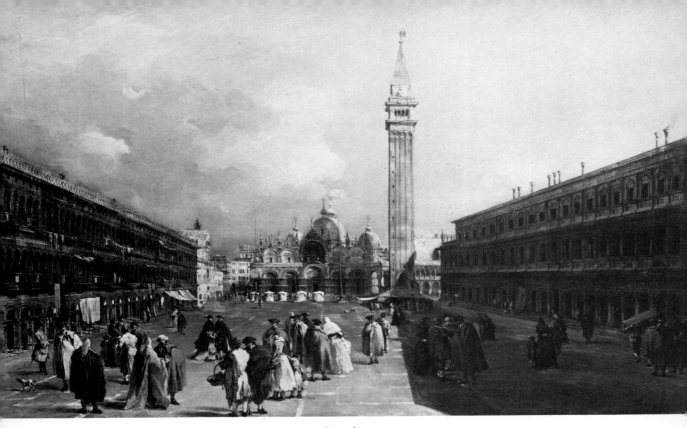

174　*Piazza S. Marco, F. Guardi*

stages of an entirely new career to him Francesco Guardi should have
modelled his style closely on that of his older and famous contemporary.
What is surprising is that he turned to Canaletto's earliest work as his
example, the type of painting Canaletto had done for the Prince of Liech-
tenstein and Stefano Conti and had abandoned more than 30 years earlier.
Guardi's *Rialto Bridge from the South* in the Wallace Collection, for instance,
might almost have been painted by Canaletto at that time; it could not
possibly be a late Canaletto – yet it was painted in about 1760.

plate 173

An even more remarkable comparison is of Guardi's painting of the
Piazza S. Marco in the National Gallery, London, with Canaletto's earliest-
known work painted about 40 years before (Pl. 127). The viewpoint is
one storey lower than Canaletto's and the scene seems somewhat stretched
laterally; the Piazza is, of course, shown with the paving which had been
laid down in 1723. But the 'feel' of the painting is close to that of Canaletto's
early picture – and much closer than to his later version from the Fogg
Museum's collection (Pl. 135). It is not surprising that the painting was
bequeathed to the National Gallery as a Canaletto. From 1854 onwards
it was regarded as a Guardi but this did not deter J. P. Richter, an eminent

228

art historian of the nineteenth century, from suggesting that 'the original naming was justified'. (It is worth comparing the Campanile in the two pictures. Guardi makes it a rectangular block, seven times its width up to the first projecting cornice. Canaletto makes it a tapered structure, as it is in fact, only five times its width; even he, though, exaggerates the height considerably.)

As Guardi gained in confidence in his new work so he developed a style of his own, the style we all know him by. If he hoped, as he must have hoped, to capture the market Canaletto had dominated, as Canaletto 35 years earlier had captured that of Carlevaris, he must have been sorely disappointed. Hardly any of the great eighteenth-century English or Italian collectors bought his paintings; art critics and his fellow artists took no notice of him at all and when he was 72, and had been painting views for 20 years, he could command only half as much as Canaletto had been paid at the age of 30. This was no doubt because there had been a change of taste in Italy and Guardi's work was against the trend towards 'neo-classicism'. His clientèle, so far as can be made out, and it is far less documented than that of Canaletto, consisted mostly of his friends and minor professional men in Venice, including one or two English residents, and a few collectors of no greater significance on the mainland of northern Italy. He must have painted over 1,000 pictures in his lifetime, yet less than 200 can be traced to their origin – very different from Canaletto, so much of whose work remains today in the hands of the descendants of those who first bought it.

As far as election to the Academy was concerned, he could not have hoped for early success when he turned from figure painting to views; the precedent of Canaletto was sufficient warning. In the event, he had to wait until he was 72 and even then the fact that his brother-in-law, G. B. Tiepolo, was the President may have had more to do with his election than any change of heart on the part of the artists.

To return to Canaletto, his output after his return from England was small by the standards he had set in the early days. There were a few views of Venice, rather more *capriccii* such as he produced since the beginning of his career, one of which he had given to the Academy (Pl. 172) and an often-told story of his being seen by a young Englishman on the Grand Tour with his bear-leader drawing the Campanile in the Piazza. 'Canaletti?' asked the tutor, John Hinchliff, later Bishop of Peterborough. 'Ah, you know me', answered the artist and took the pair to his studio, where he gave them the sketch and sold them the painting not yet made from it (neither is identifiable with certainty). There is no reason to doubt the story and it is highly significant that after the hundreds of drawings Canaletto must have

made of the Campanile he was still making *plein air* sketches of it.

In 1766 he made a pen-and-wash drawing of the inside of St Mark's which he not only dated but to which he added an inscription to the effect that it was done in his sixty-eighth year 'Cenzza Ochiali' (without spectacles). On 19 April 1768 he died aged 71, and the field was left open.

With the conclusion of Canaletto's career the story of the development of the art of townscape painting may be said to have ended: now its history was to begin. The portrayal of cities, with their streets and buildings, had begun as a matter of recording, as in the case of the Avezzano sculptor, the Antioch mosaicist or, later, the illustrators of travellers' journeys such as Reuwich or Braun and Hogenberg. It had served other purposes: as backgrounds designed to give conviction to the subject of a picture, as in the case of Lorenzetti or the Flemish masters, or for exercises in the practice of perspective, as in the case of Brunelleschi and the masters of *intarsia*. It had brought vitality to the map or plan by substituting the more realistic bird's-eye view as in the case of the Florentine engraver or de' Barbari. But, until Canaletto, it had not become Art.

It is true that he was not entirely an innovator. A Saenredam, two Vermeers, 200 van der Heydens and an El Greco are enough to deprive him of any such claim, apart from the work of his immediate predecessors such as Heintz or Carlevaris. Nevertheless, three of the first four painters mentioned were interested in townscape painting so little that they never returned to it after their one or two masterpieces in the field. As for van der Heyden, perhaps he was in advance of his time; perhaps his choice of subject was bound to have little impact when, for the first time in art history, every kind of commonplace object, incident or situation was becoming the subject of a new, meticulous and, for the most part, bourgeois, art. Whatever the cause, the school van der Heyden had created petered out, as did so much of the seventeenth-century Dutch school, and long before his death he had even abandoned it himself.

How different it was with Canaletto. At the age of 26 he painted the Liechtenstein *Piazza San Marco* (Pl. 127) (now in Lugano but, from the owner's choice, in his dining room rather than in his adjoining gallery containing many of the world's great masterpieces). It is a painting of buildings, a study of the textures of stone, brick and marble, gilded by the Venetian light. It is topographically almost exact, yet woven by the hand of a master into a work of the highest pictorial quality – in short, a masterpiece if only a minor one. The irrelevance of its immediate predecessors may be judged by comparing it with Heintz's rendering of the same subject (Pl. 121).

Far from abandoning the course foreshadowed by his *Piazza San Marco*, Canaletto followed it until the end of his life, occasionally producing an even finer work and always adding lustre to the subject he had made his own. A minor master, no doubt, but a master who elevated an essentially bourgeois art to the requirements of a clientèle which was, at any rate in eighteenth-century terms, aristocratic. The eighteenth-century English dukes may have been a long way in artistic taste and patronage from the de Medicis of sixteenth-century Florence or the fifteenth-century Duke of Urbino, but they were a cut above the seventeenth-century Dutch merchants who provided Jan van der Heyden's patrons. From the time of Canaletto's death, no artist, whatever his stature, would hesitate to use the town as his subject if he so chose and no patron, whatever his rank, would deem a townscape painting unworthy of his collection (or even of his dining room).

The history of the art, which was now to unfold, can be dealt with only cursorily here.

CANALETTO'S INFLUENCE

It was in England that Canaletto's influence was most felt, partly because of his long residence in the country and partly because that was where the bulk of his life work was hung. By the time he left England in about 1755 a school of topographical art, for the most part in the form of water-colour drawing, had been founded which was destined to add high lustre to English art. The Sandby brothers, Thomas and Paul, were at first satisfied to become mere imitators of Canaletto, only later developing their own style which was still based on his. It is hard to date Samuel Scott's work but there is every reason to suppose that he would have remained a sea-scapist all his life but for Canaletto. As it was, he turned to townscape painting in which he sometimes achieved a mastery excelling all but his master's best work.

plates 175–8

231

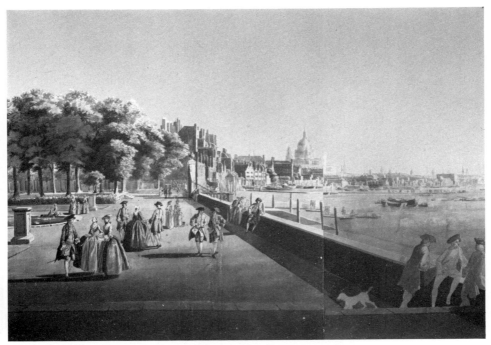

175 *View from Somerset House, Thomas Sandby, water-colour*

176 *View from Somerset House, Canaletto, pen and wash*

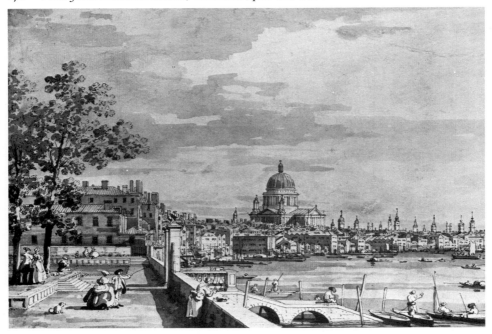

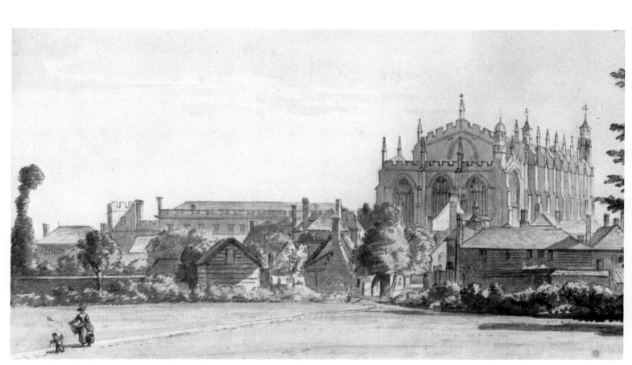

177 *Eton College from the West, Paul Sandby, detail*

178 *Eton College from the East, Canaletto, detail*

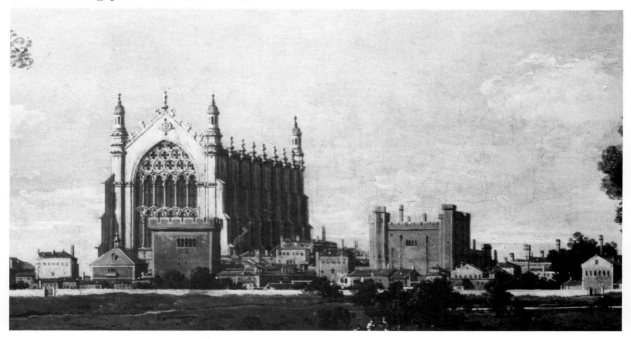

Canaletto's influence was even greater on the generation that succeeded him than on his contemporaries. William Marlow was born in 1740 and became a pupil of Samuel Scott in 1756, the year after Canaletto left London. He remained with him for five years during which time, according to Marlow, Scott 'had much business', probably partly due to Canaletto's absence. Marlow's reliance on Canaletto's methods, no doubt through Scott, is particularly evident in his paintings and water-colour drawings

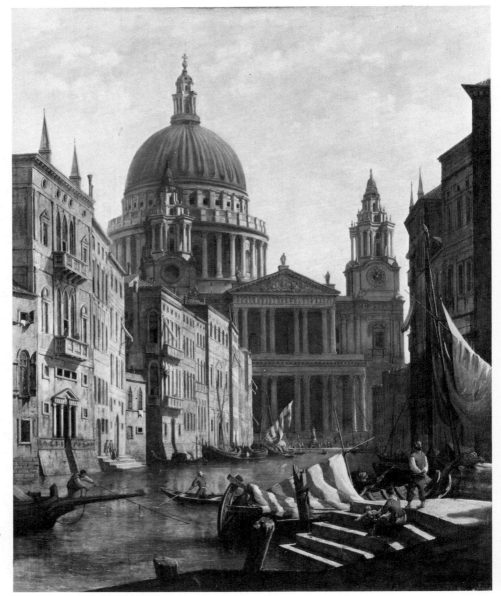

179 *William Marlow*

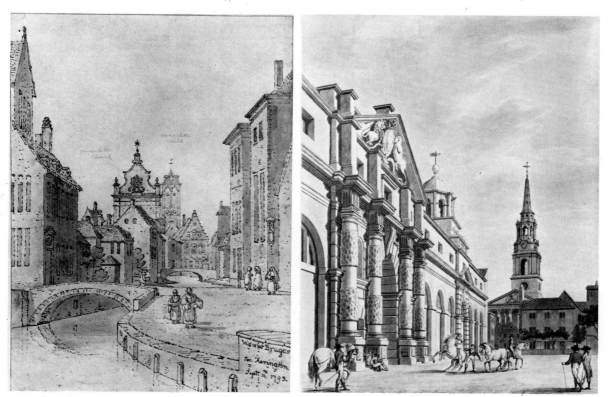

180 *Joseph Farington* 181 *King's Mews, Charing Cross, Thomas Malton*

of London scenes. Probably his best known painting is a pastiche of a
Canaletto Grand Canal scene (but with very un-Venetian palaces) domi-
nated, not by the church of the Salute, but by London's St Paul's Cathedral.

Joseph Farington (to whom Marlow made the remark about Scott's
business) was born in 1747 and is best known for his drawings for topo-
graphical publications, some in aquatint such as the *History of the River
Thames* (1794). Farington recorded his admiration of Canaletto in his diary
and on the distant tower of one of his drawings of Bruges he wrote 'Canaletti
brick'. His use of Canaletto's broken and dotted line in brown ink to
represent old and crumbling stone work is very apparent.

It is hard to imagine what the charming street scenes of Thomas Malton II
would have been had Canaletto never lived. Malton was born in 1748,
after Canaletto's arrival in England, and was the son of an architectural
draughtsman of the same name. He taught the art of perspective, and among
his pupils was J. M. W. Turner who later acknowledged his indebtedness

235

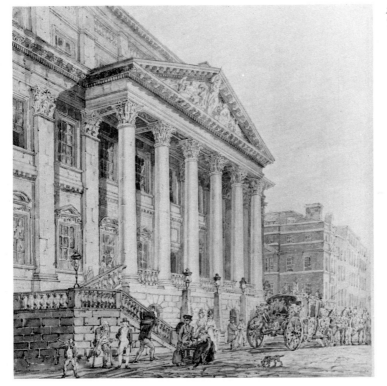

to Malton. Turner himself did not follow Canaletto's methods but he admired him enough to include 'Canaletto painting' in his view of the Molo, now in the Tate Gallery; this was a high tribute from Turner.

Thomas Girtin, born in 1775, was another who owed a debt to Thomas Malton. He frequented the house of John Henderson, a well-known collector of his day, where he copied a number of Malton's street scenes, much improving on them even at this early stage of his career. Girtin is also said to have copied Canaletto paintings and drawings at Henderson's house but Henderson was unfortunate with Canaletto; the paintings he left to the National Gallery are now catalogued as 'studio of Canaletto' and doubts have been thrown on the drawings he left to the British Museum. On the other hand, Malton also visited Sir George Beaumont's house and Sir George was at this time the owner of *The Stonemason's Yard*; he could hardly have hoped for anything better.

'If Tom Girtin had lived, I should have starved', said Turner in a much quoted remark and, however little he may have meant it, there is no doubt as to Girtin's stature as an artist. The most ambitious undertaking of his short life was a great panorama of London, now lost, called *Eidometropolis*.

It was a true panorama in that it formed a complete circle over nine feet high and 200 feet in circumference, and Girtin's surviving sketches for it, now in the British Museum, give some idea of its splendid composition. For his viewpoint, Girtin chose the southern end of Blackfriars Bridge – a few hundred yards from the spot in Southwark where Wyngaerde in the 1540s and his 100-odd successors had drawn their views of London.

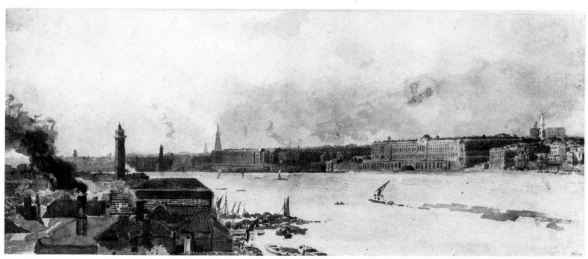

183 Somerset House from Blackfriars Bridge, T. Girtin

184 Westminster and Lambeth from Blackfriars Bridge

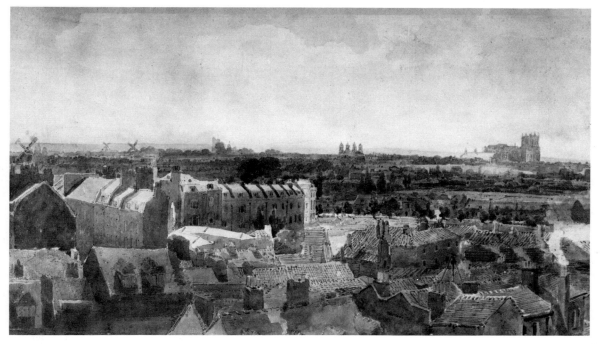

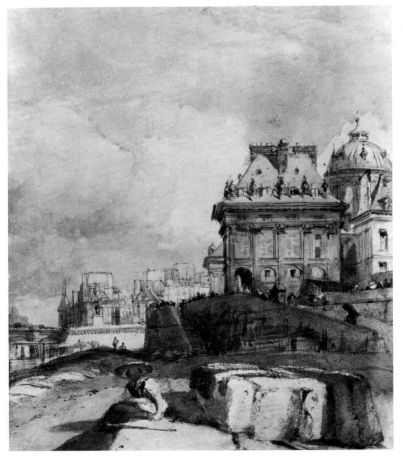

185 *The* Institut, *Paris,*
R. P. Bonington

In the year of Girtin's death, 1802, Richard Parkes Bonington was born, only to die, like Girtin, at the age of 27. The sharp, dry brush strokes he used in his superb street scenes must have been influenced by Canaletto's painting. And, as Bonington was influenced, so must Thomas Shotter Boys have been, for he was Bonington's close friend and follower. Although only two years younger than Bonington we think of Shotter Boys as a Victorian artist, for his attractive lithographs of Paris and London were published in 1839 and 1842 respectively. They provide some of the rare records of a period when aquatint engraving was dying out and photography was still in the experimental stages. Shotter Boys did not die until 1874 which was a century after Canaletto's death, and the year the Impressionists held their first exhibition which gave them their name. From that point topographical art followed a very different course.

238

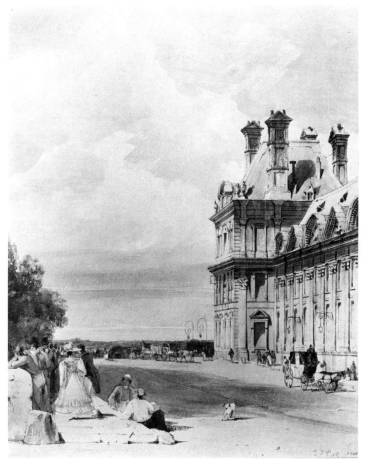

186 The Tuileries, Paris,
T. Shotter Boys

In his own city of Venice Canaletto had no successors of significance and seems to have exercised little immediate influence. He had plenty of imitators; their work had always abounded and soon proliferated to the confusion of collectors and dealers to this day but they were not taken seriously by collectors of any discrimination. This may well have been due, to a large extent, to the change of taste towards neo-classicism, already noted. Nevertheless, one would have expected Francesco Guardi, who was by far the most illustrious successor to Canaletto, to have made some impact.

We have already seen how small this proved to be before his death in 1793. His standing in the early years of the nineteenth century is illuminated by a letter written to Antonio Canova, already the most famous sculptor of his day, in Rome in 1804 replying to a request for some views of his

239

native Venice. Pietro Edwards, to whom Canova had made the request, wrote that it was most difficult to get what his friend wanted. Canaletto was by now quite unobtainable, and so even were works by his much inferior nephew Bellotto, and by Marieschi. Visentini, Joli and Battaglioli had painted almost exclusively scenes on the mainland or *capriccii* and so would be of no use. There remained Guardi. He too was not easily obtained as, in the absence of anything better, his works were now much sought after. In any case his views were very inaccurate though spirited. Besides this his technical deficiencies were outstanding. Guardi had had to work hard to earn his daily living. He had had to buy wretched canvases badly primed; he had made use of excessively oily colours. It was very doubtful indeed whether his pictures would last more than ten years. None the less efforts were being made to buy some. A few had already been seen but the price was excessive. They were pretty but no more. Meanwhile, Edwards wrote, he would go on trying. How sad, he ended, that even this branch of the great tree of painting was drying up in Venice. 'There are no more view painters of quality.'

Pietro Edwards, who was of English descent, lived at the very centre of artistic life in Venice and knew Guardi well; he had himself commissioned four pictures from the painter in 1782. There can be no question that his letter reflects the true feeling of his time, 11 years after Guardi's death. It was to be many years before Guardi's worth would be recognised and his work studied; even now it is impossible to guess what kind of an artist he would have been had Canaletto never lived or what the relationship between the two men was, if any existed.

'This branch of the great tree of painting' may have been drying up in Venice, as Edwards wrote, but it was flowering everywhere else. Whether Canaletto's methods were followed or not, the art of townscape painting, which he had done so much to create, was taken up by a vast number of painters and draughtsmen including the great, the less great and the small. Every city had its portrayers, in paint, pencil, pen and, above all, the tools of the engraver; the demands of public and publisher for views could scarcely be met. The only travellers who did not demand views to take home were those, and they were many, who found the art so easy that they preferred to make their own.

VI EPILOGUE: DOUBTS

It was in France that the direction which the art had been taking for so long was violently changed. Fouquet's view of the Île de la Cité in Paris (Pl. 25) was painted before 1450 and Corot's *Quai des Orfèvres* from virtually the same spot in 1833. Both artists tried to convey a sense of space, of a series of buildings on planes receding from the spectator's viewpoint. Both artists

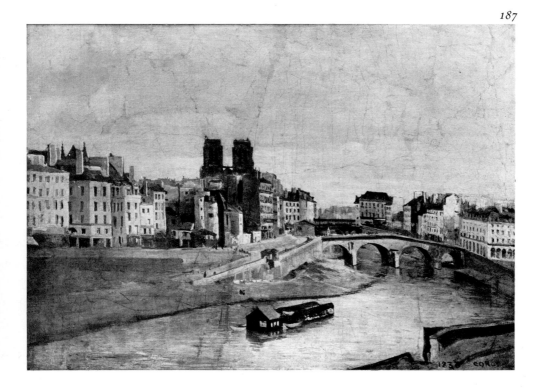

knew all about Brunelleschi's system of achieving this result by scientific methods. To Fouquet it was something new and the evidence indicates that, after trying it, he felt it had little future (see p. 33). Corot had seen the system developed to finality; he seems to feel there is something beyond it – as indeed there proved to be. There were no more experiments in perspective to be made and he devoted himself instead to the painting of trees that birds could fly through in his landscapes and white walls in his townscapes, white walls as they had not been painted since Saenredam (and were not to be painted again until Utrillo).

Four years before Corot's *Quai des Orfèvres* was painted, photography had been invented in France and artists were gradually realising its implications. At last it was possible to 'fix' that image which had for so long appeared on the ground glass of the camera obscura, so tantalizingly visible only in semi-darkness. 'This is the end of Art', said Turner on seeing his first daguerreotype, 'I am glad I have had my day.' Ruskin later recalled his own reactions: 'I found a French artist producing exquisitely bright small plates which contained, under a lens, the Grand Canal or St Mark's Place as if a magician had reduced the reality to be carried away into an enchanted land.'

By 1860 it was not only possible to take 'instantaneous' photographs of street life: stereoscopic photography had been invented and the artists' age old problem of conveying spatial realism had been solved. As with Brunelleschi's invention there were difficulties; instead of looking at a reflected

188 *Ruskin's daguerreotype of St Mark's*

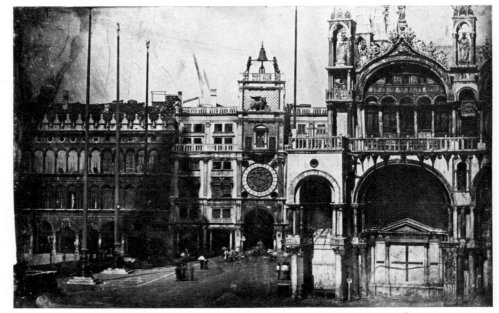

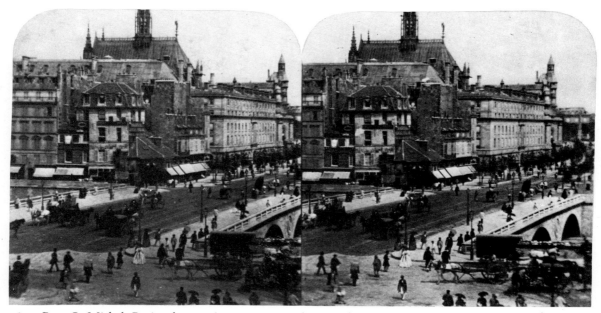

189 Pont St Michel, Paris, about 1860, stereoscopic photograph

image through a peephole (p. 20) the spectator had to focus each eye on a
separate photograph by means of an instrument. For those willing to suffer
this inconvenience a whole new world of three-dimensional sensation was
opened up. It was too late, though. The world had learnt to accept Brunell-
eschi's trick as if it were the real thing and, except as a kind of parlour
game[1], preferred single pictures that could be looked at with two eyes to
double ones requiring the use of an instrument.

Moreover, photography proved not to be 'the end of Art', as Turner
had feared. Art is resourceful at adapting itself to new conditions and
artists soon learnt to see in a way the camera could never aspire to. No
longer was there bourgeois and aristocratic art, northern realism and
southern humanism, romantic and classical art. There was the art of original
vision and all other kinds. Photography, and its imitators among artists,
provided the other kinds; the Impressionists, and those who came after
them, provided the original vision, learning much from photography as
they went along.

In all these developments the townscape played a dominant part as
subject. The first photograph was of a building, and it was probably as

[1] A highly popular parlour game. The London Stereoscopic Company advertised in 1858 a stock
of 100,000 photographs, almost all topographical and mostly of famous buildings and city views.

243

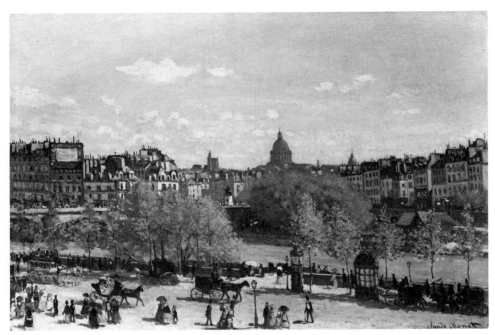

190 *Quai du Louvre, Paris, in 1866, Monet*

191 *Paris from Montmartre in 1886. Van Gogh (compare plates 21 and 22)*

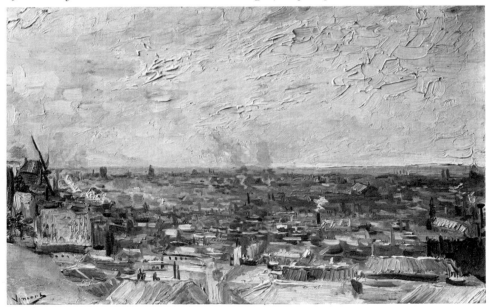

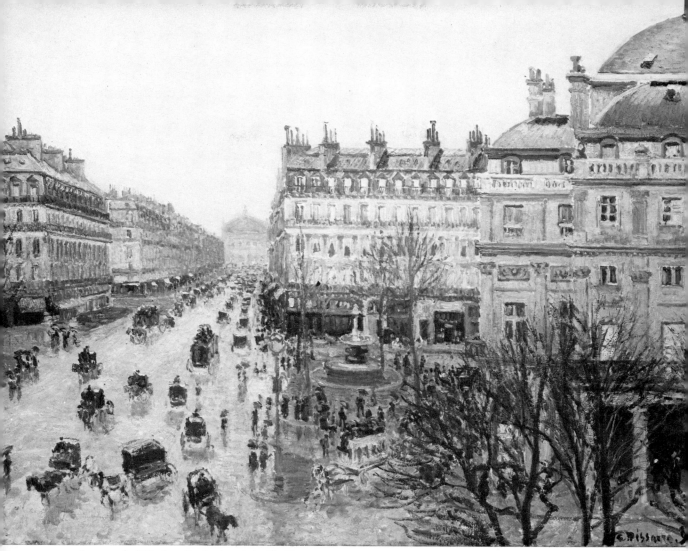

192 *Avenue de l'Opéra, Paris, in 1898, C. Pissarro*

early as 1841 that Ruskin saw daguerreotypes being taken in St Mark's Place for publication in *Excursions Daguerriennes* in 1842. The streets of Paris were the subject of the earliest stereoscopic photographs published in 1860–5. When Monet and, later, van Gogh and Pissarro and many others set out to paint sunlight, and so defy the camera, they painted the houses and streets they lived among and walked past every day. They did not need the noble palace or the ideal city for their inspiration. It was enough to study the everyday life of the town around them and invest it with the magic of the artist's individual eye.

This is what Ruskin called seeing angels where others see only empty

plate 189

245

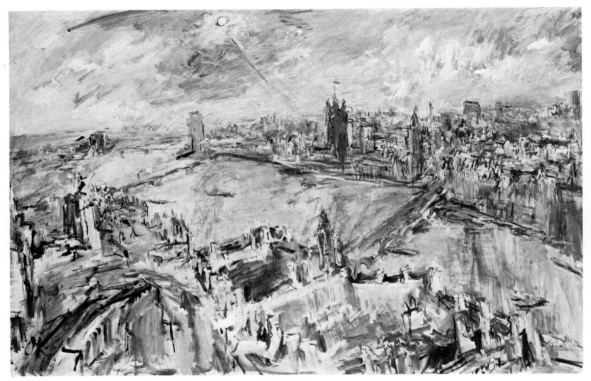

193 *Westminster, 1967, O. Kokoschka*

space. Oskar Kokoschka (born 1886) has described it equally felicitously, as might be expected of an artist who has painted some of the most distinguished townscapes of our own time. We who have been so concerned with the development of the third dimension in the portrayal of cities will respond with understanding when he says:

> Painting, you know, isn't based on just three dimensions, but on four. The fourth dimension is a projection of myself. . . . The other three dimensions are based on the vision of both eyes (not just one): the fourth dimension is based on the essential nature of vision, which is creative.

So it was with Ambrogio Lorenzetti and Robert Campin, with Canaletto and Monet, and so, no doubt, it always will be.

SOURCE NOTES AND INDEX

Source notes

Page

3 Quotations from *Modern Painters*, Vol. 4, Chap. 2, Vol. 6, pp. 28–9 in *Library Edition of Ruskin's Works*, subsequently referred to as '*Works*'.

6 Translation of Vitruvius from Sir Mortimer Wheeler, *Roman Art and Architecture*, Thames & Hudson, 1964, p. 186. John White, in *The Birth and Rebirth of Pictorial Space*, Faber 1957, p. 254 ff, uses a different translation and discusses the passage in detail. All references to perspective are influenced by White.

7 Description of the Antioch topographical border from Glanville Downey, *Ancient Antioch*, Princeton, 1963, plates 46–52. Translation of Libanius from Lewis Mumford, *The City in History*, Pelican 1966, p. 247.

14 'the edge of pure landscape'. See A. Morassi on Giorgione's *Tempest* in *Le Arti*, 1939, p. 567, quoted by Creighton Douglas in *On Subject and non-subject*, Art Bulletin, 1952, p. 211. 'its symbolism can be unravelled'. See Nicolai Rubinstein, *Journal of the Courtauld and Warburg Institutes*, Vol. 21, 1958, pp. 179–207.

16 'a professor in his Chair' and other figures; see Pierre Lavedan, *Representation des Villes dans l'Art du Moyen Âge*, Paris, 1954, p. 20.

17 'sucking the composition in'. See White (*op. cit.* note to p. 6), p. 94.

18 *City by the Sea*, see Abraham Ronen, *A Detail or a Whole, Mitteilungen der kunsthistorischen Institutes in Florenz*, 1963, p. 286 ff, with sources quoted of all other contributions to the controversy.

18 For identification of the city see Enzo Carli, *Guida della Pinacoteca*, Siena, 1938. See also Millard Meiss, *French Painting in the Time of Jean de Berry, Late 14th century*, Phaidon, 1967, p. 230 and p. 394.

19 Decio Giosefi places the date of the Piazza del Duomo painting as 1401–1409 and that of the Piazza della Signoria as 1410–1415 by reference to Donatello's base (1416) for his statue of St George Slaying the Dragon (Enciclopedia Universale, English edition New York, 1966, p. 203). These are a little earlier than the dates formerly assumed.

20 Translation from Manetti by Elizabeth Holt and Creighton Gilbert in *A Documentary History of Art*, Vol. 1, Doubleday N.Y., 1957. White (*op. cit.* note to p. 6) uses a different translation and discusses Brunelleschi's two paintings in detail, p. 113 ff.

24 For the illustrations to Mandeville, see G. F. Warner in the publication of the Roxburghe Club for 1889. For Mandeville himself see Sir Henry Yule, *Encyclopedia Brittanica*, 11th edition, extracts from which appear in later editions.

29　For the Boucicaut Master see Millard Meiss, *French Painting in the Time of Jean de Berry, The Boucicaut Master*, Phaidon, 1968. For identification of the Châteauroux miniature, see J. Hubert, *Mémoires de la Societie Antiquaires de France*, Vol. 72 (1924–7), pp. 25 ff.

32　For Fouquet generally see K. G. Perls, *Jean Fouquet*, Hyperion, New York & London, 1940 (fully illustrated) and Paul Wescher, *Jean Fouquet and His Time*, Pleiades, 1947 (fewer illustrations but more text).

33　For the missing page from Etienne Chevalier see Sotheby's Catalogue, 16–18 December 1946.

34　For identification of Fouquet's backgrounds see Paul Durrieu, *Les Antiquités Judaïque*, Paris, 1908; *Grand Chroniques de France*, Bibliothèque Nationale, undated but 1906; H. Martin, *Les Fouquets de Chantilly*, Paris, 1926.

40　For the passing of time in the Ingelbrecht Altarpiece, see Charles de Tolnay in *L'Autel Mérode du Maitre de Flémalle*, *Gazette des Beaux Arts*, Vol. 53, 1959, p. 69 ff.

34　For the Ghent Altarpiece see P. Coremans, L. Loose and J. Thissen in *L'agneau Mystique au Laboratoire*, 1953, p. 120 ff, and O. Paecht in *Burlington Magazine*, Vol. 98, 1956, p. 110 ff.

For identification of the buildings in the Ghent altarpiece see P. Coremans and Bisthoven in *L'Adoration de l'Agneau*, Brussels, 1951, and (for Ely and Ilminster) Helen Rosenau in *Some English Influences on Jan van Eyck*, Apollo, 1942, p. 125.

48　For identification of background to Chancellor Rolin see F. de Mely, *Revue Archéologique*, 5th series, Vol. III, 1916, p. 272 ff, listing most other contributions to the discussion up to that date, and J. Lejeune, *Les Van Eycks, peintres de Liège et de sa cathédrale*, Liège, 1956, with further bibliography.

49　For 'two thousand people' see Joseph Gilbert in *Landscape in Art Before Claude and Salvator*, Murray, 1885, also the authority for 'the portraits of possible wives' as the purpose of van Eyck's journeys.

51　For 'artists' bladders' and further discussion of the backgrounds reproduced see Emile Renders, *La Solution du Problème van der Weyden, Flémalle, Campin*, Beyaert, Bruges, 1931, Vol. II, p. 39. One of the bladders, or bags of skin, is shown in a still life by Chardin, reproduced in W. G. Constable, *The Painter's Workshop*, Oxford, 1954, Pl. II.

59　Kenneth Clark quoted from Foreword to *Leonardo da Vinci on Painting, a Lost Book*, by Carlo Pedretti, Peter Owen, 1965.
For the translation of Leonardo from A. Philip McMahon, *Treatise on Painting by Leonardo da Vinci*, Princeton University, 1956, pp. 101–2.
For Leonardo on Perspective see C. Pedretti, *op. cit.* p. 167 ff.
For Brunelleschi's perspective see R. Wittkower in *Brunelleschi and Proportion in Perspective* in *Journal of the Courtauld and Warburg Institutes*, Vol. 16, 1953, p. 275 ff.

61　For distortion of vertical lines in close buildings see John White in Courtauld/Warburg Journal, Vol. 1, 1949, p. 58 ff, and J. Ruskin, *The Convergence of Vertical Lines*, 1840, Works vol. 1, p. 215. For the 'beholder's share' see E. H. Gombrich, *Art and Illusion*, Phaidon, 1960, Chap. VIII.

64　For the 'ideal city' panels see Fiske Kimball in *Art Bulletin*, 1927, p. 125 ff and Kenneth Clark in *The Arts*, No. 2, p. 36. Howard Saalman in the *Burlington Magazine*, July, 1968, p. 3, provides the latest contribution. For the suggestion that they were *cassone*

panels see van Marle in *The Development of the Italian Schools of Painting*, Vol. XIV, p. 155.

66 For *intarsia* see F. Arcangeli, *Tarsie*, Rome 1943, André Chastel, *Citées Idéale*, L'Oeil, 36, 1957, p. 32 ff, and Edward Pinto, Apollo, LIX 1954, p. 147. Cecil H. Clough suggests Piero della Francesca may have designed the Urbino and Gubbio panels, Apollo, XCI 1970, p. 285.

75 Ruskin quoted from *Works*, Vol. 24, p. 163.

77 For Carpaccio's buildings, and generally, see Terisio Pignatti, *Carpaccio*, Skira, 1956.

79 The Duke of Urbino's library: G. H. Putnam, *Books and their Makers*, 1896, p. 366, quoting Burckhardt's *Die Kultur der Renaissance*, i, p. 239.
For Schedel's and Carpaccio's borrowings from Reuwich see Hugh W. Davies, *Bernhard von Breydenbach, a Bibliography*, Leighton, London, 1911, p. xxviii ff. For the Nuremberg Chronicle see Claude Jenkins, *Dr. H. Schedel and his book* in *Mediaeval Studies presented to Rose Graham*, ed. V. Ruffer and A. J. Taylor, Oxford, 1950.

82 *St Mark's Rest*, Chap. II, para. 22, *Works*, Vol. 24, p. 225. For early maps see R. V. Tooley, *Maps and Map-Makers*, Batsford, 1949.

83 For Fouquet's *Plan of Rome* see Jean Longnon, *Les Très Riches Heures du Duc de Berry*, Thames and Hudson, 1969, Pl. 106.

83 For the Berlin engraving see Friedrich Lippman, *Wood-engraving in Italy in the fifteenth century*, Quaritch, 1888, p. 30 ff, and A. Mori and G. Boffito, *Firenze nelle Vedute e Piante*, Firenze, 1926.

84 For the *View of Florence* panel, see L. D. Ettlinger, *A Fifteenth-century View of Florence*, Burlington Magazine, 1952, Vol. 94, p. 160 ff.

87 For de'Barbari see Paul Kristeller, *Jacopo de'Barbari*, International Chalcographical Society, 1896, and Tancred Borenius, *Four Early Engravers*, Medici Society, 1923, also Lippman, *op. cit.*

95 Ruskin quoted from *Pre-Raphaelitism*, *Works*, vol. 12, p. 348.

96 For Italian patrons' taste see A. Richard Turner, *The Vision of Landscape in Renaissance Italy*, Princeton University Press, 1966. Gombrich quoted from *Gazette des Beaux Arts*, Vol. XLI, 1953, p. 338.

99 For Flemings in Titian's workshop see Gombrich above.

101 For the Netherlands and the Renaissance see Margaret Whinney, *Early Flemish Painting*, Faber, 1968, p. 122.
For date of Marriage at Cana see Max J. Friedlaender, *From van Eyck to Breugel*, Phaidon, 1956, p. 50.
For summary of buildings suggested by various authorities see *Les Primitifs Flamands* ('Corpus'), Louvre, Vol. I, p. 118.

105 For full descriptions and over 100 reproductions of the models of Munich, Landshut, Ingolstadt, Straubing and Burghausen see A. von Reitzenstein, *Die Alte Bairische Stadt*, Callwey, Munich, 1967.

107 For Marcus Gheraerts see Walpole Society, Vol. III, p. 3 ff.

110 A copy of Zalterius's view is in the Correr Museum, Venice. For Braun & Hogenberg generally see Ruthardt Oehme, *Old European Cities*, Thames & Hudson, 1965 and the facsimile edition published by Theatrum Orbis Terrarum, Amsterdam, 1965.

112 For Braun & Hogenberg's London View see H. B. Wheatley, *London Topographical Record*, Vol. 2, 1903, p. 42.

116 For 'El Greco wholly Greek' see Robert Byron and D. T. Rice, *The Birth of Western Painting*, Routledge, 1930.

120 For identity of boy see Leo Bronstein, *El Greco*, Idehurst Press, 1951. Translation by Robert Byron.

121 The *View of Saragossa* is discussed in A. de Beruete's *Velasquez*, Methuen, 1906, p. 59 and José López-Rey, *Velasquez, a Catalogue Raisonné*, Faber, 1963, pp. 174–5.

122 Details of Hans Bol from W. R. Valentiner in *Bulletin of the Art Division of the Los Angeles County Museum*, Spring 1947, pp. 16–19, quoting from Karel Van Mander, the 'Netherlandish Vasari'.
'an Irish painter' – Robert Barker (1739–1806); see source note to p. 237.

123 For accounts of all views from Schedel to Merian see Friedrich Bachmann, *Die Alten Städtebilder*, Leipzig, 1939.
For Merian's oil painting see L. H. Wüthrich, *Die Handzeichnungen von Matthaeus Merian*, Basle, 1963.

124 'Aachen to Zwolle' see Bachmann, (*op. cit.* note to p. 123).

125 For the Panoramic Views of London, 1600–1666, see Irene Scouloudi's study issued under that title by the Corporation of London, 1953.

126 For Visscher see T. F. Ordish in the London Topographical Society's *Record*, Vol. VI, 1909, p. 39 ff, and W. Martin in *The Early Maps of London*, London and Middlesex Archaeological Society's *Transactions*, N.S., III, p. 274 ff.

129 For Claude de Jongh see John Hayes in the *Burlington Magazine*, January 1956, p. 3 ff.

129 For Thomas Wyck see Hilda F. Finberg in *Walpole Society*, Vol. IX, 1920–1, p. 47.

134 For Hollar's biography and work see A. M. Hind, *Wenceslas Hollar*, John Lane, 1922.
For Hollar's influence see Martin Hardie, *Water-colour painting in England*, Vol. I, Batsford, 1966, p. 60.
For Place's influence see Henry M. Hake, *Walpole Society*, Vol. X, 1922, p. 39 ff.

137 For painters in Rome see Hermann Egger, *Römische Veduten*, Schroll, Vienna, 1931.
For Vredeman de Vries, see introduction to *Perspective* by Arnold K. Placzek, Dover Publications, New York, 1966.

142 For Fabritius's picture see E. P. Richardson, *Art in America*, 1937, p. 127 ff; Roger Hinks, *Peepshow and Roving Eye, Architectural Review*, September, 1955, p. 161 ff; C. Hofstede de Groot, *Catalogue Raisonné of Dutch Painters*, London, 1927, Vol. I, p. 574.

143 For Saenredam see P. T. A. Swillens, *Pieter Janszoon Saenredam*, Utrecht, 1953.

146 Van Gogh's description is quoted by Jean Leymarie in *Dutch Painting*, Skira, 1956, p. 188.

147 For Vermeer and Esaias van der Velde see Rolf Fritz, *Das Stadt und Straszenbild in der holländischen Malerei des 17 Jahrhunderts*, dissertation, Berlin, 1932.

149 'the first *plein air* painting' – Ludwig Goldscheider, *Johannes Vermeer*, Phaidon, 1967, p. 19 – but 'only supposition' in the view of C. D. Goudappel, Archivist of Delft Gemeentearchief.
See also W. Stechow, *Dutch Landscape Painting*, Phaidon, 1966, pp. 124 ff.

150 Ruskin's quotation from his evidence to the National Gallery Site Commission, *Works*, Vol. 13, p. 545.

151 For references to crane on Cologne Cathedral see Neil MacLaren, *The Dutch School*, National Gallery Catalogue, 1968, p. 157 ff.

157 Hinks (see note to p. 142) compared the two paintings.

161 For Heintz's influence see W. G. Constable, *Canaletto*, Oxford, 1962, p. 56. From this point on the use made of this book (which embodies much of F. J. B. Watson's earlier researches in *Canaletto*, Elek, 1949 and 1954) is so great as to make further reference to its pages impracticable.

163 For reproduction of Vanvitelli's 1688 *Piazza Navona* see Briganti, *G. Van Vittel*, Rome, 1960, Pl. 20.

165 Carlevaris-Canaletto's master-pupil relationship – see Michael Levey, *Painting in 18th Century Venice*, Phaidon, 1959, p. 81, quoting G. A. Moschini, writing in the early 19th century.
For biography and works see Aldo Rizzi, *Carlevarijs*, Alfieri, Venice, 1967.

166 Canaletto's drawing of the Piazza – compare *Piazza Looking South*, No. 62, Fig. 30 in K. T. Parker, *The Drawings of Canaletto at Windsor Castle*, with No. 50, Fig. 92 of reproductions of *Le fabriche, e vedute . . . in Carlevarijs*.

167 For Lord Manchester's letters home see *Memoirs Containing Letters* etc., Christian Cole, London, 1735.

170 Carlevaris's apoplexy: Moschini again, quoted by Levey (see note to p. 165).
The Venetian View Painters' bibliography is far too copious to be quoted here in any detail. Quite apart from contemporary sources, there has during this century been a stream of books, articles and monographs on their work – the catalogue of the 1967 Exhibition *I Vedutisti Veneziani del Settecento* lists nearly a thousand items. The most valuable books on the subject in English are the four already quoted by W. G. Constable, F. J. B. Watson, Michael Levey and K. T. Parker, and the most useful bibliography is in the 1967 catalogue referred to above. Almost all the statements for which no source note is given come from one of these sources.

174 Carlevaris's second Regatta painting; reproduced in *Luca Carlevarijs* by Aldo Rizzi, Alfieri, Venezia, 1967 – but the catalogue raisonné in it throws no light on when the painting left Venice.

177 For Joseph Smith see Francis Haskell, *Patrons and Painters*, Chatto & Windus, 1963, Chap. 11.

183 Levey, *18th Century Venice*, p. 83, and Watson, *Canaletto*, p. 11, believe Canaletto had a workshop of pupils and assistants. Constable, pp. 163–4, believes he had occasional help only, and he unrepentantly repeats this belief in the introduction to the catalogue of the 1964–5 Canaletto Exhibition in Canada, p. 17.

187 Marieschi's painting signed 'MM' is in the Manchester Art Gallery.

188 For quotation from Ruskin see *Modern Painters*, *Works*, Vol. 3, p. 53.

191 For Filoso see Ruth Rubinstein in Sotheby's catalogue of Old Master Drawings, 9 July, 1968, p. 58 ff; for Zocchi see catalogue of exhibition in the Pierpont Morgan Library, New York, 1968, and the *New Yorker*, 18 May, 1968, p. 32–3.
For Fabris see Antonio Morassi in *Arte Veneta*, XX, 1966, p. 279 ff.
The section on Piranesi, including translations, is based on A. Hyatt Mayor, *G. B. Piranesi*, Bittner, New York, 1951, Arthur Samuel, *Piranesi*, London, 1910, and (the standard work) A. M. Hind, *G. B. Piranesi*, 1922, reprinted 1967 Holland Press.

194 For Hollar's influence in England see Martin Hardie, *Water-colour Painting in Britain*, Vol. 1, Batsford, 1966.

195 For Knyff see H. V. S. and Margaret S. Ogden, *English Taste in Landscape in the 17th Century*, Ann Arbour, Michigan, 1955, p. 124 ff, and cyclostyled catalogue of British Museum Exhibition *The Beginnings of English Topographical Drawing*, 1949–50.

196 For Sutton Nicholls see Hugh Phillips, *Mid-GeorgianLondon*, Collins, 1954, p. 6.

197 For Danckerts's *Whitehall* see Burlington Fine Arts Club, catalogue of *Old London Exhibition*, 1920, p. 54 ff.

198 For York Water Gate see *Survey of London*, Vol. XVIII, *The Strand*, 1937, p. 59 ff. For van Aken, see R. Edwards, *Apollo*, Feb. 1936; Hilda F. Finberg, *Country Life*, 18 Sept. 1920; J. Hanbury Williams, *The Connoisseur*, 1938, p. 440; *Walpole Society*, Vol. IV, p. 117.

201 For Samuel Scott see Harald Peake in catalogue of Agnew's Exhibition, April, 1951, and reviews of the Exhibition, especially F. J. B. Watson in *Burlington Magazine*, May 1951; also Hilda F. Finberg, *Walpole Society*, Vol. IX, p. 49. A book on Scott is in preparation.
For Canaletto in England all subsequent writers rely largely on Hilda F. Finberg's researches published in the *Walpole Society*, Vols. IX and X.

205 For Canaletto's investments see Watson, p. 14, quoting Vertue's *Notebooks*, III, p. 132.
Sir Osbert Sitwell is quoted from *Left Hand, Right Hand*, Macmillan, 1946, p. 71.

213 For the Charing Cross directory, see Hugh Phillips, *Mid-Georgian London*, Collins, 1964, p. 100 ff, and Ambrose Heal, *The Signboards of Old London Shops*, Batsford, 1947, p. 179.

215 For William James, see Edward Edwards, *Anecdotes of Painters*, 1808, p. 26; Finberg in *Walpole Society*, Vol. IX, p. 51; Watson, *Burlington Magazine*, reviewing Scott Exhibition, May 1951.

217 The Wallace Collection paintings referred to are Constable No's. 205, p. 271, and 257, p. 296.
For the re-attribution of six Canaletto paintings to Bellotto see Terisio Pignatti, National Gallery of Canada Bulletin 9–10/1967, translated from *Arte Veneta*, 1966.

221 For Bellotto in Warsaw, see Mieczyslaw Wallis, *Canaletto The Painter of Warsaw*, Warsaw, 1954; also catalogue of Exhibition at the Whitechapel Art Gallery, London; May 1957.
Bellotto's biographer: H. A. Fritzsche, *Bernardo Belotto gennant Canaletto*, Burg b. Magdeburg, 1936.

224 'A practising artist of distinction', Lawrence Gowing in *Vermeer*, Faber, 1952, pp. 23, 70 and 137 – on the last going so far as to suggest that the first stage in the painting of the Mauritshuis *Head of a Girl* 'was a direct transcription of the incidence of light on the screen of the camera obscura'.

228 J. P. Richter's note on the Guardi *Piazza S. Marco* is in the National Gallery archives. It is undated and refers to O. Mundler as having written against the entry of the picture 'Franc Guardi' in 1854 'and ever since the picture has been given to Guardi'.

229 For Guardi's beginnings as a view painter see Dennis Mahon in *Burlington Magazine*, Feb. 1968, p. 71, and also in *Problemi Guardeschi*, Alfieri, 1967; A. Morassi in *Studies in the History of Art dedicated to William Suida*, 1959, p. 338 ff, and Francis

Haskell in *Francesco Guardi as Vedutista and Some of his Patrons*; Journal of the Warburg and Courtauld Institutes, Vol. 23, 1960, p. 256 ff. For full bibliography of Guardi see catalogue of the 1965 Exhibition in Venice.

231 For Canaletto's influence see catalogues of British Museum Exhibition *Canaletto and English Draughtsmen*, 1953, and Guildhall Exhibition, *Canaletto and His Influence on London Artists*, 1965.

236 For Girtin's painting at Henderson's and Beaumont's, see Martin Hardie, *Water-colour Painting in Britain*, Batsford 1967, Vol. II, p. 11.

236 For Henderson's 'Canalettos' see Constable p. 156 and p. 646 of the index; the National Gallery catalogues his two paintings as 'studio'.

237 For Girtin's *Eidometropolis* see Thomas Girtin and David Loshak, *The Art of Thomas Girtin*, Black, 1954, p. 35 ff, and Hubert J. Pagnell in *The London Panoramas of Robert Barker and Thomas Girtin*, London Topographical Society, No. 109, 1968 (the 'Robert Barker' is the Irish painter referred to in the footnote to p. 122).

240 For Pietro Edwards on Guardi in 1804 see F. Haskell in the Journal of the Warburg and Courtauld Institutes, Vol. 23, *op. cit.*, quoted by permission.

242 For the artists' first reaction to photography see Aaron Scharf, *Art and Photography*, Allen Lane, 1968, Chapters 3 and 4. Ruskin is quoted from *Works*, Vol. 35, p. 373.

243 For 'the first photograph' see Helmut Gernsheim *History of Photography*, Oxford, 1955. Pl. 18 and 1969, Pl. 21. It is the view from Nicephore Niepce's window at Gras, 1826.

246 For Kokoschka's comment see *A Colloquy between Oskar Kokoschka and Ludwig Goldscheider*, Phaidon, 1966, p. 7.

Index

Roman figures refer to page numbers, italic figures to illustration numbers. Museums and galleries appear under the town in which they are situated and are included only when referred to in the text; locations of all works illustrated and artists' full names and dates will be found in the List of Illustrations. Source notes are not included in the Index.